The
Intellectual Handyman
On Art

The
Intellectual Handyman
On Art

A Compilation of

Essays

by

GARY R. PETERSON

iUniverse, Inc.
Bloomington

The Intellectual Handyman On Art
A Compilation of Essays by Gary R. Peterson

iUniverse books may be ordered through booksellers or by contacting:

iUniverse
1663 Liberty Drive
Bloomington, IN 47403
www.iuniverse.com
1-800-Authors (1-800-288-4677)

ISBN: 978-1-4620-5687-3 (sc)
ISBN: 978-1-4620-5688-0 (ebk)

Printed in the United States of America

iUniverse rev. date: 10/04/2011

My state-of-the-art artbot has just two knobs: "Beliefs" and "Desires."

—Gary Peterson

CONTENTS

Author's Preface

The Intellectual Handyman is a moniker bestowed on me by my friend Karl. I guess it means a jack of all trades in the arts and sciences. I'm honored. I'll buy him dinner as soon as this book of essays makes me a household name. However, there are others who question my qualifications and ask me what it is that makes me think anybody cares about what I think about anything? Fair question, so let me dumb down my curriculum vitae for the cynics.

I've been drawing, painting, playing guitar, and keeping mental notes since I was a kid. After graduating from high school (where I was called Guru Gar) I lived on a communal farm, cultivating buzzables for a brief spell before getting a job at an airport just long enough to buy a motorcycle, and then headed for Colorado where my girlfriend had gone off to college. Although my own higher education was self-inflicted, I wrote term papers for college students, mostly liberal arts—philosophy, mythology, art history—just for fun and aced them all. I dropped-in on music composition classes at University of Denver where the professor chided me about being "really into" music—replete with air quotes—because of the way I'd stop in uninvited. But he let me stay and I learned to like the sound of parallel fifths, a musical progression that, according to classical theory, is to be avoided like nails on a chalkboard. So I joined an avant-garde band of all music majors except for me on guitar. We played some gigs at the college and got an audition at a recording studio that declined to give the group a contract, but offered me a job as a session player. I should have taken it. The band split and I ended up back in Michigan teaching guitar at the Warren Conservatory of Music, a glorified music store with a lofty name where I stayed one lesson ahead of my students. Some of my teaching colleagues were members of the Detroit Symphony Orchestra—even a future conductor—not that they would remember me today, or at least care to admit it.

I quit teaching—to the surprising dismay of students and parents—and played solo gigs in coffee houses and bars but didn't like working at night. So I took a job as a rough carpenter, framing houses in Michigan and Colorado for the next couple of years. Frequent blows to the thumb with a 28-ounce corrugated hammer head changed my guitar playing style and the hard physical labor finally led me to actually enroll in college, Lawrence Technical University, where I studied architecture for a couple of years. To pay for tuition, I painted signs and murals: a large Mediterranean-themed triptych for a Virginia Slims tennis tournament comes to mind. I also airbrushed flames and other decorative images on motorcycles, airplanes, anything. As for my studies, calculus was a bear, but I liked the art and design classes, also physics, ergonomics, etc. I found the work of architect Le Corbusier to be attuned with those in other diverse fields, giants like Fernand Léger, Hermann von Helmholtz or J. S. Bach. It was hard to keep my mind on architecture.

Now a college drop-out, I started hand-building acoustic guitars for customers that included some name-brand musicians like Graham Nash. As always, I embraced the math and music, ratios and scales, design and aesthetics in that creative endeavor, inventing tools and machines to help in the construction process. But after a few industrious years, my passion started to seem like work. I got married and took a job with Design Fabrications, Inc., a retail interiors design firm and spent much of the next thirty years heading the art and design department, leading the transition from pencils and markers to computer generated renderings. Writing trade magazine articles was also among my many duties. It was a swell vocation that allowed me to entertain my fine-art muses on the side. I exhibited my art at a couple of galleries and the public library, and I was even on TV. Speaking of which, my retro TV test pattern art icon—favorably reviewed in *Playboy* magazine—is a perennial favorite and still a big seller. I also won a first-place award in *Better Homes & Gardens* magazine for home remodeling, took the family to Europe and other adventures, wrote a novel, *Rhapsody In Overdrive*, and then a philosophical treatise, *Humor Scene Investigation*, that was critically acclaimed by scholars at the College of William and Mary and in the *International Journal of Humor Research*. That serious honor led to my self-appointment as Dean of Behavioral Sciences at the Peterson Institute of Arts & Sciences Research Laboratory and Gift Shop, a lofty, if nebulous, position that I still hold today.

I retired from the design firm but continued as a fine-artist working in pen and ink, a medium that lends itself nicely to my investigations of gestalt perceptions and the art of omission which is drawing. It is also way less messy than painting, and I can scribble anywhere. To kick off this new phase, I created a series of drawings, my interpretations of a dozen famous paintings from Detroit Institute of Arts collection, which are likely still available if you hurry (but the greeting card versions are sold out at the DIA Museum Shop). I donated similar works to the Cranbrook Academy of Arts for a fundraising auction, figuring that the mere mention of such revered institutions would look good on my resume, no?

Unfortunately, the fancy suburban galleries that I hoped would exhibit my new works declined and the cutting edge downtown venues that did offer to show them seemed a lot like dilapidated warehouses to me. Not wanting to go all bohemian again at this point of my life, or even tend a booth at the art fair, I decided to just post my artwork online from the comfort of my leather couch. But amidst the hoards of real working artists—some essential, others desperate—I was just another vanity artist taking up space, too content to bother much at promoting my cerebrally challenging line art, so I decided to become a famous author slash art critic instead and started web-logging on sites like ArtId and FineArtAmerica.com, expressing the same phenomenological acuity seen in the discombobulated limns of my pen and ink art, except in written form—blogs, essays and anecdotes. This book unifies that canon of nominally related ruminations. I needed to catalog my thoughts for my own future references anyway, but will also publish them here on the outside chance that they'll strike a chord with artists, scholars, and wisenheimers alike.

Art has long since replaced drugs as my mind-altering substance of choice, hence the "your brain on art" skew of this book title. Aesthetics supplanted psychedelics and I became a student of the brain while trying to fill a few gaps in the chronology. I'm a left-brained proponent of logic and scientific method, but I gladly accommodate pure reason and metaphysics too, even some politics and religion. Writing about art is one of my favorite art forms. I try to make each text flow effortlessly for the reader. In fact, I spend too much time knitting these words together; primping, editing, and simplifying for that vaunted fluidity. Each essay is crafted like a top-forty pop song with the rigor of a doctoral thesis. I'm proud that my academic work has been peer-reviewed in respected science journals, but

then I'm also a contributing editor for Avanti Press: that's right—funny greeting cards. You got a problem with that? Rhetorical question.

So, no—I'm not a PhD, but I eat them for breakfast. If I'd have buckled down and studied at any accredited university from the get-go, I might have learned what I know sooner but, frankly, I couldn't understand aesthetic judgments or, say, the synthetic *a priori* propositions of Immanuel Kant any better than I do now.

Anyway, many thanks go, as always, to my wife (formerly the girlfriend way back in the second paragraph) Elizabeth, a teacher, and to my sons Jesse and Andrew, a mechanic and a lawyer, all for keeping this intellectual handyman informed of the latest developments in adaptive learning, internal combustion, and fair use doctrine, for starters. Thanks also to those colleagues who graciously allowed me to quote them on the back of this book, and to any who didn't, my apologies. I just hope that discriminating readers everywhere will enjoy this compilation of essays. If it helps, an inventory of my audio/visual/literary indulgences can be accessed online at www.garypetersonart.com.

1. ART & PHILOSOPHY

What Makes Good Art?

Good art connects the dots for you. It links the intellect to an emotion and makes you feel good—or at least smart. It unravels a mystery and lets you think you did it yourself. Good art strikes a chord that resonates with sensibilities beyond the physical. It broadcasts on a wavelength to which one's mind is attuned; it speaks to you even if no one else can hear it. But art is just a reflection of reality whether good, bad, or ugly, and subjective terms like "good" simply mean that we enjoy something, and "bad"—well, not so much. So, art isn't good or bad; it's just art or not art.

We often think of art as a form of self-expression, but that's mainly a trait of modern art. Historically, artists didn't take liberties with worldly depictions except maybe as prescribed by the ruling powers. Sure, Michelangelo got away with the occasional visual poke at his personal enemies by portraying them as buffoons, and he even worked his own portrait into the ceiling of the Sistine Chapel, but those were just the sideshow antics of a testy subordinate. Art transcends the artist.

Art is aesthetic like humor is funny. It's the precarious balance of details that we appreciate. A single dab of paint can bring to life the visage of a beautiful woman if that tiny dot is perfectly placed in her eye like a glint of light. But good art doesn't have to be representational. An abstract painting can evoke the same sense of wonder on a more cerebral level. The human brain has feature detector cells that get fired-up only when stimulated by the sight of certain shapes and angles in a specific context or orientation. It's like the difference between a funny joke well-told, and nitrous oxide: they both can make you laugh but, in the end, reality is a chemical reaction.

So the "good" in art doesn't reside in the subject *or* the medium but in the magical agent that binds them together. We can forgive an artist's sloppy brushwork if the painting resembles a loved one. On the

other hand, we might dismiss the masterstroke of genius if the subject of the painting is offensive. A friend of mine couldn't appreciate a recent exhibition of painted portraits of famous rap artists because of his distaste for that particular musical genre. Sentiments influence perception. I'm no party to gangsta mentality, but I kind of liked the paintings.

Most of all, the brain is forgiving, if sloppy. It's amazing how it can make something out of nothing, especially with art where the whole is more than the sum of its parts. This is true even when the parts are strange and ambiguous like the drifting figurations that often comprise my own disjointed line drawings. With them, it's not what you see, but how you see it. Yet, unlike the urge of an artist/writer to promote his own works, "good" art has no ulterior motive.

* * *

Beliefs, Desires, and the Male Gaze

So, art connects the intellect with an emotion. But the intellect is rigid and emotions are unstable—they can easily flare up and get out of hand. Michelangelo is said to have taken a hammer and whacked a sculpture because it wouldn't talk to him. When expressing a creative urge, artists unconsciously convert intelligence and emotions into the more manageable aspects of beliefs and desires. Art lies in the difference between belief and desire.

Beliefs and desires are "intentional" states of mind because they aim at something: the object of our desire or the thing in which we believe. Beliefs are filed under "knowledge" with the likes of faith, intuition, suspicion, etcetera, while "desire" is stored with hopes, wishes, needs, and demands.

Beliefs are the simplest form of mental representation: the building blocks of conscious thought. Beliefs become knowledge only if they are proven true. They are, along with external motivations, the value system that controls our behavior. You are what you believe.

The Scottish philosopher David Hume said our beliefs don't depend on experience or reason, just ideas: the imagination. If our expectations are repeatedly met, our beliefs become habit:

The idea of heat becomes a belief in the presence of a flame.

But doubt is the scourge of belief, so it's ouch, ouch, ouch . . . until eventually our behavior becomes automatic. Aesthetic judgments mean feeling pleasure: the sense of the beauty that is in the eye, not in the pie. An object of desire can become art when we impose our beliefs on it. The artist's job is to make a believer out of the viewer; or as Pablo Picasso put it:

Art is the lie that tells the truth.

Desire is stronger than belief. When desire motivates one's behavior, the rationale is "I believe it will be satisfying." As a renowned Post-structuralist once said:

> The phenomenology that emerges from analytic experience, demonstrates in desire the paradoxical, deviant, erratic, eccentric, even scandalous character by which it is distinguished from need.
>
> —Jacques Lacan

Elsewhere, it's been said:

> You can't always get what you want/but if you try sometimes, you get what you need.
>
> —Jagger/Richards

As an artist creates a piece of work, his or her intentions constantly change, the hand updating reality even before the paint dries, guided by everything from gut feelings to game theory. Ceteris paribus means "all things considered." Art is a language and an artist's beliefs and desires are inherent in every visual element of the composition.

Desire instigates, and belief mediates. Together they affect the figure and ground of a picture while sorting out what is and what ought to be. Form can be as stark as a gnarly tree against the winter sky or as sensuous as a nubile nude nestled in nuance. Meanwhile, abstract expressionists turn a canvas into an event and conceptual artists think "outside the box," but squares of belief generally submit to circles of desires.

The artist's personality can show up in the smallest details, perhaps in the physiognomy of a portrait: the subtle of facial expressions from the mysterious smile of Mona Lisa to the cocksure sneer of a velvet Elvis.

The glint in a Mannerist eye can turn into daggers in a blink of pop art. Our desires become ironic when we see how they've been fulfilled in a consumer society.

I'm building a robot artist, an art-bot named Hal, no wait—Gar. The mechanism is hardwired to emulate any archetypal artist from an ancient stone-hammer steeped in the deity-rich milieu of antiquity to a postmodern militant feminist with an axe to grind. Whatever artist I choose, fine-tuning the art-bot is done with just two knobs: belief and desire. (The deluxe model may also have an optional ego attenuator for the proto-typical Modern artist and an irony filter for the Postmodernist.)

Visual stimuli is channeled through every lobe of the brain from the visual cortex to the basal ganglia—more proof that it's not *what* you see, but *how* you see it. We can't just show our humanoid a picture book of U.S. presidents, map the stimulated brain cells on the scalp with an ink pen, and expect to see a tattoo of Abe Lincoln. However, a similar study involving the anterior cingulate cortex and the Victoria's Secret catalog did reveal a thing or two about the male gaze and photographic memory, namely: take a picture—it lasts longer.

Rembrandt clearly believed that beauty wasn't everything and Picasso had some interesting ideas about feminine beauty as evidenced in his renderings of, say, Dora Marr—good, and Les Demoiselles d'Avignon—well, let's just go with the "eye of the beholder" thing on that one. Point being, artists paint with the brain, not with a brush. Each mark on paper by the artist can be interpreted by the viewer as a symbolic gesture of desire.

Art is created when two contrary ideas meld into one. Or perhaps one idea with different skews of belief and desire like Edouard Manet's *Olympia* pretending that she's *Venus of Urbino*. To wit: It was during the high Renaissance that Titian painted saints and angels and putti with the best of them. But the humanism of antiquity had also resurfaced in the beliefs and desires of this self-confident new age and Titian was commissioned for a painting by a wealthy merchant who really just wanted a picture of a naked woman to hang over the couch. *Venus of Urbino* was the lofty title given to this lusty piece.

Three hundred years hence, Edouard Manet was inspired by Titian's work. Pandering to his own desire, he asked his favorite model if she wanted to get famous in his next picture and recast her in the role of *Venus of Urbino*. Fresh from her successful part in the controversial picture *A Snack*

in the Grass, she melds her own beliefs with a desire to put her own spin on the seductive icon from Urbino, and voila!—*Olympia* was born (Fig. 1).

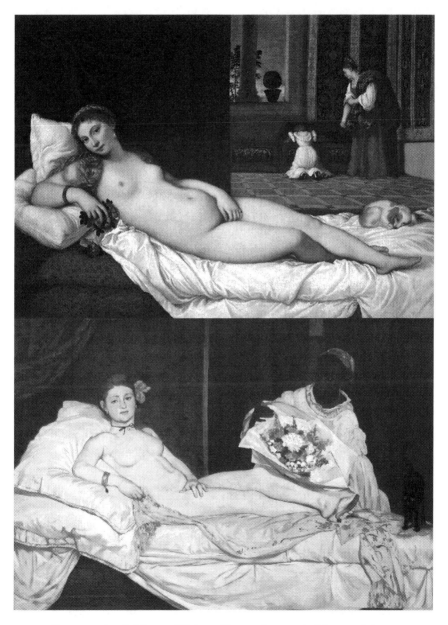

Figure 1. (top) *Venus of Urbino*, Titian; (bottom) *Olympia*, Manet

On the surface, Manet's scandalous masterpiece (now in the Musée d'Orsay, Paris) replicates Titian's tableaux right down to the charm bracelet, but the sentiments take a turn towards the down and dirty. Venus' "come hither" look is replaced by Olympia's blank "all business" stare. It caused a real hub-bub amongst the Parisian salon crowd of the day and even now Olympia seems more naked than any other nude in art history. To Manet's credit, the same slick and greasy surface treatment of this painting worked equally well on his many beautiful still-life flower paintings. Meanwhile, forging his role as arbiter of bad taste, he leveraged his notoriety by pandering to a new set of desires and beliefs called social realism.

So can we assume that one can accurately predict the behavior of any artist given his or her beliefs and desires? No, not always. Here's why: Art, like humor, provides a stage on which it is socially acceptable to act out one's fantasies. Artists can fly in the face of social mores and convention. It is almost expected nowadays. With humor, "things said in jest/are things said nonetheless." But there is always an element of truth involved, and this truth is even truer in the world of visual arts.

<p style="text-align:center">* * *</p>

The Divine Comedy: Dante's Inferno

The funniest part of *The Divine Comedy* is when Barbariccia signals his demons to march by tooting his butt trumpet. Otherwise, the story isn't very funny.

Dante Alighieri's epic poem, written in medieval Italy, chronicles his trip through hell, purgatory and paradise (guided mostly by the ancient poet Virgil). Dante's trilogy brought the Italian language up to speed in the world of literature. The first of the three books is *Inferno* and it's a hellish read in any language—but at least in Italian it rhymes.

The *Holy Bible* portrays hell as the "gnawing and gnashing of teeth" and such. Dante's description is even more prolific. It's a freakish nightmare of a story. The torments have wretched souls howling like dogs, pale and colorless with sores and mold-encrusted orifices. Dante meticulously conveys the maladies and malfeasance that his eyes witness and his testimony intended to instill a fear of God. The punishments are on a graduated scale.

There are nine rings of hell in the Inferno. The infamous inscription above the entrance reads:

Abandon all hope whoever enters here.

Hopelessness in a place where the sun never shines? That's a bum trip for sure. Dante's Inferno is a malaise of fire and ice populated by "shades," which are sort of like zombies. Here's the tour.

First ring: Non-Christians spend their endless days living with the likes of insatiable she-wolves. That's mild.

Second ring: Fire storms are forecast in the region designated for those who lived a lustful life. It's a great sorrow to remember happy times while in misery.

Third ring: A cold filthy rain pours on this squalid neighborhood where the gluttonous are food for Cerebus, a beast with three throats and blood in his eyes. That bad dog rips whatever flesh these shades have left.

Fourth ring: In this ditch, the demon Plutus rides herd over prodigal types that will forever push huge stones back and forth but get nowhere.

Fifth ring: The wrathful and sullen (apparently you can catch hell just for being moody) herein get to drink the slimy waters of the river Styx.

Sixth ring: The heretics in this rut have to deal with the three Furies and Medusa with her hair of horned vipers. Here one cannot see the present but only the future—and it ain't good.

Seventh ring: This is where common frauds inflict pain and death on their neighbors who are, of course, more panderers and sorcerers. There is hell fire aplenty, and serpents with hairy armpits.

Eighth ring: This ring, Malebolge, and its subdivisions are reserved for treacherous frauds—the likes of Alexander and Dionysius. (Who knew?) For those not sunk up to their brows in boiling blood, it's the hounds of hell. Other sinners are in crap-filled ditches. Others have their noses hacked off and more scabs than a fish has scales. Astrologers have their heads turned backwards.

Ninth ring: This central pit of Dante's Inferno is where hell freezes over leaving its inhabitants, including Judas, with their tears

frozen solid. One beast has tears rolling out of six eyes, down three chins into a bloody frozen froth.

Dante supposedly bridged the gap between ancient and modern literature, but his version of hell is still medieval compared to, say, the existentialist philosopher Jean Paul Sartre who proposed simply:

> Hell is other people.

Dante was not without his prejudices; he had a grudge against those who exiled him from his home in Florence. Personal vendetta colored his view of the world—the ponderous blend of history, mythology, and religion expounded in this cautionary tome. For instance, Pope Boniface, who conspired against Dante in real life, is placed in the eighth ring of the Inferno.

Dante shows something akin to a sense of humor when, in reference to the diabolical tortures and ghastly scenarios that he sees in the Inferno, he wonders:

> Tante chi stipa nove travaglie e pene?

which, very loosely translated, means: "Who thought this stuff up?" This is funny because obviously it was Dante himself; he wrote the damned book. Talk about poetic license.

Things get a little better in *Purgatory* (the second book of the trilogy), and then finally in *Paradiso* where Virgil can't go but where Dante hooks up with his childhood sweetheart and lifelong inspiration, Beatrice. It's the happy ending which, in my view, makes this comedy divine.

* * *

On My Couch in Plato's Cave

I had just sat down to read *The Matrix and Philosophy* when I realized . . . there are squirrels on my roof. I can't see them, but I can see their shadows on the lawn as I look out of the window on this sunny morning. I'm reminded of Plato's Cave, the one with the campfire inside and the prisoners beyond that, facing the back wall so that they can never see anything but shadows

cast from the fire light. My world view from here on my comfortable leather couch does have its parallels with that ancient scenario. The cave allegory highlights the gap between shadow and substance, appearance and reality. But unlike those prisoners who know of nothing about the world outside of shadows on the wall, I recognize that there probably are squirrels loping along the ridge of my roof. Still, there remains a shadow of doubt in my mind. Maybe it's just a prankster with hand puppets up there (on the roof, not just in my head).

Perception is a three-way affair; it takes an object, an observer, and the medium between them. Let's say I shine a spotlight on your face in the dark. Now I can see color, texture, and facial features (my, what squinty eyes you have) instead of just a dark silhouette where your head has blocked the light on the wall behind you. The angle at which I aim that light beam alters my perception of you. With the light overhead, like natural sunlight, you are easy to look at. But point the light upwards from the darkness below your chin and, whoa—scary! And even in the best light, we lose the details in the distance. In other words: Seeing is not necessarily believing.

Language also conveys "second-hand" views and likewise distorts reality with word play. That's why Plato didn't cotton to poets: too much drama, not enough description. Roses are red, and donuts are—doh! (Sorry, wrong Homer). But seriously, people will blindly accept the mediated words of poets, priests, and pop-stars. We all tend to pass judgment on people and things we don't really know. Today, as always, we must weigh the verbal accounts of anybody with an agenda—that ilk of zealots, hucksters, and political pundits who want to sell you everything from ideological dogma to mortgage-backed derivatives.

Experience is the essence of knowledge, or as we philo-sofa types call it—epistemology. Wisdom is how you use that knowledge. Rene Descartes said, "I think, therefore I am." But how much can we really know about anything besides ourselves? The answer: Not nearly as much as we believe. And even then, our perceptions are colored by our prejudices, emotions, and cheap sunglasses. If shadows represent the lowest rung of the comprehension ladder, then reflections and images are only slightly higher. And just when you think you've got reality pegged, context changes everything because of the whole sum of its parts thing. Plato's Allegory of the Cave suggests that we must not only step outside into the proverbial sunlight to better discern the details that enrich our lives, but—as a matter

of duty—parlay those details into ideal forms of justice, honor, and the odd toga party.

Meanwhile, are those shadows that I see from squirrels on my roof or just a puppet master with a couple of sweat socks? I can't be absolutely sure. But if I had to bet my life on it, I'd go with squirrels. And, sure enough, I now hear the patter of tiny paws on the eaves, and then—voila! There they are! A couple of furry nut-bags suddenly leap into plain view, scurry twice around the tree trunk just outside of my picture window, and then chase their shadows across the lawn and back out of sight. Well, now—back to my book.

* * *

The Rise and Fall of Deconstructionism

If philosophy tells us how to think, then deconstruction is literary criticism that derides the ever-changing meaning of a published thought. It also shows how people exploit the ambiguities of natural languages for their own advantage.

Written words and spoken words light up different sets of brain cells on their way to apprehension. The written word is indelible and subject to meticulous scrutiny whereas the spoken word is quickly separated from the speaker and left vulnerable to critical interpretation. But even if every word had only a single meaning, words could never completely convey the irreducible essence of a given entity or concept. Consider Mona Lisa: the woman, the painting, and a verbal description of either. The only property that is common to all three manifestations is the logical essence of that concept, which is beyond words. Deconstruction derives from phenomenology, the "bracketing" (isolation) of an object from its surroundings allowing us to perceive that object in a continuum of all possible contexts. This was the view of so-called continental philosophy that was never widely embraced by the analytic school that underlies the hegemony of the English language.

Reading Jacques Derrida, the champion of deconstruction, is difficult enough, but reading him in his native French tongue is a flat-out assault on my sensibilities. His tenet of "undecideability" seems only to neuter deconstructionism of its own potency. This is ironic considering the

homage he pays to the misogynistic hero of his book *Éperon: Les Styles de Nietzsche*. Derrida translates Friedrich Nietzsche thusly:

> . . . truth is like a woman. It resembles the . . . complicity between woman, life, seduction, and modesty—all the veiled effects. Woman is but one name for that untruth of truth.

One can see why deconstructionism may have lost its mojo to the more utilitarian agenda of, say, feminism. Nietzsche, although not a decontructionist per se, also once opined (to Martin Heidegger):

> The question of being is anachronistic, and its suspicious relationship with time makes its pursuit—at least in traditional metaphysics—a symptom of decadence.

Is it any wonder Nietzsche went verrückt? If one is not braced for such paranoid preponderances regarding the ephemeral nature of the present and its banal implications upon common sense, then one's only recourse is laughter. Ha! Ditto deconstructionism. Any body of text that is deconstructed becomes a joke without a punch line: all foreplay and no orgasm. To its credit, deconstruction does pander to both types of humor: practical jokes and poetic justice. The former is analytic like the statement, "a frankfurter is a hot dog." It's just another name for the same thing. The latter is synthetic in that it tells us something new, albeit metaphorically, about the subject, i.e. "Frank is a hot dog," implying that there is a man named Francis and he is a real showoff.

Deconstruction, in the end, forsakes the tragic-comic ironies of literature that define the human condition which it seems best suited to venerate, in favor of linguistic puns that merely confuse to amuse.

* * *

Thus Spake Garathustra

Art was no longer imitating life but vice versa, so Garathustra chucked it all and moved up north to live in a bat cave. He scrawled pictures of moose and beavers on the walls with wild berries, and lead a hungry, horny, but mostly happy life for many years until he finally went nuts and came back

to civilization where all that was left of art were video games and air guitar that anyone could play like a superstar.

"Art is dead" he proclaimed.

"WTF?" everyone twittered.

"Virtual reality cannot be without real reality." Thus spake Garathustra.

Old-schoolers still slung paint while the new ones pushed pixels. Some had artistic vision and others, not so much. Art became a competitive sport. Flame wars broke out on the Internet, so Gar left cyberspace for nature. Hanging out with the plein aire crowd, he was nonetheless content to memorize the scenery instead of painting it. When they booted him out, he hooked up with some figurists but got on their bad side waving his arms all "look at me—draw me" and stuff. Thus began Garathustra's downward spiral.

He tried watercolors, duck and trout stamps, but his masks were gummy and the competition stiff. Auction houses were selling pickled sheep for big bucks so he tried conceptual art with cow pies. He showed at a gallery called The Pied Cow and stunk the place up. So he turned off his mind, relaxed, and floated downstream. He slept under bridges and on sidewalks and in abandoned cars. He took lots of catnaps but things always seemed the same when he awoke: Artificial. Being philosophical, like so many artists, he fell prey to existentialism and convinced himself that there is no good art or bad art, just art that bangs your gong or not.

Garathustra developed an arcane visual language to express his pleasure and pain. A picture is worth a thousand words but just when he was getting some traction with the critics the economy tanked and he couldn't get a sawbuck for his abstracts. He was despondent. Pretty soon he was drawing menus and manuals and hawking advice on the street corner. "Never match wits with idiots" he'd say, "but don't put all your colored eggs in the intelligence basket. Paint with emotion. Temper those Apollonian sensibilities with a Dionysian splatter-fest now and then. Get down and dirty." Thus spake Garathustra.

He painted in the moment, in the zone, working with live models or from photographs or just making stuff up in his head. He got all bohemian, stoned and tattooed but then he got lucky when—unlike that other thustra, that misogynistic figment of Nietzsche's imagination—Garathustra found a woman, a real nice gal. O.K., she

found him. They primped and posed for each other and did Day-Glo body painting and other erotic works that never saw the black light of day but they soon ditched that scene to start anew.

Garathustra wanted artists to rule the world (what's wrong with that picture?) but with power comes responsibility. He cleaned up his act and went on the lecture circuit. "Make love not war" became his shibboleth but in a pinch he made the first punch count.

"In a food fight, put your money on the hambone." Thus spake Garathustra.

Funny how things turn out; he coined that phrase into a retirement fund and back to the cozy cave he went with his überwoman slash interior decorator. On a laptop they ordered the perfect art to hang over the couch in Plato's den: art that spoke to them, real art by real artists from vast online emporiums. Meanwhile, the happy couple still makes hand puppets in the firelight and draws stick-figure beasts with berries. They joined a social network to keep in touch and market their own brand of swag. Some artists are ahead of the curve and others reinvent themselves at will. Timing is everything.

Art, like life, is a process. It's not what you see, but how you see it. It's not always a pretty picture but "art is dead" my ass. Long live art!

* * *

Abstraction and Empathy

It doesn't seem like a hundred years ago that Wilhelm Worringer published *Abstraction and Empathy* (Abstraktion und Einfühlung). His thesis on the psychology of style is a primer on modernism that has influenced artists from Kandinsky onward. Written just after Cezanne painted his "Bathers" and a year before Picasso's "Les Demoiselles," it marked the shift in the arts from academic towards the primitive and linear styles rediscovered in artifacts like African tribal masks and Japanese woodcut prints. It anticipated Cubism and Art Deco too. It's a freeze-dried view of the organic nature of things.

This book challenged my perspective on abstract art. I take a scientific view of natural phenomena whereas Worringer opts for intuition and metaphysics claiming that any art which merely imitates the visible world does so to elicit empathy from the observer—an "objectified

self-enjoyment," or what we might today call "wrapping one's head around" something. Supposedly, any society with such a projective world view is complacent in their environment—too comfortable with their own bad selves. He further contends that insecure peoples living in hostile surroundings develop an artistic volition based on a "spiritual dread of space." This fear leads to an aversion of the third dimension: depth. But certain cultures and civilizations transcend the sensory world by making art that is an "inorganic crystallization" of the spiritual world, one that provides an object with "material individuality and closed unity." Hence, art becomes a rigid simulacrum constrained to a single plane. Wow, I did not see that coming. It's like we can't believe our eyes so we iron out our skin into one flat surface and "see" only what we touch.

The dividing line between empathic art (mimesis) and abstraction separates the Western mindset of Classical Greece and Rome (and later the Renaissance) from Eastern mysticism as seen in Egyptian hieroglyphics, Gothic tectonics, as well as Christian and Islamic decoration. I suspect Worringer's views favor the psychological leanings of Jung's archetypes over Freud's libido; or the alienated philosophy of Schopenhauer over the logical axioms of Wittgenstein. Worringer's ideas have even been applied to the literature of Proust and T. S. Eliot. I might look for a musical analogy between classical and jazz, but all music is abstract.

Favoring the experiential over the unknowable (a priori), I consider abstract art—the extraction of essence from form—to be an intellectual endeavor. Nuh-uh, says Worringer: It's strictly intuitive. That's always a red flag for me therefore I must report a flaw in his theory. To wit: In his depiction of space-time as a necessary evil, Worringer posits that even the sculptural (3D) arts should "purify" an external object down to its absolute value. So far, so good. He deems Egypt's ancient pyramids—memorials to the supernatural forces that shape the human psyche—as the perfect form. He vigorously pursues this conclusion citing pyramid power as "the perfect example of all abstract tendencies," the ultimate construct for "divesting the cubic of its agonizing quality" and being the most "consistent imaginable fulfillment of this endeavor"—the so-called material individualization and closed unity.

Wrong!

Here's the rub. Given the stated purpose and criteria of his argument, the perfect form would have to be the tetrahedron—a three-side pyramid, not four! For Worringer to overlook this logical conclusion is astonishing.

A tetrahedron, the geodesic building block of simple linear elegance and spatial economy, is one of the most spiritually inspired constructs in the material world—the right tool for this job. Methinks it just didn't fit the intent that Worringer ascribes to the ancients (and who knows what they were thinking?) It's a glaring inconsistency that subverts his otherwise impressive theory. It happens.

Still, I concede that it does not diminish Worringer's worthy exposition or his legacy. Any theory, especially one as wide in scope as his, will likely falter in the light of new evidence and constant scrutiny, but *Abstraction and Empathy*, in its bold investigative nature, transcends the mere correctness or incorrectness of a few details. This landmark treatise, which delimits the aesthetics of art from the platitudes of natural beauty, is as entertaining as it is informative.

<p style="text-align:center">* * *</p>

Reading Kant in Santa Fe

I try to take the right reading material when I go on vacation. I've taken Voltaire to France, Dante to Italy and Steinbeck to California. But my wife and I go to Santa Fe often enough that I'm already up to speed on the Anasazi, Coronado and Georgia O'Keeffe, so on our most recent trip to New Mexico I brought Immanuel Kant's *Critique of Pure Reason*. Not that Kant ever traveled outside of Prussia in his life. Let's just say I was behind on my eighteenth century German philosophy.

Well, what a fustercluck that book turned out to be; even more daunting than his *Critique of Judgment* which at least focused on art and aesthetics. The semantics are abominable. Kant peels back every aspect of reality in layers of words that either must have changed definitions over the last couple of centuries, or else something got lost in translation. Still, I read the whole thing and got the gist of what he was *trying* to do: develop a way of thinking about the nature of our world. I've reached similar conclusions in my own philosophic investigations. But his tome is a righteous tangle. For instance, what's the difference between knowledge and understanding? And why turn the latter into an object by calling it *the* understanding? What I call a medium, he calls a manifold. It's hard to tell an argument from a principle. Kant makes the most sense when he's quoting Plato, Descartes or Hume, and although I can take or

leave Aristotle, I do like logical syllogisms. At least Kant's fundamental "categories" are reminiscent of Plato's "ideal forms." That seems to be an accurate, if ancient, premonition about the hierarchal process of memory in the human brain as we now know it.

Kant tries to describe every possible relationship between subject and object—the viewer and the viewed—but he constantly cites the impossibility of knowing any "thing in itself." I guess that when we see lightning and hear thunder; those are what he would call "intuitions" of a mysterious electrical event. He wraps every proposition in fancy hermeneutics, like:

> The aggregate parts of a phenomenon are given only in regressive synthesis of decomposition which is never in absolute completeness, either finite or infinite.

See what I mean? Sheesh! Still, his *a priori* conceptions and representations of thought do seem to lend themselves to art (and criticism), which is, after all, just a current concept of reality. Stand by.

I soldiered through the nearly impenetrable layers of intuitions, sensations, perceptions, conceptions, determinations and judgments surrounding a given object, all precariously arranged to support his transcendental notions that, somehow, objects and events must happen in the mind *before* they can occur externally because we can't even exist unless objects fill the space around us. Supposedly, *a priori* synthesis is how we wrap our heads around the metaphysical, things like love, art, math and God. Oh yeah, and freedom and immortality too. OK, so the human soul needs an external reality, namely space and time, to validate our own existence. I get that. It's like any color appears white until at least one other hue is present to compare it with.

Kant mentions psychology in his critique, but he wasn't up on the workings of the brain back in 1780 like we are today. He didn't know how his so-called apperceptions correlate to brain parts; that cognition and differentiation is an executive function of the pre-frontal cortex, and that reward-induced memory retrieval in the dorsolateral area puts a personal spin on one's judgments under the guise of metaphysics when, in fact, it is just the imagination, which would draw blanks if not for the hippocampus recommending certain prior sensual experiences to one's memory banks in an empirical, categorical, sort of way.

Now, a word about Santa Fe: Food. OK, two words: Art.

We strolled through the farmer's market near the rail yard on a warm, bright Saturday morning, checking out the peppers and pistachios, and listening to some hip cowpoke troubadours sing and play, before we eventually walked across the train tracks over to SITE Santa Fe, an art venue/museum/gallery, air-conditioned, that showcases a more cerebral, as opposed to decorative, genre in state-of-the-art art. In this case, it was the avant-garde sensibilities of contemporary artist Suzanne Bocanegra's mixed-media exhibit that resonated with the postulates of Kant that were still rattling in my head.

One element in Bocanegra's installation was a reconstitution of a Jan Brueghel the Elder painting called *Sense of Smell* (1618) where each flower petal in the original is now an individual painted-paper cut out, pinned on a dark wall, but without the original pictorial context: an allegorical figure representing the sense of smell, reposed in a classical garden setting, sniffing said flowers. Perhaps that mythological aspect seemed irrelevant to the artist, or maybe she's just not that good at drawing people (unlikely), only flowers. But it's not like the viewer is penalized even if one is not aware of the historical backdrop. It's just superfluous knowledge. An aesthetic judgment, after all, is the disinterested pleasure of form without a specific purpose. Kant might have called this visual decontextualization "the empty determination of an empirical intuition in unconditioned synthesis" or something. In other words, art has a purpose that's more important than whatever that purpose is. In my mind, it might just as well have been a brain lesion in my striate cortex visually disconnecting the flowers from the background. Still, via Kant's convoluted reasoning or not, Bocanegra's artistic investigation made sense to me. The spaced-out decomposition of painted petals wall-hung in that cool dark cavernous gallery caused, epiphenomenally, the sympathetic sparking of a complimentary neural network in my head, just shy of tweaking my olfactory bulb for a fragrant whiff of synesthesia to tickle the ganglia of my aesthetic judgment. It's the interplay of experience and pure reason that sparks the imagination. Now that's what I call art.

Proffering such indulgent sophistry is not to cast aspersions on the abundance of splendid regional artwork found in Santa Fe: the more traditional celebrations and decorative heritage of natives and explorers inhabiting the ochre hills, polka-dotted with juniper and pine, all aglow with vivid colors of sun and sky and sagebrush as captured on many a

canvas. Of this I am reminded as we re-emerge into the enchanted radiance of that high desert city and now, with hot tamale and cold drink in hand; watch the awesome smoldering spectacle of not-too-distant hills and mountains ablaze in a phenomenal display of unbridled nature. All metaphors aside—it's been a record-breaking summer for wildfires across the entire Southwest.

<p style="text-align:center">* * *</p>

2. ART & PSYCHOLOGY

Dreams and Other Mental Imagery

As dreams go, I could just as easily have been promenading down the Champs d'Elysee in Paris, but *nooo*. Instead, I dreamt I was in a traffic jam on a freeway in Detroit. I steered my car into the middle lane, around the dimwit who'd been texting while driving, and proceeded with caution. Then I woke up, slowly, and watched that rush hour dreamscape degenerate into abstract patterns of the spontaneous sensory data that I was "seeing" with closed eyes.

That's called a hypnopompic state: the brain's semi-conscious attempt to make something out of nothing, but it says a lot about mental imagery in general. Sometimes we see the retinas and other ganglia inside of our own eyeballs and think ites something external. Earlier, I thought I saw Colonel Sander's face in the roiling clouds of morning light even though my head was buried deep in a pillow. A similar "twilight" dream state is called hypnagogic when we're falling asleep. It's a lot like an opium-induced pipedream. Or, ahem, so I'm told.

Mental images stem from memory but can resonate, in novel ways, with the personal beliefs and desires latent in one's neural underpinnings. The traffic jam scenario above was built by free association with random memory traces that best fit the spontaneous retinal activity—the nervous energy or background "noise" of autonomous cell-firings. Mental imagery is the modulation of these visual stimuli, and sparks up the visual cortex. In other words, the dream wasn't random—the vision that initiated it was. It's like interpreting abstract art versus realism, the latter of which leaves less to the imagination. High blood pressure might play a role too and, admittedly, I ate some fried chicken last night. Mental note: Upgrade menu for more sophisticated dreams. Music, meditation, and other metaphysical juju can also help to conjure up primo visions.

With scanning gadgetry like CAT, PET and fMRI, we can map out brain activity during spells of mental imagery. If only we could feel our own brain cells firing, then we'd experience objective reality by the neural configurations it entails. I guess, in essence, that's exactly what happens. Mental imagery draws on perception, emotion, and even the motor control areas via the basal ganglia. That's why abstract art is so much fun. It's like a tabloid horoscope or a Bob Dylan song; it seems highly personal but it's tailored to, well, everyone! By forging specifics from generalities, our brains can fabricate scenarios to fit any data. So don't think twice, it's alright. You don't need a cognitive neuroscientist to know which way the wind blows.

Mental images engage Brodmann's area 17 in the visual cortex. This is where the shapes and patterns sent from the eyeballs are organized and hooked up with stimuli gleaned from the memory vaults. It's where visual depictions meet verbal descriptions, according to behaviorist notions. And whatever it is you think you see, can trigger emotional responses like joy or fear or horn-honking. Same to you, pal.

The whole mental imagery process can seem counter-intuitive, much like the James-Lange theory that ascribes emotions to our actions instead of vice versa. This profound affect has a time element. I have even reversed time with my brain. To wit: I dreamed I was in my office at The Peterson Institute when a coworker, Poindexter, walked past my door and disappeared from view. Then suddenly I heard an ominous thumping as he tumbled down a flight of stairs. I thought oh boy, not good—there's been an accident and I saw alarmed expressions on the faces of some other colleagues. I was about to proceed to the aid of said klutz when suddenly I awoke from the dream and realized two things. First, a tree branch had fallen (damned poplars) on the roof of my house right over my bedroom where I was sleeping. Secondly, the noise not only woke me up, but had also coincided with the staircase incident in the dream that had occupied several seconds of my time. In other words, my mind had fabricated the accident scenario retroactively, transforming the thumping sound of a tree branch hitting my roof into that of a tumbling body in my dream—all before spontaneously awaking me in real time. It had reversed the order of perceived events!

Now, did time really reverse? Or stop? Or did I just lose track of it? Perhaps a glut of the chemical neurotransmitter adnosine clogged up in the frontal cortex of my brain, a holding tank for short-term memory, causing

time to seemingly stop because I just plain forgot about it. But amnesia aside, the prospect of time manipulation is more fun than subjective illusions. It's a handy affectation when you want to micro-manage a lucid, luscious, or ludicrous dream. Like Salvador Dali, one might even bring a camera or paint brush on the return trip. That would be surrealistic. Sure, those cars in my traffic-jam dream might turn into giant ants or jellyfish, but then, whoa!—did that cute little fox in the Mercury Cougar that I'm tailgating just wink at me in her rear-view mirror? Yeah, I know—in my dreams.

* * *

Bipolar Depression

Don't think of it as a bipolar disorder but rather a widely varying disposition over which one has no control. Not to trivialize the mental malady that toggles the mind between anxious impulse and self-destructive tendencies, but extreme mood swings do have some creative potential. Sudden relief from any anxiety provides the impetus for novel ideas, artistic vision and inspiration. The sufferer should be ready to act on these impulses to write, paint, or compose music. But often times, mania and depression overlap and you don't know whether to laugh or cry. Those euphoric doldrums are an unsettling malaise at best and an agitated state of hypersensitivity more often than not. It's like someone whispering sweet nothings in your ear with a bullhorn.

These superimposed moods range from cavalier exuberance, to the interminable tedium of a flawed milieu—the conspiracy of gum chewers & knuckle crackers (that is to say all other people) that populate the world outside of your head when you're wired, and frustrate any creative urges. There's no reason to revile them and their annoying activities any more than they care to engage your intellectual ruminations or to indulge your fantasies. If the result is a sense of isolation, maybe it is time to wake up and smell the neuropeptides.

Such jarring moodiness can be stabilized with a cocktail of drugs (serotonin reuptake, or monoamine oxidase inhibitors for you pharmacology buffs). But you may be "old school" in this regard and just as soon save the drugs for recreational purposes, or at least physical pain. Meds and therapy might be helpful to you and the economy, but

given that prescription drug abuse is now more prevalent than ever, I'd opt not to spend the next several years and half a nest egg on all the lithium needed to catch that bright elusive butterfly of mental health. On the other hand, even "normal" brain functions do bear one reductive truth: reality is a chemical reaction. In that regard, one can affect a calm state of mind by letting "hard-wired" personality traits interface with certain external stimuli such as abstract art, bird calls, or haiku; things with simple, but irregular structure seem to work best. It may help to keep sketches and written thoughts handy for when you're in a funk and need to remind yourself how things look on the sunny side of your brain. Alternately, it is advisable to exercise. Skating, biking, or a bounce on the bedsprings might help, if you get my drift.

Meanwhile, just grin and bear it and try ever harder not to alienate loved ones and the other people who have to live and deal with you, and rest assured that "normal" is just a matter of numbers. Try to use your anxieties creatively. Laugh at yourself or, better yet, at someone else. Write an essay or deconstruct one; paint a picture or just put a mustache on another. Try yodeling. Of course these things are done on an upswing because it's impossible to be creative while being flummoxed by abject despair. At that point, you've just got to hop up on the good foot, proverbially speaking, and shake it all about.

Bipolar disorder used to be called manic-depression. But even if you have a grumpy disposition, you could still marry a saint, raise a family, hold a job, see the world, and find plenty 'nuff joy in the world to plow through the rough patches. Just keep putting one foot in front of the other.

* * *

Your Brain On Fibonacci

My wife and I want to retire to New Mexico but first I'll have to sink the spare cash in our gravy boat (think cookie jar) into some get-rich-quick scheme so we can afford to live in the rarified art-o-sphere of Santa Fe if not some alien crash pad near Roswell.

So I researched the art market and found that auction prices have roared back from the recent melt-down much like the Dow Jones Averages. Old Masters drawings are hot, and even Banksy street art seems

no more speculative than mortgage-backed derivatives these days. But China's emerging financial markets seem even more lucrative than their comic art, and online trading makes betting money on the stock market so push-button easy that I've decided to dabble in securities instead. And not only Sotheby's.

I was poring over stock charts and technical indicators like moving averages, standard deviations, and harmonic convergences, when I came across the Elliott Wave method of picking winners based on Fibonacci numbers—a.k.a. the Golden Mean ratio to us art types. Shades of *The DaVinci Code*, right? Ha! One might just as well use fractals, karma, and Chinese New Year to chart a Wall Street strategy. Seeing a myth that needed exploding, I set off on a tangent to do so.

I pedaled over to the Peterson Institute and hooked myself up to an EEG and charted my idling brain. Alpha waves broadcast from my occipital lobes but only when I closed my eyes. That was relaxing. Brain waves—alpha, beta, theta, gamma, snoozy and sneezy—disappear whenever I think, or see, or do the hokey pokey. They mainly provide background noise that serves to synchronize the channels of communication between various populations of brain cells which act like transistors and charged particles.

Well, it turns out that market behavior indeed parallels the process of short-term memory. Wait, what? Yep, the brain has a clock-radio that modulates brain wave patterns to convey information and store memory. By means of code sequencing and matching filters, the oscillating circuitry of neural networks forge harmonics and eigenvalues into the logical process that we call thought. More than just AC/DC, it's the quantum mechanics that turns chaos into cognition—and it all operates at resonant frequencies based on the Golden Mean.

We're not talking decimal arithmetic or even binary math but base 1.618 . . . also known as Phi: The Golden Mean Ratio. Why? According to one Volkmar Weiss, "It's a non-linear process where the rate parameter produces the first island of stability." Well, put a star on that forehead. I guess it's the scalability of their frequencies that allows brain waves to interact. But there's a glitch.

A line can be cut into two parts so that the smaller is to the larger, as the larger is to the whole enchilada. That single point—the most pleasing proportion to artists, philosophers, and conspiracy theorists since ancient times—is an irrational number. Likewise, the efficacy of Fibonacci's

numbers—1, 2, 3, 5, 8, 13 . . . is that the sum of each consecutive pair equals the next number in the sequence and therefore each successive ratio (3:2, 5:3, 8:5, 13:8 . . .) creeps ever closer to that magic number, 1.618 . . . It's the recurring proportion that da Vinci used in art, Béla Bartók used in music, and Ralph Elliott used to speculate in the stock market. Problem is that the golden mean isn't found on any real-world measuring stick because its precise value is infinitely long. One gets ever-closer but never really gets there. That asymptote is both the beauty and the bogey.

Information consists of memory—the link between intelligence and mere cognizance. And memory is like music. With its neurotransmitters and electricity, the brain detects and records perceptions in the harmonic overtones of the oscillating sub-systems. So now I'm thinking that any stock market tips might well take the form of a melody, say, *We're In The Money,* or *Blue Money,* or Pink Floyd's—well, you get my drift. But the lyrics aren't important; I don't think I'll buy me a football team. Words have their own meaning whereas tonal relationships convey info via melody, harmony, and rhythm. Still, as Barrett Strong would say, "The best things in life are free, but you can keep 'em for the birds and bees . . ." Everybody, hum along.

Finally, don't ask why, quantum theory suggests that a person can attend to only seven thoughts at a time—nine max, if you've got the IQ for it. This correlates to complex waveforms with up to nine harmonics, with wave crossings at zero equal to the quantum number. (Personally, I think there's only one thought with several parts, but that's neither here nor there.) It's all based on probability and chaos—like the stock market and maybe Abstract Expressionism.

So now I'm back to thinking maybe I'll just buy some art I can live with, perhaps an odalisque, a sunset, or some quirky mindscape. Maybe something fractal or at least something in a frame having the same Golden Mean proportions as a giant credit card. As for the stock market? Forget the quantum mechanics; the cup-and-handle configurations; the head-and-shoulders or saw tooth signals with the Fibonacci bent of Elliott's Wave Principles. I've found a much simpler investment theory and it's one-hundred percent effective: Buy low and sell high.

Land of Enchantment, here we come!

* * *

Color Psychology in Art, Design, & Acid Rock

Color has a dual-personality: It is light and it is pigment.

When we see a certain color, we are actually seeing the wavelength of light which is not absorbed by that pigment. The eye is most sensitive to yellow-green light, but it also makes "warm" colors, like red, seem to advance towards the viewer while "cool" colors, like blue, recede. The "warm-cool" labels are arbitrary. They could just as well be classified as "loud-quiet" or "emotional-intelligent." They are psychological.

Colors can affect physical reactions. The color red can speed the heart, and yellow may increase metabolism but, then again, these are just common effects of any novel stimuli. Still, every color does have its tendencies just like every person has a disposition. Talk show hosts have green waiting rooms for their guests to relax. Pink holding tanks have a calming effect on belligerent prisoners—at least short term. But before long those inmates will be ready to riot when the novelty wears off.

From intimate to clinical, soothing to provocative, the psychological effects of color are subjective and personal. They are also associative; a red light means stop and green means go, or sometimes port and starboard. Colors are metaphoric. To have "the blues" means to be depressed, and "seeing red" means to be enraged (but incidentally, bulls don't see red—they see a guy in fancy pants taunting them with a flag). Color is a pleasurable sensation with a limited downside. Color is never painful unless it triggers some higher thought process—a memory or association but, certain color phobias notwithstanding, that's why rose-colored glasses were invented.

Color is to an artist as the chromatic scale to a musician. Certain colors can seem either harmonious or out of tune with each other. In music, the lower the mathematic ratio is between two tone frequencies, the better it sounds to our ears. Colors behave in similar ways. Musically speaking, major and minor chords create happy and sad moods. Ditto with certain color combinations: vivid, complimentary colors are lively as a blue sky full of hot-air balloons while muted achromatic hues are as soulful as a smoky lounge full of jazz musicians.

Colors have been characterized in many different ways by every culture throughout history, but sticking with the musical motif, I'll cite the lyrics Jimi (Purple Haze) Hendrix. In his song *Axis Bold as Love* he personifies his emotions thusly abridged:

> Anger, he towers in shiny metallic *purple* armor . . . Queen
> Jealousy's fiery *green* gown snares at the grassy ground . . .
> *blue* are the life-giving waters taken for granted . . . happy
> *turquoise* armies lay opposite . . . *red* is confident, flashing
> trophies of war and ribbons of euphoria . . . *orange* is young
> and full of daring but very unsteady . . . *yellow* in this case is
> not so mellow but frightened like me . . .

I'd like to paint a picture of that epic scenario some day.

Meanwhile, a school of artists known as Color Field painters (akin to Abstract Expressionists) includes Mark Rothko and Helen Frankenthaler. They try to elicit purely emotional reactions through the tonal interplay of diffuse colors on their large canvas surfaces. And Henri Matisse painted striking but surprisingly naturalistic looking portraits using vibrant reds, blues and greens in lieu of flesh tones. Landscape painters traditionally use earth-tones that are "rich" and "fertile," but Wolf Kahn's pastel forests are luminescent frissons of foliage. They are joyful.

Artists can intimately control colors in their paintings while interior designers can control the entire visual field of an enclosed space. Well-lighted walls make a room appear larger and more inviting. Dark rich muted colors with warm wood tones provide an exotic atmosphere in which to brood, reflect, and sip espresso. Starbuck's decorators have got that ambiance down pat. Most retailers use light and color to attract and influence customers. A new upscale supermarket in my town has an interior clad in equal measures of silver metallic, terra cotta tile, and light wood tones. The color-corrected track-lighting shimmers from all surfaces with a healthy pink glow that makes me hope the food I'm buying looks half as good when I get it home.

Color also factors into the industrial arts as well as marketing. The purchase of a laptop computer or smart phone may hinge on its color. Trademark colors are also a way to "brand" the retailer's identity into our hearts and minds. When you see a red and white target, a green block, or a blue oval, chances are you associate it with some corporation—Target stores, H&R Block, or Ford

Color is like humor: It's subjective. Tell a joke and some people will laugh, others not. Likewise, people are differently affected by a given color or scheme. Color is a property. It has no form or content. If colors were words, they'd be adjectives, words that suggest a mood like "black" humor

or "white" lies. Of course, paint companies give their colors lofty names like Fragrant Cloud or Earth Glaze, names that are ambiguous but more appealing than, say, Stink Bomb or Mold Spore.

As for clothing fashions, all I can say is that for every pair of pink and purple hounds-tooth knickers or tam-o-sham, there is someone with a personality to suit—probably a golfer. Myself, I don't wear gray or beige clothing. I look old enough already. But not to end on a down note, I will cite some colorful lyrics of yet another musical legend from "the sixties," namely, Donovan.

> Colour sky Havana lake
> Colour sky rose carmethene
> Alizarian crimson
> Wear your love like heaven . . .

* * *

Seeing Sound

This visual abstraction (Fig. 2) seems electromagnetic: a bristling force field all centrifugal and kinetic and laughing at gravity too, but is it some galactic spiral like a cosmic pinwheel in 3K soup or is this nebular nooky the nucleus of some organic germ cell or a runny egg? Is it a nautilus or just water down the drain?

A faint octogram scrawled on the surface dissolves in the flux as swervy vectors radiate to a backbeat rhythm. One can almost hear the harmonic overtones that are clearly seen. It has a musical timbre; a shimmering tremolo in sweet syrup that usurps the suck and gurgle of chaos. The signal-to-noise ratio translates to a figure-ground visual aspect as this membrane mambos with a black hole in an eerie plasmatic light while unlikely reflections of deep space propagate towards the edge of the universe. Is it a color weather radar map of a sun storm? (Shown here in grayscale.)

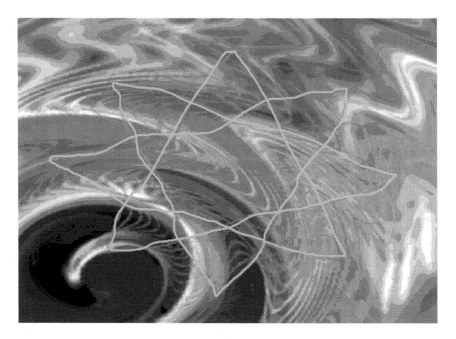

Figure 2. *Seeing Sound*

No. Actually, it's a screenshot of the random patterns generated by my Microsoft Media Viewer (visualization setting: Alchemy) captured from my computer monitor and frozen in time at the push of a button while I was listening to a wave file of some splendid new music: my own instrumental composition called *String Theory* (that you can download on the Internet.)

To think that I used to screw up the picture on my old black and white TV by messing with the vertical hold and fiddling with the knobs on the back of the set—the ones labeled "Qualified Technicians Only"—just for the visual effects. Ha! Nowadays the glorified kaleidoscopes we call computers can turn an audio event into an objet d'art at the flick of a wrist. Of course, an algorithm that creates "art" isn't exactly Abstract Expressionism but that's not the issue here.

The connection between this push-button abstraction and its musical attribute is tenuous though; any sound or noise would have sufficed. The disturbances on this raster are triggered mainly by the wave amplitude of low frequencies like those from a bass guitar or a kick drum. That is to say it's rhythmic, but not owing to melody or harmony. I saw no color

correlation between the visual and audio spectrums, no slow red light for the bass notes and fast blue light for treble, let alone the tints and shades of higher and lower octaves. It's not exactly Walt Disney's film *Fantasia*—he really did a number on *The Sorcerer's Apprentice* with that 'toon—but these desktop graphics do manage to convey the click and sizzle of a jazzy ride cymbal pretty well, what with the raindrops-on-oil effects and all.

Of course, there was a time when, transfixed by colored light, I might get lost in the luminous amorphous globules and become one with the fluid free-forms in a lava lamp. Then again, I was probably "baked" on brownies, if you know what I'm saying. But psychedelic interludes with Betty Crocker aside, one sure thing is that the synesthesia found in today's animated computer graphics, beyond the flying toasters, might have blown my mind for good back then.

Still, the marriage of art and pure music is necessarily abstract. It is an intimate connection between the eye and ear, a sound-stage of color and form in space-time, not just the coincidental sights and sounds of music videos. It's oscilloscopic, like the stringy knots of warbling light in my head when I hear myself giving artistic credit to the computer programmers that write the code for those random pattern generators. So put that in your "what is art?" pipe and smoke it.

* * *

Making Sense of Abstract Art

A discussion on a popular online art forum inspired me to formulate the following thoughts and create the accompanying piece of abstract art (Fig. 3)

When the eye sends light signals to the brain, those impulses go through the lateral geniculate nucleus to the visual cortex (the projection screen in the back of the head) which then routes the signals back to the LGN via the information processing channels of the subconscious including memory, associations, personality and all other so-called intentional states of mind, such as beliefs and desires, which are extensions of the intellect and emotions, and which account for things like empathy and spirituality in art and religion.

Without this perceptual feedback, the owner of the brain cannot recognize the image before his eyes. For example, that person might

describe seeing something that has a five-pointed polar array connected with lines, but he doesn't see a "star" as we know it (or a face or a salad fork, etcetera). Like a dog watching TV, he sees only an ambiguous blur of light and shapes.

An artist can also imagine (visualize) an object and paint a picture of it, but if we eliminate any referent, real or imagined, all that's left is the mental abstraction which is as unrecognizable as the front (reticular) half of the vision. Now substitute this strange back-half of the mental configuration with some random concept—say a circle to represent motion—and paint a picture of it. Then, say, you deduce that a straight line is needed to support that symbolic "wheel" and add it in. With color, texture, and the juxtaposition of myriad elements, the artist adds deeper "meanings" to his vision, or he might add a purely decorative element for the heck of it, and so on and so forth in a push-pull process of aesthetic judgments until we have a satisfying entity that is both self-referential yet based on our beliefs and desires. The process toggles between focus and distraction (conscious), instinct and reflex (sub-conscious) to arrive at a construct of pure abstraction.

Someone posed the question of "how would a blind person express him or herself on canvas?" It reminded me of an account of a man, blind since birth that became an accomplished guitarist. In his adult years, a surgical procedure gave him sight for the first time and (after meeting the wife and kids, etc.) someone showed him his guitar for the first time. He had no idea what it was; not a clue. This thing with which he was so intimately familiar through touch and tone was totally unrecognizable to him upon sight. He had only ever "seen" it with his hands which shrink the "visible" world to an arm's length. Beyond that, I suspect he could detect interior spaces by the echoes and acoustic resonances of sound in a room (the abstract properties of musical composition are something else altogether).

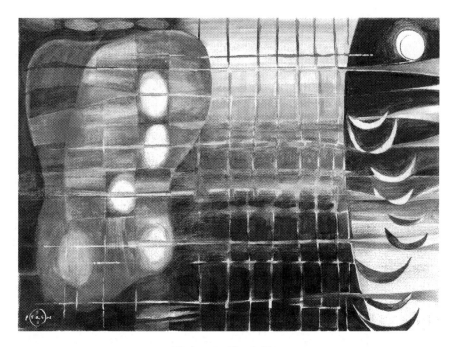

Figure 3. *Touch Tone*

Trying to imagine the world without sight, I created this abstract visual representation of the sensations of touch and tones while playing the guitar as "seen" inside of my head without any reference to the instrument's outward appearance. Only the area where the two hands touch the guitar fills the picture frame. Beyond that is nothingness without eyesight. Color is a property of light (vision) but also correlates to sound which, like light, is a function of wave frequency (shown here in grayscale; see color version at garypetersonart.com).

The amorphous shape at left is where the palm of the hand and thumb touches the back of the guitar neck. The white spots are the fingertips playing an A minor-seventh chord, my favorite. The four flat ovals at top left are where the left-hand fingers wrap around the fret board. The white dot at top right is where the little finger rests on the soundboard for a finger-picking style. The crescents are fingernails (but feel free to perceive them as some kind of lunar calendar or mystical whatnot if you prefer). The strings and frets are obvious; they can be "seen" (anticipated) by touch. The prong at the bottom, just left of center, is the occasional zinger,

the twanging sound of the fingers scraping across the bronze wound bass strings.

As fascinating as the parallels are between light and sound, the differences are also profound. I used color as a convenient analogy in the original rendering but I would emphasize that a blind person has no concept of color as we know it. Then again, Ray and Stevie (Jose, Doc, Blind Lemon, et al) demonstrate the expanded resources and enhanced musical connections possible in human brains that are free from the demands of visual processing. Those acquired sensibilities are beyond our experience except as enrapt listeners, but I hope that I've provided a reasonable visual model with *Touch Tones*.

* * *

Aoccdrnig to Rscheearch

Aoccdrnig to rscheearch at Cmabrigde Uinervtisy, it deosn't mttaer in waht oredr the ltteers in a wrod are, the olny iprmoetnt tihng is taht the frist and lsat ltteer be at the rghit pclae. The rset can be a total mses and you can sitll raed it wouthit porbelm. Tihs is bcuseae the huamn mnid deos not raed ervey lteter by istlef, but the wrod as a wlohe. Pettry amzanig huh?

The oft-cited paragraph above suggests that words, not letters, are the building blocks of language and spell-checking is optional in the human brain. Wondering if this self-correcting phenomenon also occurred in visual art, I randomly took an image of Georges Seurat's familiar masterpiece *A Sunday Afternoon on La Grande Jatte*, divided it into forty-nine equal parts and turned each part upside down (Fig. 4A). Yep, I can still recognize it, but I've found that forty-nine is the optimal quantity to obscure a picture in this manner. Any less means bigger pieces and soon leaves the whole picture upside down. Any more, and the pieces reduce to pixels that can spin without changing the image. I'm a scientific guy, but seven up by seven across seems pretty mystical.

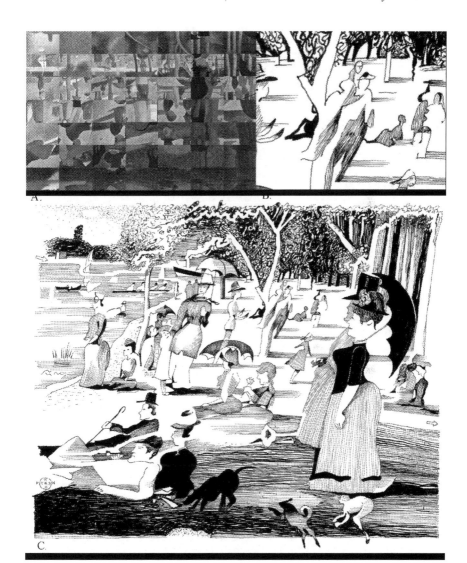

Figure 4. (A) 49 parts individually rotated; (B) Detail of C;
(C) *La Grande Jatte* (after Georges Seurat)

So the brain is also forgiving when viewing art. It takes what you give it and fills in the gaps as it sees fit. This is true with both representational and abstract art. I like to straddle the borderline of recognition when drawing pictures. My line art has about a ten-percent threshold of recognition

which means that relatively large portions of a drawing are unidentifiable if separated from the whole shebang.

The detail shown (Fig. 4B) is from my linear translation of Seurat's piece. On its own, it makes one wonder what are these morphological mutations that seem to look like something, but who knows what? It has something to do with phenomenology: the structures of consciousness when experiencing the meaning of an object—how things look when we're not looking at them. In this case, the said morph-o-doodles turn into children and monkeys and lovers and soldiers as soon as we divert our gaze by one degree. Only in context to the whole does it make any sense at all. Fortunately, the fact that my artworks are primarily scientific investigations spares me the sanctimony of the "you call this art?" crowd.

Then again, Georges Seurat was scientific too, what with his pointillism trying to emulate the physics of light. My line investigations are more cerebral. If I were viewing Seurat's bourgeois beachscape of leisurely strollers, you could check my brain with Doppler color radar, or whatever tomography the medicos are using today, and find the brightest mental storms clumped around the lateral geniculate nucleus because that's where colors are mixed in the brain. My pen and ink rendition, on the other hand, would affect hot spots near the layer of feature-cells in the visual cortex because of the way the eye pinballs through my pen and ink map of the original (Fig. 4C). I've actually drawn a maze into this picture-puzzle. As for the words that started this query, they light up different parts of the brain like Broca's area and Wernicke's neighborhood.

Still, the visual cortex forgives the ambiguous but decorative squibs and blotches as charitably as the more cognitive regions ignore the rampant typos. The big picture emerges from the seamy details largely due to memory traces plowed in the furrows of gray matter. In conclusion, I submit that the pre-attentive process of vision averages out background noise until some figure grabs your attention, be it a top hat or a big bustle, for scrutiny by pin-point focus. Also: Limited-edition silk-screened prints of my pen & ink homage to Seurat are likely still available as you read this. Forty bucks.

* * *

Flea Market Neurology

Son of Pete Estates abuts the Peterson Institute campus. It's not exactly a gated community, but there's a chain across the road next to my house with a NO DUMPING sign on it. That's where the annual art auction/block party is under way to raise funds for some new speed bumps and a statue of the Authority Figure in the commons area. There's also a flea market today. I donated some furniture and art, but I just noticed an anatomical model of the human brain marked ten bucks on the display table, so now I'm thinking about how my own brain works. With time to kill before the neighborhood potluck and lawn dart event, I'll share some insights.

My brain reminds me of an old Radio Shack project I once designed: an acoustic guitar/door chimes unit with transistors and solenoids that could fingerpick *Classical Gas*. Those were heady days alright. But Ohm's law has parallels in brain circuitry except with neurons and ganglia instead of wires and resistors. The human brain doesn't have discrete parts for every function. All types of brain cells form countless circuits that generate subjective reality from tracts of ganglia just as handily as today's computers parlay electrons into everything from wordplay and pie charts to data mining and crowd sourcing—replete with annoying side effects like Facebook and Wikileaks. The philosophy of mind has boiled down to the brainy algorithms by which life now imitates art. It's from this complex schema that amusing interludes of consciousness and social media emerge. Without it the ghost in the machine would hardly muster a facial tic.

The whole brain forges our perceptions into human experience, but it's the dorsolateral pre-frontal cortex (PFC) that lends an aesthetic buzz while the nucleus accumbens gets laughs out of false alarms. Many brain parts are named for their shapes, such as the amygdale and hippocampus after almonds and seahorses. The caudate and putamen form a sort of devil's tail in the mid-brain. It's a rare brain part that single-handedly controls any aspect of human behavior, but the caudate does seem to be the seat of revenge. Stay tuned.

Some brain circuits are always on until something trips the kill switch. Love, for instance, is a many-splendored anxiety that, together with hate, is a zero sum game. They trigger hormones to short out each other's circuits. That seems hay-wired, but they don't call it lovesick for nothing. A subcortical gyrus called the insula—deep in a fissure between the pre-motor and parietal lobes—turns these raw emotions into sentient

feelings. It clocks our sense of time and reflects our sense of self by bouncing it off the frontal lobes. The insula also imparts empathy; it takes emotional impulses piped in from the hippocampus and thalamus, via memory traces in the orbitofrontal cortex, to turn external events into highly personal experiences. That's how we identify with other people and their issues. That's also why we enjoy representational art—because it reminds us of something else.

I like to let the basal ganglia guide my pencil-pushing hand on orders from the motor cortex, but without the benefit of visual feedback. That was the case with my pen and ink rendering entitled *Table Lamp Approaching Lightspeed* which just sold for ten thousand dollars at the auction! Just kidding. We don't get a lot of wealthy art patrons at this glorified yard sale. But a biology teacher from the junior high school did just pull up in a minivan and bought the toy brain for seven bucks and change. My volunteer shift is over.

Elizabeth and I walk over to our neighbor's house—the one with the garden gnomes that have significantly lowered my property values—for cocktails. Their garage is cluttered with sale items like crock pots, exercycles, and other odd appliances. We end up playing a board game with Buck and Edith and now I'm thinking about how my brain cobbles together *this* scenario. I ask my parahippocampus what's happening and it tells me there's a table and chairs and people involved but it has to check with the bilateral fusiform clear on the other side of my head to identify the faces. Turns out, I'm playing Parcheesi in the rumpus room and, frankly, it looks like Buck is cheating. Reading faces is what the fusiform does.

I share my random thoughts with the hosts until their eyes glaze over and Buck finally asks what part of my brain makes me think anyone cares, but the question is rhetorical. "Oh, I'm sorry," I say, "Please, tell us more about your kids." I'm not being sarcastic. We have a family too and empathy dictates that one nods approvingly at the coma-inducing details about other peoples' kids and grandkids, knowing we'll get our turn. If I'd wanted to be sarcastic, I'd have asked him about his new leaf blower or that irritable bowel. I'm not completely averse to tedious social intercourse, just pretty much. Still, we need friends to take in our mail while we're away on vacation next week.

Sarcasm is the irony of inferring one thing by stating the opposite. A verbal inference lights up the right ventromedial PFC while the right parahippocampal gyrus detects the sarcasm. This applies to the person

that gets the joke, not the wiseacre who cracks it. The truth value of the ruse depends a lot on facial recognition of the speaker, as well as voice timbre, history and familiarity with said mediator, once again implicating the bilateral fusiform gyrus to distill symbolic language from a mere speech act involving a personal relationship. In other words, detecting *sarcasm requires that a person know what the speaker believes that the listener believes*. The left brain understands the language and the right brain puts it in context. It may take the entire cerebral cortex to sort out a subtle metaphor. The parahippocampal gyri are roughly located behind the eye brows, reminding me of Frida Khalo who was, coincidently, Diego Rivera's wife. And since one non-sequitur deserves another, we sometimes sneeze at sunlight because the optic nerves run along side of the olfactory bulb. That ought to raise some eyebrow.

Suddenly, Jerome—the neighborhood whistleblower—walks in and my right medial caudate snarls up in a knot. He ratted me out to the city for feeding leftover lab samples to the coyotes and dumping some deadwood in the park. I'm kind of miffed at him. His wife's quite the looker though, which sparks my anterior cingulate—the repository of pleasant visual stimuli. The insula may treat love and hate as equals but, frankly, it's biased towards disgust and contempt, tempered by the putamen down the striatum line, with subtle shadings of learned incentives and other motivational cues gleaned from around the skull, all filtered through the beliefs and desires that we store in the memory traces of every impulse that has snaked those drains before. That triggers appropriate acts of aggression, preferably make love not war, so naturally I'm all "Hel-*loh, Betty!*" Now, mental telepathy is beyond the scope of this discussion, but my wife fires a metaphysical warning shot at me from her frontal lobes—a subtle message with a distinct 'curb your fusiform or sleep on the patio' skew. My dorsal striatum is conflicted but I relent. Meanwhile, Betty says hi.

"So, Jerome—you been patrolling the 'hood for scofflaws?" I defer.

"Yeah—all clear except for the suspicious activity going on in here," he says.

My left pre-frontal lobe scans that semantically encoded utterance for any memory matches in my superior temporal sulcus, Wernicke's area, since the barb was spoken, as written here, with a straight face. Meanwhile, my right lobe checks for poetic justice, as opposed to practical humor, and yep—there it is: *sarcasm*. The inference being that my character is suspect.

"You're just paranoid," I suggest. Then I tell Jerome that Buck and I are refurbishing an old brain scanner that we salvaged from a dumpster behind the Institute. Buck gives me a 'huh?' kind of look. I get that a lot. We go out in the garage to check out the equipment.

"Is this a CAT or a PET scanner?" Jerome, a plumbing inspector, wonders aloud as he kneels down in front of the used appliance.

"It's a Whirlpool," I point out.

"That's a clothes dryer!" Jerome scoffs, "How mental do you think I am?"

"Stick your head in there and let's find out," I tell him.

So, he sticks his head in the dryer. (He's got some loose change in the old lint trap, if you know what I'm saying.) But even though his amygdale and hypothalamus were strobing like a disco ball, there was no activity whatsoever in the left caudate or insula. Apparently, he didn't get the joke. My dorsal striatum was in stitches though. It seems to bear that the only human trait controlled by a singular dominant brain part is revenge, and that originates in that crescent stretch of mid-brain nuclei called the caudate. Hook up a voltage tester to it with some alligator clips, and you'd see that it charges up the instant you decide to punish somebody for their transgressions against you. Revenge isn't as primitive of a reflex as laughing, but it is related to the sense of humor, which is in turn a sense of superiority, except that it isn't triggered by anxiety or incongruity, but just for the hell of it.

It is a riotous panoply of feedback that resonates in the wake of normal neural activity let alone in that sweet spot of dark human behavior. But if revenge is sweet, then forgiveness is divine. That's why the humorsphere—that limbic network of nyuk-nyuks—bumps up the dosage of beta-blockers so we can chill, satisfied to simply imagine devious scenarios of our rivals' submissions rather than executing the actual plans of attack so frowned upon by polite society. But enough guy talk and sociopathic behavior. Like the Jackie DeShannon song in that crate of used LPs on the floor between the boom box and beanbag chair says: "What the world needs now is love, sweet love"—or at least some inhibitory mediation between the insula and nucleus accumbens.

* * *

3. ART & SCIENCE

Optical Devices and Art

In this age of conspiracy theories, it's no surprise that artist David Hockney's book *Secret Knowledge* caused a flap some years ago. In it he purports that many of history's great painters used optical devices like lenses, mirrors, and primitive cameras in the creation of their works. Omigosh!

I've not yet read that book, but I'm amused by the fervor with which the debunkists mock Hockney and his theory. Surely he can't really believe that "the Old Masters didn't know how to draw" as one detractor fumes, adding that it's Hockney who can't paint or draw. Oh, the acrimony! The project is a work of art in itself just to spark such dialogue. In a world inundated with imagery, I wonder who can truly imagine how the great minds of less-jaded ages viewed their technology, gadgets that would spawn a yawn by today's standards.

Art is still made with a human touch by traditional artists trained in ateliers, forging ahead with themes of humanity, universal and timeless. But art is in the brain before it reaches the hand so why not employ optics now and then to help focus the vision? Even an object seen through a vacuum is distorted by lighting and distance before it reaches an imperfect eye. Besides, everything we see is ultimately reduced to a postage stamp-sized array of photons beamed upside-down on the back of our eyeballs anyways. At that point, it's all in the head.

Of course, tools should be used to best effect if at all, otherwise it's like stealing a bad idea. One could fault, say, Eric Fischl for using photos to compose quirky scenes that end up looking like haphazard snapshots taken by a kinky tourist, but they also make for some interesting, if voyeuristic, scenarios. Photo-based paintings have a distinctive realism about them. I look for this aspect (see my checklist in Chapter 4) but I wouldn't hold artistic expression hostage over it. There's a difference between craft and art. An artist doesn't have to reinvent the wheel time and again as a slave

to tradition. Skilled painters will always be regarded for their style and technique, but advancing art as a current concept of reality isn't always their objective. Meanwhile, innovators run the risk of crackpotism.

In an experiment of my own, I designed a dual-mirror device that superimposes the view of an object onto a sketchpad so that the user can "trace" said object. But because the referent and the drawing surface don't actually occupy the same space, there's a distortion issue as seen in my pencil rendering of a stack of cameras (Fig. 5). I prefer the unpredictability of drawing something with the naked eye without looking at the sketch as I draw it. This results in a surprisingly coherent rendition except for the overall form. Without the visual feedback, the looking back and forth between object and image, an accurate translation of the basic shape goes adrift in this rudderless hand-eye maneuver.

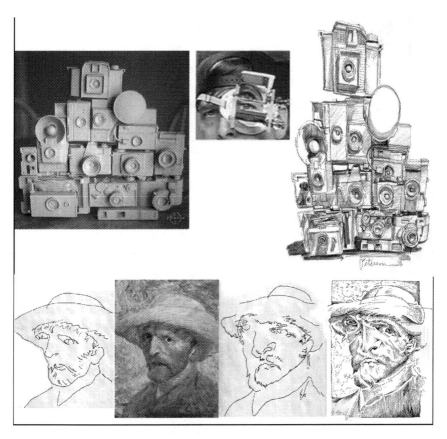

Figure 5. *Top L to R: Camera assemblage; Synchrotraceur device;*
Stack o' Cameras *drawing; Bottom L to R: Synchrotrace; Van Gogh self*
portrait; freehand sketched without looking; finished maze drawing.

Referencing Van Gogh's painted self-portrait; I redrew the rough outline on the left while my synchro-tracer was strapped to my head. The outline on the right was drawn straight, no chaser. That unaided doodle was more fun so I went with it, the finished results as shown. At best, any tracing device serves to delineate only the basic outline—the fundamental mode if you will. Once an artist establishes a baseline, all else flows swimmingly.

Investigating the ways, means, and motives of artists past and present promotes an appreciation of art. When the debate over optical devices becomes rancorous, one can just move on and argue about whether Ingres used a French curve or Hopper a straight edge. Pretty soon someone will

chastise Brunelleschi for having advanced the principles of perspective in the first place.

Serendipity means finding one thing while looking for another. I found not only that mechanical aids aren't all they're cracked up to be, but also that paintings and drawings may actually require more active participation by the viewer than watching videos or listening to music because those latter things have a built-in time aspect that makes the audience more passive, read lazy, as the program glides past them. Therefore, I submit that *viewing* art is as demanding and rewarding as it is to create it—and only slightly less likely to make one rich and famous.

<center>* * *</center>

The Mechanics of Vision

Beauty is in the eye of the beholder whether you're looking at La Gioconda or Lady Gaga. For everything from graffiti to a Grecian urn, you use your vision to enjoy art.

I'm having my head examined by the experts here at The Peterson Institute of Arts and Sciences Research Laboratory and Gift Shop, and I want you to see things through my eyes, literally. Let me walk you through my eyeball while my colleague Doctor D. L. Rayburn stands by on the outside. So don your wet-suits for a slog thru the vitreous humor—but please, no flash photography. You'll have to get really small, so if hypodermic needles and quivering eyeballs make you squeamish, well, just relax and . . . we're in.

Feel free to take off the rubber suits and put on these—whoa! The orb is rotating. Let me lock my eye movement from the control center in my superior colliculus. Mental note: I must have developed X-ray vision; look at the frontal lobes on that bystander.

Dr. Rayburn, please prop my eyelid back up. We could use the light in here. OK folks, don't trip on the plumbing but turn your attention to the retina on the back wall. It receives light that enters the eye in the form of photons. I see a hand. Yes, the young woman with the long legs and short lab coat—you have a question?

"Are photons like fireflies?"

Photons are little balls of energy that cause chemical changes when they hit vision cells in the eyes and send electric signals to the brain. So,

yeah—fireflies. But very few of them ever reach the retina. Photons bounce off of the cornea or get lost in this glial gumbo. Those that do make it form patterns on the retina—that shag carpet of cells well-connected to the brain. We're talking about a network that could make Facebook go cross-eyed.

Let's watch a photon come in the window. Doctor Rayburn will now fire off a single photon of light from a photon gun. Here's the wind-up, and the pulse, and—ouch! Holy smoke, what a humdinger! That corpuscle had some heat on it. My fovea is smoldering. Dr. Rayburn must have had it set on "stun." Keep that in mind the next time you're at a laser light show. Let's cross over to the other eye. Watch your heads as we slide down the optic chiasma into the fresh peeper.

When we look at something, we often focus on a point in front or beyond the object to spread our vision evenly on it: a blank stare or, in this case, the male gaze. Contours, contrast, and color gives us clues as to what it is, but details require pin-point focus and eye movements. The eye darts from one point of interest to the next: winks, smiles, and protrusions, but you can't see the whole until you look past the parts.

If you focus on the letter "x" in the word "fixation," everything else becomes background "noise." The eyes would be hard-pressed to analyze everything in the field of view. One seldom looks that hard unless, say, someone calls to you at a crowded gallery opening or maybe you misplace your suitcase full of cash at the airport. When they have to, your eyes will usually find what they're looking for. But beware. The eye also goes to the weakest link: a toothless grin or a fly in the Chardonnay.

That little dish in the middle of the retina is the fovea. It's packed with cones but no rods. Cone cells resolve details and colors while rods see shapes in dim light. We can see faint stars or shadowy creatures in the night if we don't look at them, at least not directly. An off-center glance aligns the weak light signal with the rod cells outside of the fovea. For depth perception, humans have their eyes on the same side of the head, although portraits by Picasso may have both eyes on the same side of nose.

Here comes another photon ricocheted off of a mystery image. Dr. Rayburn throttled back for this pink puff-ball. Yet, the plucky photon tickles a cell and sends a signal into my brain through that little hole in the wall, the optic nerve.

Yes, the man in the hardhat and galoshes—a question?

"Is the optic nerve like a funnel?"

More like a sodium and potassium battery that propels a charge along the axonal membrane deep into the brain where the cells all share information in a parallel process that computers can't even dream about. A computer strings images together like beads on a loom. The human eye builds a scenario in the order of visual interest—angles, curves, outlines—by flexing six orbital muscles to survey the world. The brain puts a subjective spin on everything we see. In fact, I feel strangely aroused right now. Let's follow that impulse along this coaxial cable towards the big screen theater in the back of my head: the visual cortex.

A physicist considers the primary colors to be red, blue, and green while an artist says magenta, cyan, and yellow. Whom to believe—some Poindexter in a lab coat or the Bohemian in a smock? Both. One applies to light and the other to pigments.

"So then colors are light that is either reflected or absorbed?"

Well, what an honor—it's the Authority Figure. Welcome, sir. You must have snuck up on the service elevator. As you well know, the additive synthesis of—hey, where'd the old geezer go? He blended in with the grey matter. Well, never mind him. Where's the young gal with the—

"Hang on, I'm coming."

Ahh, 'she's like a raaiiin-bow . . . she comes in colors . . . '

"What are you singing?"

It's a song by the Rolling Stones.

"Who?"

No, Stones.

"Who's that?"

The same guys that wrote 'Paint It Black.'

"Wow. How old are you?"

Never mind. Let's just catch up to the signal.

The pulse enters a color filter called the lateral geniculate nucleus. Reducing three-color signals down to one is what these opposing cells do, sort of like a Polaroid camera. Now, smile everybody . . . Whoa—flashbulb!

Our perky little voltage spike zips along towards a synapse. We're not talking Grand Canyon here, just a half millionth of a centimeter. But no sparks cross these gaps, just chemicals called neurotransmitters. Similar molecules, like those in LSD, can unlatch synaptic gates and allow stray signals into restricted regions of the brain causing short circuits that can

make us smell sounds or taste colors. Synesthesia can be mind-blowing. I don't recommend it.

The impulse strikes a bundle of nerves like a billiard ball scattering signals towards the farthest pockets of the brain. Which shall we follow? I'll check a roadmap of this cerebral landscape—the throbbing blobs of neural cells, the thick and thin, pale and rich stripes of the brain. There's the anterior cingulate cortex for art aesthetics and the basal ganglia connected to the motor cortex for hand-eye coordination. It's quite a sight on the way to sight.

Doctor Rayburn, I noticed some atrophy above the anterior vermis of the cerebellum. That's right—schizophrenia. Write me a prescription, will you? On the up side, I think I found my sense of humor lurking near the amygdale.

Certain brain cells are feature detectors. They know what they're looking for and what to do when they find it. A feature cell is hardwired to fire, say, only when light falls in a straight line across the retina, or an arc, or a right angle heading north by northwest, but many cell groups are needed to construct a visual perception. There is no single brain cell with grandma's face on it. That involves the entire fusiform gyrus, but the internalization of any picture is abstract. It's not a connect-the-dots affair. If we mapped the brain cells involved in "seeing" an image, it would include most every stripe, gap, bulb and lobe in this three pound organ. I can't just look at *Sports Illustrated* and expect to see Pavel Datsyuk projected on the inside of my skull. Ditto the swimsuit issue, but, again, that's where a photographic memory pays off. Fortunately, my brain has a mind of its own. I think.

Uh oh, we're lost. Let's split up into teams and rendezvous later. You guys take that path. Miss Firefly and I will head south and meet you in the thalamus.

"Excuse me, but I can see what you have in mind."

How do you know what's on my mind?

"We're knee deep in it."

OK, well, uh . . . hey, look! The tour group that I lost this morning is straggling in. Let's compare notes with them and see what we can make of this single red photon we've been tracking. When I flip this switch labeled "Gestalt," the sparking tangle of static electricity and the electrochemical traces of memory, cognizance, and emotion pulsing through my perception

engine will complete the whole visual perception from the sum of its parts so we can all see the big picture. Here goes, and voila . . .

Look, everyone! It's Doctor Rayburn—the lovely Doctor Dorothy Rayburn. Hello Doctor Dot. It's nice to see—gad zooks, woman! You performed the whole procedure dressed like *that*—a logo T-shirt, latex gloves and anti-static platform shoes like the ones available in all colors and sizes in the Gift Shop open weekdays 'til six and Sunday from noon to four? Hot couture!

Peep show's over, folks. This concludes our tour of the pathways to visual perception. Thank you and come again to The Peterson Institute where you get a free bumper sticker with every paid admission. Please exit single file through the pupils while I try not to blink. Now, everybody—out of my head!

* * *

Figure-Ground Reversal in the Brain.

One thing I always look for in any picture is whether the "figure" swaps light and dark values with the background. I call this effect reverse-gestalt and it lends depth to any image, representational or abstract. It's like a ball of ying-yang in a box of flip-flop.

Take my pen and ink version of Ed Munch's *The Scream* as an example (Fig. 6). The guy in this picture sports a dark frock that stands out on the light-colored bridge while his big ol' head sticks out—light on dark—like a molar over troubled waters. Yet, we see his head and body as a single figure above all. Your brain has to work a little harder to integrate these pictorial elements but it provides an aesthetic payoff, an extra kick in the mental pants so to speak.

Figure 6. *The Scream* (after Edvard Munch).

And it doesn't have to be a wholesale inversion. To find even a small region that reverses polarity is like switching-on an electrical circuit that charges a picture with an alternating current. Reverse-gestalt packs its perceptual punch by making the viewer subliminally "do the math" in his or her head. It works the same way as subtle innuendo does in a joke, such as "an abstract expressionist painting entitled 'Drop Cloth.'"

Highlights and shadows are well suited for the gestalt effect. That's why late one night, as we emerged from the hot tub on the observation deck here at The Peterson Institute, I suggested to my lovely associate and research partner, Elisé, that she strike a pose, (dishabille, if you get my drift) on the patio where her statuesque contours would be grazed by the backyard spotlight as it spilled on yonder privacy fence, thereby highlighting her classic figure against a stark shadow on one hand, and its silhouette over an incandescent backwash on the other, while I whipped off a quick sketch to illustrate said modeling effect for this article. But she nixed my big idea, hence *The Scream* instead.

Anyhow, before we dive back into the brain, let me get some fancy words out of my system: Lateral geniculate nuclei, superior colliculus, and occipital lobe. Thank you.

Drawing is called the art of omission. The lines and shadings are a kind of visual shorthand for objects, real or imagined, to be "read" by a mechanism of brain cells. The things we look at are just light patterns to the eyeball, transmitted via the LGN—the brain's color filter (see fancy words above)—with guidance from the wheelhouse located mid-brain, to the visual cortex in the back of the head. When the brain decodes the image, outlines always trump color values in the hierarchy of pattern recognition. It detects edges by tallying the total of cell firings across the receptive field while special cells sort those lines by size, shape, and attitude. It basically undoes what the artist did in reverse order.

That the brain does extra work to discern a camouflaged figure is apparent, but how and where in the brain is this done? My fMRI scanner is on the blink, awaiting repair on my workbench along with a microwave oven and a garage door opener, so I went instead to do some preliminary research at a local university where the student body thinks I'm a professor. So let's get psychophysical.

My guess was that the seat of gestalt, the figure-ground phenomenon, was away from the main rash of activity on the surface of the visual cortex so I decided to explore the corpus callosum, the fault line between the

right and left brain where sparks of primitive instinct flicker on the walls of that canyon. It seemed logical that an echo might be the source of this type of inversion. But the logic of the brain doesn't always make sense. Could this peculiar aspect of vision be a purely autonomous process not located in any particular part of the brain? I wondered. Then I heard the amygdale laugh out loud. If there are clumps of brain stuff the likes of fusiform gyrus and parahippocampus—specialized nodules that can recognize faces and buildings like grandma at the casino—it's a good bet that reverse-gestalt has its own switch on the dashboard. But it was mostly emotional firmware down there in the control room. I did see a homunculus sitting behind the wheel, steering the eyeballs while the cerebellum relayed signals from both eyes up to the opposing faces of the striate cortex, setting up oscillations that melded into a single visual field. Meanwhile, signals from the rods and cones converged onto bipolar cells, bullseyes and rimshots, each firing according to wherever the light hit the retina, with higher firing-rates marking an "edge." The receptive cell-fields down the line get even more complicated and exacting as the signal moves towards the visual cortex.

The thresholds of light and dark tell a story like music does in the silence between tones. Reverse-gestalt is like an inversion of a musical chord, that is, any combination of C, E and G notes played together is still a C-major. But here's the rub. Gestalt psychology is descriptive, not explanatory. It can't explain peripheral vision and only describes fixations. Computational models have taken over brain theory. Fourier mathematics now suggests how the brain "sees" stuff in the spatial frequencies that tickle the neurons in a selective filter called the prestriate cortex, a.k.a. Brodmann area 18. This is where:

> the responses of V2 neurons are modulated by illusory contours whether the stimulus is part of the figure or the ground (Qiu and von der Heydt, 2005).

Now we're getting somewhere! Let's take one step back to Brodmann area 17, or V1, a six-layer cake called the striate cortex. Feedback from lateral connections, modulate the contextual effects of this receptive field. Smells like gestalt to me. The info relayed to V1 is already stripped down to outlines but it sends progressively non-linear info to subsequent regions. The ventral stream (the "what" pathway) starts in V1 and heads

for visual areas V2 and V4, and is associated with form recognition and object representation while the dorsal stream (the "how" path) leads to V3 before they hook up again in the temporal lobe.

Think of V1 as a Dagwood sandwich, except that instead of bacon, lettuce and tomato, the layers are of ganglia, granular cells, and other gray matter, then your eyeball is an olive on one end of a toothpick poked through those layers and each one it passes through corresponds to the myriad aspects of a single point in your field of vision, the edges, contrasts, shapes and colors of whatever your eyes are aimed at.

So there it is. I must have missed an issue of the *Journal of Neurophysiology* back in June of 2007 that said:

> Recent theoretical studies have demonstrated that border-ownership assignment can be modeled as a process of self-organization by lateral interactions within V2 cortex (von der Heydt et al, Johns Hopkins University).

I'm just glad to finally know what the deal is. I mean, "border-ownership assignment!" I couldn't have said it better myself. That's what I was looking for: reverse-gestalt.

Reporting live from Brodmann area 18, layer V2 in the occipital lobe of the visual cortex; this is The Intellectual Handyman saying, "See ya!"

* * *

The Frontrunner and Alsorans

Not that it's a race, but based on the ticks of my visitor clock at FineArtAmerica.com, my pen and ink drawing *Tacoma Narrows Bridge 1940*, (Fig. 7) is the new runaway favorite among my published works: nearly 5000 views now, blowing past the previous frontrunners, *American Gothic Revisited* and *Rainy Day in Paris*. I'll say more about the Tacoma Bridge after some words about the following one.

The Mackinac Bridge connects Michigan's upper and lower peninsulas. Five miles long, with towers reaching five hundred and fifty odd feet above the water, this suspension bridge is for motor vehicles only, but the governor said I could walk across it on Labor Day, so I did. I've also floated under, flown above, and crossed over it on a motorcycle (beware of the

expansion joints!) many times in addition to the countless car trips. But to stand flat-footed on the suspended road bed beneath one of those colossal towers in the windy straits between two Great Lakes is exhilarating. High winds can flip small cars over the guard rail. If you stand still long enough to get your knees to stop knocking, you detect an awesome sensation: a realization that the entire road bed is swinging in the breeze. Physics 101 taught us that F=ma. The acceleration in this case is almost imperceptible but the massive force of that steel and concrete pendulum could pop a Brinks truck like a zit.

I watched them build this marvel when I was a kid; still have a piece of the cable on my workbench. I imagine the engineers back in 1956 knitting over their azimuths, eigenfunctions and modulus of elasticity, recalling the lessons of old Gallopin' Gertie—the aforementioned Tacoma Bridge—and tied Mac down real good to avoid the faux pas of self-destruction. Any army knows to break stride when marching over a bridge.

It was back in 1940 when the Tacoma Narrows Bridge, like any giant zither strung out over a couple of jumbo tuning forks, started rockin' an' rollin' to a tune called natural resonant frequency as suggested in my hastily scribbled depiction. I shouldn't be surprised that this doodle is getting notice; it's one of my favorites. But then, nobody wanted to pony up the moolah to buy the 18" X 24" pen and ink original, so I've doubled the price. That's right—two hundred smackers. Step right up.

UPDATE #1: It was nearly a year ago that I mentioned a spike in the number of online views of my drawing *Tacoma Narrows Bridge, 1940*. The count was then at 5000—lookers aplenty but no buyers. So I raised the price.

Well, I'm not exactly sure who's driving the tour bus but the visitor count is now well over 13,000 views. That's three times the volume of my next most popular drawing and ten times the average overall. Still, no takers on this original pen and ink icon. Granted, I did sell a laser print of this image to one fellow who, with my permission, incorporated the drawing into his deck of tarot cards, specifically the Ten of Swords. You can enjoy his paranormal take on the historic event underlying the picture online at Arcanalogue.blogspot and watch actual footage of ol' Gallopin' Gertie doing her dance of destruction.

Mind you, the original inspiration for my frenetic doodle was just a curious interest in a photo in my old college physics book. I wasn't trying to channel the supernatural or anything beyond my usual investigation of visual phenomena; I was just musing about that famously iffy engineering gaffe. Still, I can't account for the runaway popularity of my humble depiction of that aeroelastic event.

Anyways, I've raised the price again. It is now $13,000+. That's right, thirteen large. And not only that, but the price will automatically increase by one dollar each time a new visitor hits my FAA view counter (13,322 at the moment). So, if you're thinking of adding this masterpiece to your collection, you might want to pony up the jack, and pronto, before you have to make a run to the bank for a loan.

UPDATE #2: 20,251 views at publication time. Still available. Hurry.

Figure 7. *Tacoma Narrows Bridge*

* * *

Patent Approved

I invented a musical percussion instrument for drummers: an accessory that attaches to a high-hat cymbal stand and produces a wooden hands-a-clapping sound. I call it The Blox.

After drumming up the interest of a major musical instrument manufacturer, I decided to patent the device. I not only built a working prototype but also wrote the patent specifications and produced the working drawings. It is handy to be an artist and a writer; I should compose a musical score about it too. But as it turns out, the experience of applying for a utility patent with the U.S. Patent and Trademark Office was as valuable as the actual device, that rhythmic rattletrap has proven to be. I'll share some personal insights to the process for the benefit of other inventors.

The rigid standards of the USPTO are outlined in the voluminous Code of Federal Regulations. It stipulates, in tedious detail, the guidelines for the air-tight verbal descriptions required for patent specifications and the supporting line art. There is no room to hide behind the metaphors, sloppy anecdotes and fuzzy logic of informal communication. And no optical illusions either. You must be accurate and precise in the conveyance of your concept, at least to a level where an engineer or subject matter expert in a given field could fabricate a working model of your big idea. It is descriptive writing only a lawyer could love. Then again, I read legal briefs and depositions for fun. So, I was aghast to find that maybe my technical writing wasn't as good as I thought; sort of like after I first decided to become a famous literary author and discovered I couldn't spell worth beens. But having paid several hundred bucks to apply for the patent, I was determined to hammer the documents into shape per the USPTO mandates.

There are several formal sections to the written Specifications that seem redundant at first. The Abstract is a generic description for the casual reader, but there's also the Summary, Description of Drawings, Preferred Embodiment, and, most importantly, the Claims. There are also formal guidelines for everything from margins to typestyle to line spacing and numbering that makes the lingering nightmare of high-school English class seem like a free-style poetry slam. Today's typical blogospheric gibberish would self-destruct on the launching pad. But after just a couple of notices from the Patent Office, one to file missing parts and another

to make further corrections, I addressed the problems that the official examiner—someone probably more attuned to gene-splicers, green energy or perpetual motion machines rather than homemade musical contraptions—checked off on a form that was mailed to me and, over a few months time, the formal aspect of my application was accepted.

The content of my submission—the actual verbal description of my invention—also seemed perfectly concise to me. I thought I nailed it. And, in fact, everything was approved except for the most legally relevant part of the specs: the Claims. On that regard I was cited for non-compliance and had to amend a handful of the numbered claims many times over to satisfy the objections of the examiner—a real stickler, judging by the all-business tone of voice on her answering machine. But I persevered and succeeded, and will now divulge what I wish they would have told me in the first place. It boils down to this: The written Claims must describe only what your invention *is*—not was it *does*.

You'd think a statement like "this arm goes up and down and strikes that box with this paddle and makes noise" would suffice, right? Nuh-uh. Such nonsense, I was informed, is:

> . . . narrative in form and replete with indefinite and functional or operational language.

Well, la-de-da. Turns out, the whole premise is that if you describe the object well enough—convey the essential physical *structure* of the device—then its function will be self-evident; it becomes clear exactly what the device can and will do without actually saying what that action is! It makes perfect sense to me now: ". . . an array of swiveling blocks laterally transverse to the horizontal axle rod . . ." etc. It is akin to the artificial intelligence of a computer or other alien that can perfectly describe something without having a clue about what it actually is.

Likewise, the patent drawings are straight-forward drafts with no hidden lines or arrows except to indicate numbered parts on a list. The renderings are checked against any "prior art" of existing patents, only one of which, surprisingly, was even a close cousin to my hand-clapper.

In the year plus that passed while my patent application was being processed (a time during which I was legally covered while said musical instrument company deliberated on whether or not to buy my invention; *not*) I realized that my brainchild just didn't have all that much

commercial potential. And it's not like I had any famous drummers on board—Art Blakey, Ginger Baker, or Meg White to pull some names out of a high-hat—the first of whom is long gone anyways. Still, at least I would have the prestige of owning a patent because my device was finally *approved* by the USPTO—subject to a final publishing fee of an extra thousand dollars I hadn't counted on.

I framed the Notice of Allowance for U.S. Patent Application #12/575,601—*A Foot-operated Acoustic-mechanical Hand-Clapping Sounding Device*—and hung it on my wall, whereas the subsequent Notice of Abandonment will remain in its envelope in that big fat folder in the bottom drawer of my file cabinet. I've decided to spend the money publishing this book instead.

<div align="center">* * *</div>

I Was on TV Once

In the days before Idol or YouTube or even before the Internet, I was Artist of the Month at the Troy Library. That included an appearance on a local TV program.

After one false start, the taped interview went smoothly. The host asked me questions including the only one that I'd prompted him on beforehand: I told him to ask about my painting *'47 Cadillac*. He did.

In the next ten minutes I explained, succinctly, the mechanisms sight: how the eye pinballs from one point of visual interest to the next and how the brain strings the information together. Without constant visual feedback the lines get lost in the basal ganglia but even if I don't watch what I'm drawing, the viewer's eye will retrace this path and their brain will fill in the details. Sure, the final image may have flubbery tires and an apneatic grill but this is of the essence and not just bad hand-eye coordination. Call it anthropomorphism.

(And now a word from our sponsor . . .

www.garypetersonart.com

. . . And we're back).

The interview wound down with the usual patter about beauty and inspiration and a plug for Eino's Art Supplies. I was satisfied with the effort—until the program aired later that week.

I had imagined speaking to the avant garde of artistes and connoisseurs, but Dick Richards, the amiable host, was more familiar with his viewing audience: quilting bees, koffee klatches, and shut-ins.

Guess which ten minutes of the interview was edited out! Bingo.

On the upside, I learned how important a make-up artist is on the set of a TV show. Too bad I didn't have one. I'll never slick back my hair again.

* * *

Television in the 40s & 50s

Imagine if you will, that you are watching images made of flickering silver light, the luminous effect of charged particles shot from an electron gun as they strike the phosphor coated glass interior of the cathode ray tube of which you are on the outside looking in: Television, circa 1950.

Scanning rapidly down the raster, in horizontal lines, the light beams zip across the screen thirty times per second—the minimum rate at which your eyes are fooled into believing that they see talking heads and whatnot on the surface of that tiny window—magically evoking those forms and facsimiles from within the box, generated by the glowing orange heat of vacuum tubes, those clunky predecessors to transistors. You're liable to see the electronically induced images of dancing bears, or shapely majorettes the likes of Mary Hartline, the co-star of Super Circus, or maybe Howdy Doody the cowboy marionette as he two-steps across all of the television screens in every household lucky enough to own a TV set. It's a mahogany cabinet with a cloth grille, two knobs and rabbit ears: a piece of furniture that chatters at you while you are transfixed by its electro-static spectacle.

Watching TV in the early days was as fantastic as watching any idolized virtual reality live-broadcast dance party or slow motion instant replay disaster, any Superbowl celebrity extravaganza or wardrobe malfunction that you see today on your 80 inch high-definition, plasma flat-screen jumbotron surround-sound home entertainment complex with all of its bells and whistles, Dolby 12.5, a satellite dish and ice maker: that electronic media center in front of which we recline and worship at the alter of the

Almighty Matrix of Oz. Just imagine all of the retro-active moon-glow technology of yesteryear, and you'll get a sense of the wonderment that an entire generation of bug-eyed baby boomers felt while soaking up the cathode rays emitted by their humble little television sets in the late 40s and early 50s—the Golden Age of Television.

The quaint programs that were broadcast on those rustic analog receivers evolved in some measure from Vaudeville, as the stars of that venue migrated to motion pictures, radio, and ultimately to television. It was entertainment with a naive kind of aw-shucks mid-century moxie that the 40s and 50s had in general. Milton Berle, Lucy Ball, and Red Skelton were some of the benefactors of the new medium. They become royalty to the general viewing public. Their shtick was, after all, physical comedy that you had to see to enjoy; the kind of slapstick hilarity that would eventually inform the persona of future TV characters, clowns, and sidekicks such as, for instance, Michael Richards—"Kramer" on *Seinfeld*—forty odd years later.

As for the apparatus itself, there were a growing number of television manufacturers in the 1940s and 50s: GE, RCA, Philco, DuMont, Zenith, and as I recall Muntz—the brand of TV in front of which I squandered many a blissful hour in my youth. But unlike so many other great inventions of the twentieth century that are synonymous with a single name like Alexander Graham Bell or Tom Edison, there is much controversy as to who gets the dubious honor of being the inventor of the boob tube. In my mind it is clear. Television was born in 1927, give or take twenty years, fathered by a man named Philo T. Farnsworth, an electrical engineer from Utah. And it was imagination, not necessity that was the mother of this invention.

It can be argued that the advent of television was actually a culmination of individual achievements by the likes of people like Karl Ferdinand Braun who developed the first cathode ray tube before the turn of that century, or Vladymir Zworykin who filed a patent for a gizmo that was suspiciously like the iconoscope that Farnsworth developed, except that Zworykin's conceptual version was apparently one spark short of a circuit. A working model of his device was not actually built until many years after Farnsworth's offering. Sometimes the spoils of victory go to the inventor with the best PR (public relations) much like Sir Isaac Newton stole Gottfried Leibnitz's thunder with the invention of calculus back in the 18th century. But I give the TV honor to Farnsworth (who also

received an honorary doctorate from Brigham Young University) because he had the vision, no pun intended, but more so, the intent to create exactly the system of components that we've come to know as television: the elaborate jumble of modulators, rectifiers and transmitters that let us peek, voyeuristically at times, through that proverbial window on the world that is so indispensable to us today. Besides, who can forget a name like his? If I had been a publicist back in the 1920s, and he had asked me for advice on how he could be assured of the distinction of being recognized as the inventor of television, I would have told him to change his name to something like Philo T. Farnsworth.

Ironically, Farnsworth himself questioned his own efforts after seeing some of the intellectually bereft dreck that television spawned from the get-go. I suspect that his temporary dismay was akin to that of the scientific community in the 1970s and 80s that saw the Internet, their powerful tool for the dissemination of scientific research, evolve into the commercial and entertainment network of the World Wide Web. But it's all good.

The hegemony of vision over the lesser of mankind's natural senses made television the super nova of mass media that it is. But as the famed futurist Marshall MacLuhan once said, television is a "cool medium" meaning that TV does the talking and we do the listening. Nowadays, the social and political influence of TV is being challenged by the more interactive Internet (not to mention the virtual reality of video games for sheer entertainment). Even our TV shows are now subject to instant viewer input as to how a given storyline should end; A glut of National Wannabee shows welcome your opinion, in real time, for the price of a phone call. Otherwise, there's nothing new about talent shows. Ted Mack's Amateur Hour was a staple of both radio and television throughout the 40s, 50's and beyond. It was a showcase for showbiz hopefuls. Of course, nowadays, overnight success is a much more viable concept.

Television shaped—some would say distorted—our perceptions of reality as much as it entertained us during the big snooze era after the Second World War. It provided a nation with role models and lifestyles that were moralistic to the point of far-fetched; the good guys always wore white hats (*The Lone Ranger*); justice was always served (*Dragnet*); guys met gals at malt shops (*Dobie Gillis*). There were family values aplenty in every paternal episode of *Father Knows Best*. Many of today's popular children's shows evolved from prototypes of the 40s and 50s: Kukla, Fran,

and Ollie, Romper Room, and Captain Kangaroo showed the way for the Smurfs, Barneys, and Teletubbies. Compared to all of those, *Sesame Street* seems more like kiddie college, what with its educational bent. I think Elmo has a PhD. It's never too early to introduce new viewers to the efficacy of edutainment.

Today's digital home entertainment systems and their infinite variety of programming are a far cry from the "electronic campfire" that cast a ghostly light, in shades of Uncle Milty or Clara Belle, on the walls of our nation's living rooms in the early years. But beware: TVs can still suck the life out of a room with the flick of a switch (even though computer chips have replaced the vacuum tubes). And now a word from our sponsor . . .

Early television, with all of three channels—CBS, NBC, and ABC networks (in the United States)—was necessarily a commercial venture. Television was fertile ground for advertising. Of course, the television commercial has become a genre of its own. Back then there were no computer generated graphics, but advertisers used celebrities, animation, jingles, and gimmicks galore to brand their message on our brains. A Faygo soda pop commercial with its cartoon cowboys galloping alongside a stagecoach comes to my mind: "Which way did he go? Which way did he go? He went for F-a-y-g-o!" Another earlier pitch, a memorable enticement for cigarettes, was a tad burlesque but who could forget the pair of gams on that pack of Lucky Strikes that danced across the stage every week on *Your Hit Parade*? And the big corporations could sponsor entire shows; Kraft and Texaco were patrons of their own television theaters. Bless their philanthropic hearts.

But to characterize the mystical, hypnotic power of early television, let's focus in on an unlikely, but enduring cultural icon from the 40s and 50s era of broadcasting: The Indian head TV test pattern. This well-recognized graphic image is ingrained in the psyche of a generation of viewers, each of who may have occasionally awakened on the sofa after broadcast hours only to be staring at this futuristic pattern of circles, grids, diagonal arrays—and the portrait of a Native American Indian chief in a feathered head-dress positioned near the top and center of this classic test pattern image. Every local broadcast studio had its own version, but this one was the big chief of them all: the standard of reference. Originally copyrighted by RCA, this pattern was generated electronically from the studio onto our TV screens by an instrument called a monoscope. It was used to calibrate and fine-tune the unstable fidelity of early vacuum

picture tubes. Although laughably obsolete today, the statically charged perceptions of an entire generation reverberate from that reference signal: an omniscient cipher even more all-seeing than the CBS eyeball (the NBC peacock feathers had no eyes but heralded the arrival of color TV in the 50s). Many other subliminal logos radiated from the plasmatic bluster of this all-powerful medium, but I recommend that you view my rendition of the classic Indianhead test pattern (Fig. 8).

So, without further adieu, I turn this broadcast over Chief Whatchamacallit—best viewed to the audio accompaniment of a single continuous musical tone A-440. Thank you for tuning in. You've been a wonderful audience. Good night and God bless. (Fade to black . . . cue National Anthem.)

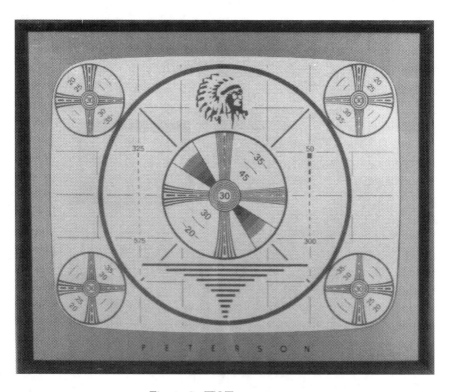

Figure 8. *TV Test pattern art*

* * *

4. ART & ANALYSIS

The Art World is Elliptical

An artist interprets objects for the viewer but something always gets lost, added, or changed in translation. Representation seldom takes the direct route from object to subject. Distortion increases as the path deviates through a given medium. Much of the infidelity can be chalked up to "artistic expression."

Three-way relationships are algebraic. I've based a schematic of visual perception on an ellipse with the object and subject being at either focus (Fig. 9). To give the artist equal weight in the equation, an equilateral triangle dictates the height. Note that the term "object" also means "referent," but becomes "concept" in the case of abstract art.

This elliptical boundary separates the aesthetic from prosthetic: art from eye candy. The aspects of art can be quantified by general consensus and questionnaires the likes of "How does this piece of art make you feel? Warm and fuzzy? Dyspeptic? Would you hang this in your home? What room or closet?" This helps define boundaries and resolves disputes about the artistic values of, for instance, line-art versus clip-art, or color-fields vs. food stains.

To locate a style of art relative to the traditional visual traits of the known art world, use the following elliptical formula:

$$(x-h)^2 / a^2 + (y-k)^2 / b^2$$

where

"a" (the major axis) charts ambiguity ranging from pure essence to physical form: a continuum from Abstract art such as a de Kooning—located safely inside of the swamp gas barrier—to Conceptual art which stops just short of a

yard sale, e.g. the inverted urinal entitled *Fountain* by R. Mutt (a.k.a. Marcel Duchamp).

"b" (the minor axis) is the amount of visual data packed into a given work of art ranging from the flat-line response (as in an EEG) of minimalism at one end, through the metaphoric maelstroms of symbolism and the hyper-embellishments of Rococco (think Chateau de Versailles).

"h" and "k" are coefficients of historical and cultural aspects. They allow us to calibrate past perceptions towards current concepts of reality. These values adjust the Cartesian origin of the ellipse to accommodate arcane or outdated ideas of art, or perhaps just reconcile the classical ideals of Apollo and Dionysus with more contemporary visions from the likes of George Andreas to Iggy Pop.

"y" is the degree of visual data—contours, color, highlight and shadow, etc.—used to affect recognition of a given face or figure. Minimalists can also evoke emotions with subtle color fields whereas allegory or narrative art can convey an epic love story or just a ring-tailed whopper.

"x" locates the formal intentions of the artist, assuming his or her skill of expressing that vision with exacting verisimilitude or at least a nervous existentialism.

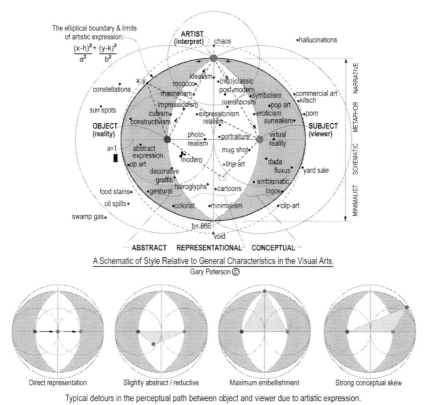

Figure 9. *Elliptical art-world schematics*

The crescent-shaped area (gray) on the left side of the ellipse is where artistic expression operates from behind the object which is theoretically hidden from the viewer. Abstract art thereby becomes a self-representing object.

The white football-shaped area in the center is for representational art: that which projects a relatively straight-forward interpretation of an object to the observer.

The right-hand crescent is home to conceptual art because the viewer must assign new meanings to things not normally associated with the given object. It's the kind of thing that makes you wonder, "Why is that sheep in a tank of formaldehyde?" You'll have to ask Damien Hirst.

Not shown here, the z-axis would form two cones with a common base (the ellipse) and vertices at opposite ends. This axis could represent

the human disposition ranging from pure emotion—that which puts a charge in religious icons, family portraits, or puppy paintings—to the intellectual mindset of abstract art for appreciating the intuitions of Rothko, Motherwell, or even Cy Twombly. Either way, you must hook up the intellect with an emotion to get a proper buzz from art. The intermingling of these attendant brain waves makes you feel good, or at least smart, and the evidence would pop up in a 3-D model or a galvanometer.

Perceptions can be manipulated and even the smartest cookie can be scammed by a cunning artiste, but who's to scoff when the art matches the cerebral resonance of both players. At least now you can reference "The Ellipse" to help you sort fine art from beef hearts (with all due respect to the late Don Van Vliet). Then again, maybe all you're looking for is a velvet Elvis.

<p style="text-align:center">* * *</p>

A Checklist for Viewing Art

Here's a list of questions and visual elements that I look for in a painting or any other picture. I'm not talking about complex aesthetic judgments, but just the formal visual cues that provide entry points into the actual content of the work (before any narrative or historical context is considered):

1.) *Is it representational . . . ?* The work depicts people, places, or recognizable things whether photo-realistically or stylized. This includes figurative, still-life, landscape, and narrative art in any style or genre. It may also include decorative or conceptual art with recognizable imagery, text or symbols (independent of any written message).

2.) *. . . or is it abstract?* A work composed of purely geometric, gestured or diffusive elements appealing directly to the feature-detecting cells in the brain that sort out formal visual properties. I consider certain aspects of decorative or conceptual art as abstract. Surface texture is also considered in all of the above.

3.) *Figure/Ground:* The perceived separation of forms from the background. Think signal and noise. The figure and ground can swap light and dark values in different parts of the picture. I like when that happens and I call it reverse-gestalt. Rod type vision cells hold the big picture steady in the viewer's eye even while it darts around allowing the cone cells to survey the details. This is what makes any still picture a dynamic event.

4.) *Composition:* How the secondary forms and details are organized to support the main figure. I call it the harmonic order. Think fractals. The brain is very forgiving and will fill in any gaps to complete a picture as it sees fit. My drawings depend on that.

5.) *Scale:* Abstract art is always full scale, yet the visual elements can be perceived as any size from microscopic to cosmic. The question of resolution falls here; is the perceived object detailed or fuzzy, close range or distant?

6.) *Perspective:* is an extension of scale in both abstract and representational art. I like compositions that provide a distant view from within an enclosed space in the foreground of the picture. This activates higher cognizance levels in the brain.

7.) *Light Source:* Where is the implied light source in the picture? A single point from above provides the dramatic highlights and shadows of nature while diffused lighting softens things. Radiant light is when objects seem to be internally lit.

8.) *Color:* The illusion of volumes and solids can be done with shades of gray but color lends an emotional impact. A good color scheme is like the key in which a musical piece is written, or even just a single chord that resonates nicely in my head.

9.) *Gravity:* This directional force seems obvious and in most pictorial scenes but it can also be implied in abstract compositions in which case I ponder if the visual elements would expand or collapse if the snapshot moved forward in time.

10.) Cropping: The relationship between the picture and its borders (usually a rectangle, sometimes framed) strongly influences many of the other visual and contextual aspects of the composition.

* * *

On The Surface: Appearance and Reality

I was in the library when a picture on the cover of a magazine caught my eye. At first glance, the abstract image looked to me like some kind of strange western landscape inside the magnified view of a semi-precious stone like moss agate or petrified wood. I'm kind of a rock hound.

I love the abstract art of nature (and the abstract nature of art): the chance patterns of earthy elements and planetary fragments worked over, sometimes for eons, by the forces of nature. It's the suspended animation of mineral deposits, steeped in a primordial stew all potent and fertile, commingling in visual intercourse like water and oil. Ditto the sky with its face-in-the-cloud formations at sunset, or the gnarly knots and burls in curly maple and other exotic woods—all of the random patterns in nature that my mind interprets as it pleases. My brain might assign meaning to the mix, maybe cosmic or mythical or just sentimental. Or if, in a figurative mood, it sees a driftwood tree trunk as the suggestive sun-bleached limbs of the goddess Venus languishing in lurid repose on a windswept beach, well then that's my business. It's all good. Art and imagination comprise such mental transfigurations.

But, alas, that isn't the case with this cover photo. An off-color emulsion of queasy waves in my cerebral surf suddenly spews a noxious gumbo onto the picture plane. What the . . . ?

Turns out I'm not looking at lapidary art but photojournalism: the alarming visual to a sad report. The surface value of that glossy picture is hijacked by a deeper meaning that imparts a dark emotion onto the splotchy abstraction. With a sinking feeling I realize that it's the image of an ocean wave polluted nearly beyond recognition by raw petroleum sludge in a debacle otherwise known as the BP oil spill.

I'd been hoodwinked by the formal visual properties—the eerie lava-lamp coalescence—of a man-made disaster as portrayed in that slick photo (by Dave Martin for *Audubon*). It does, after all, have an expressionist flare, somewhere between a Pollock and a Rothko, I'd even

say structuralism, but that would implicate Mother Nature as the artist and this isn't her work. I'm not averse to the post-modern irony of this unintentional oil painting, it's just that I prefer the natural patterns inherent in wood, stone or water that resonate with the happy diversions of my youth. But a socio-psychological aspect—the ghost in my own machine—has torpedoed that pleasure cruise and now it's a picture of wicked ugly waves that I'm gawking at like I'd just seen a shipwreck or an exploding whale.

Representational art brings a narrative to visual chaos whereas formalism liberates the image from its subject and aims it toward abstraction. That way, one can survey the contours of, say, grandpa's face without pondering his fish stories or wooden leg. Some essences can't exist without substance; the roundness of a cannonball is just circular without iron or lead. Meanwhile, a seascape is substantive, but greasy waves tend to poison its appearance. I'm stunned how the subtlest shift in perception launched such a dismal sea change of meaning.

It's a terse tale told by that crude oil and water-colored picture, but I'm still compelled by the basic visual cues of gravity, scale and reflections of the sea and sky in it. I haven't been down to the Gulf in quite a while, but I've done my share of fishing and body surfing there. It's a special place and I'm disheartened by the visual composition of tar balls in a briny sludge and its negative implication for wildlife, not to mention the human toll. That message in the medium is a stain that won't soon wash away.

Of course, face value works both ways; clouds can have silver linings—not that we're sure to find one here. It's the mismatch of form and content that catches us off guard. When we're lucky, the glitch is comical instead of tragic. We laugh at visual puns and practical humor—an error in the medium, a fly in the ointment—as readily as we laugh at any ironic message it may convey. We enjoy many things at face value: music, poetry, optical illusions. Decorative art implies that there are no hidden messages in its patterns, proportions, and harmony. It sidesteps cognition and goes straight for the aesthetic buzzer located in the brain's anterior cingulate cortex. I can enjoy a color, say blue or brown, without attributing that property to some physical element but, admittedly, it often involves math or wave theory and I'm never fully insulated from the realities hidden in content or context.

So, can disaster spawn aesthetic beauty? Yeah, but it's a lot less likely to evoke any fun fantasies or indulgent metaphors involving dolphins



Gary R. Peterson

and mermaids and pretty pink conch shells. Then again, looking at my collection of rocks and stones, and my weird drawings and paintings thereof, isn't exactly a walk on the beach either.

*　　*　　*

Pen and Ink Technique

Dip a pen in ink and make some marks on paper—lines, dots, or solid fills. Once you get started, you can get creative.

A pen and ink artist can cross-hatch or use a stipple effect to make shades and highlights to create the illusion of mass and volume of objects in a drawing. Line art is like etching, woodcuts, and lithography in character. Some great line artists were draftsmen the likes of Leonardo DaVinci and Albrecht Dürer whose fine detailing seemed photographic even before modern cameras were invented. Other artists with keen senses of line included Rembrandt, Matisse, and Picasso.

A Speedball pen has interchangeable nibs that come in many shapes and sizes, but a brush, fountain pen, or a good old fashion quill can be used for any type of line drawing from fancy calligraphy to a Ralph Steadman-quality splatter-fest of ink (which is sort of like Rorschach ink blots but with some artistic merit). Technical pens are more precise for drafting or doodling and come in felt tip, ball point, and cartridge type instruments that don't need constant dipping.

I often sketch with a fine felt-tipped pen and then draw pencil grid lines on top of it. I then project a larger version of that grid onto Bristol board and redraw the original image on it with a dipping pen and India black ink. Easier yet is to enlarged a photocopy of the sketch and transfer (trace) it onto the board using graphite paper.

Drawing long lines and curves can provide you with Zen-like bliss as you watch the ink flow onto the smooth paper surface. But like painting with watercolors, there is no turning back once you've made your mark, so warm up first by doodling on scratch paper to get a rhythm going then fine-tune your balance between relaxed and tense. You'll find yourself using every muscle in your body for fine motor control. Don't forget to take a break now and then to avoid hand cramping; that can get gnarly.

68

If you make a mistake, it is possible to shave an ink mark from the paper with a fine razor tool or X-acto knife, but don't scratch it off or you might ruin your drawing. It's best to get it right the first time.

Whether sparse or elegant, rustic or refined, pen and ink drawings scribe unique pathways for the eye to follow. They employ the mechanics of sight as well as artistic vision. Line art provides a road-map that guides the eye along the contours. This can lend a maze-like quality to drawings. In fact, many of my drawings are picture-puzzle mazes. (Continued below)

* * *

A Maze in Grace

Like each one of the dozen pen and ink drawings in my DIA Series (based on twelve famous artworks in the Detroit Institute of Arts), my rendition of John Singer Sargent's *Madame Poirson* is also a maze. There is a single white path that winds from arrow to arrow through each drawing without crossing any black lines (Fig. 10).

These line drawings are the results of my investigation into the way the eye travels through any image, pin-balling from one point of interest to the next. I incorporated the mazes to illustrate how we see things and remind the viewer that art is interactive, with my picture-puzzles being just a tad more accommodating than usual in that regard.

If you're a discerning collector who has been looking for a picture you can really roll your eyes at, here are some of the many pre-visualized masterworks that I've re-tooled to make your job easier than following a bouncing ball. Furthermore, the contemporary look and feel of pen and ink will compliment any wall.

All originals are signed by yours truly with a Ticonderoga #2 pencil. If you'd like, I'll even run a yellow highlight marker through the labyrinth at no extra charge, but that will pretty much take the fun out of it for first-time viewers and also void my liberal return policy. Visit www.garypetersonart.com for fine lines aplenty such as in my reinterpretation of John Singleton Copley's shark scenario (the one originally commissioned by Brook "Peg-Leg" Watson).

I happily bend the rules of fine draftsmanship. My pen and ink renderings are scientific investigations about how we see. When we look at things, our eyeballs shift from one point of interest to the next while it

sends data to the brain for integration. Ambiguous details can still convey the big picture. With respect to the underlying narratives, my drawings are equal parts medium and message.

When sketching, I look at the object—not the drawing. Not watching what I'm doing, my hand-eye coordination breaks down. I call it the moment of abstraction. Points of visual interest—faces, figures, borders and angles—become exaggerated and the basic outlines of the resulting drawings are sometimes laughable but coherent enough to fill in the details (e.g. highlight, shadow, reflection). At this point, the drawing process becomes gestured, emblematic, and just plain decorative.

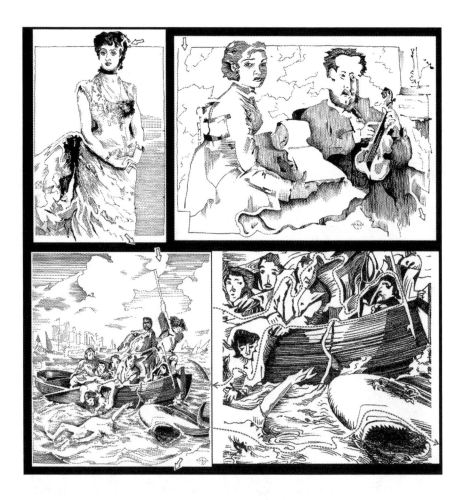

Figure 10. Top-left: *Madame Poirson* (after Sargeant); top right: *Violin Student* (after Degas); bottom left: *Watson and the Shark* (after Copley); bottom right: detail.

Yes, the drawings look odd. For instance, viewing my interpretation of Degas' *Violinist with Young Woman* one might ask, "Why is this man's scalp floating away?" And what's up with Van Gogh's wandering eye (see Fig. 5) or the harpoon in Copley's shark scenario seen here? Now you know. The brain fills in the gaps as it sees fit.

This approach seems akin to Cubism, but it's actually more a function of time than of space: a continuous event versus multiple viewpoints. I deconstruct a picture to find an alternate route to the same end. A musical analogy would be to build harmonies on a familiar, but fractured, melody. Of course, pen and ink drawings are more like piano sonatas than orchestral works: They say it all in black and white. Still, there's a vital resonance in these feverish depictions.

One byproduct of my method is that the drawings easily become mazes and each one contains a built-in "roadmap" noted by two small arrows, in and out, where the eye can enter the labyrinth and flow to the exit along the single continuous white pathway without crossing any black lines. So, each work is also a picture puzzle that you can solve if you like. You're welcome.

* * *

I Cut Off My Ear

Well, I did it—and what a bloody mess. I cut off my ear. Hurts like the dickens. That's it wrapped in one-hundred percent acid-free cotton rag.

I thought my art would create its own buzz, but I am distraught that my DIA Dozen series of pen & ink drawings—including my interpretation of Van Gogh's self-portrait—hasn't been the instant success I'd hoped for: not the break-out event that would have savvy collectors snapping them up. So I lopped off my ear. And I don't mean surgically removed; I hacked it off with a rusty linoleum knife. What was I thinking?

I'm not delusional like Van Gogh was when he pulled the same shocking publicity stunt over a century ago. He was despondent. His only patron in his trying lifetime was his brother Theo who bought one measly

painting. And when his best bud, Paul Gaugin, left Arles and hopped a barge to Tahiti, Vince handed his ear to his favorite hooker. As for me, I don't have any favorites. Hell, I've only got two friends—and one of them is pretty iffy.

But my dear wife, who's pretty disgusted with me right now, is sewing my ear back on as we speak. Unfortunately, the only thread she could find in the sewing basket is bright blue. I'm afraid to look in the mirror. But that's nothing new, just this morning . . . well, that's not important. The question is, "for what?" Publicity! Forgive me. That's worse than self-mutilation.

It's just that I know what my artistic vision is worth. Despite the high caliber of talent in the world of comfortably retired hobbyists, mine is the gold standard of Gestalt: Any picture of mine, in general, makes a whole lot more sense than any of its indecipherable parts. The human brain is forgiving and my haphazard drawings exploit that trait. The fact that they're also mazes is just a quirky indulgence. I'll continue to investigate the mid-brain: the efficacy of the striatum and the role that the basal ganglia play on hand-eye coordination. Or, in this case, hand-ear coordination.

On the sunny side, I'm happy to announce that my pen & ink drawings are available to you for practically pocket knife—I mean pocket change. Sounds like a sweet deal to me. I might even offer free shipping, but I'll have to play that by ear.

*　　*　　*

What's the Latin Word for Lascivious?

From Boone's Farm to Bali Hai, it's time to get down and dirty at a group-groping, grape stomping festival o' fun (Fig. 11), shedding your inhibitions and spilling the wine (and taking that pearl) at this grasser on Andros island thrown by Titian (hey, is that Venus of Urbino over there?) but in a Gary "Son of Pete" Peterson style judging by the looks of this hullabaloo, and even as pan-piperettes Lady Chianti and Vine Rose (Sunny Day Women #12 & 35) take five for libations and a foot rub, Mad Dog balances a carafe of 20/20 on his forehead before he goes face down for nap time like Dionysus who is flat on his Bacchus up on the hill, seeing double with one eye on the Thunderbird of paradise who, in turn, is well-lubricated on fermented berries in a tree high above the reveler's,

all gregarious and convivial, tanked up and stripped down, and sticking together as they wallow in the sensuous muck. So sock that bottle over to—hey, that's not wine, it's olive oil! Who wants to play Twister?

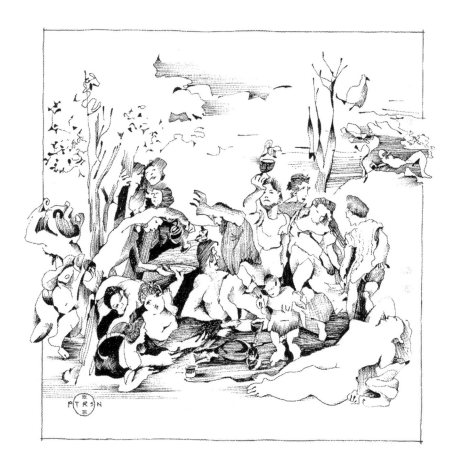

Figure 11. *Grasser at Andros* (after Titian)

* * *

A Bit of Francis Bacon

I always see an aspect of time in Francis Bacon's work, as in time-lapse photography. My own drawing approach produces much the same results, hence my mantra, "It's not what you see but how." But Bacon squandered his vision on the grotesque. I can wrap my head around ugly, but not demented. Then again I didn't live through the tragedies of that man's life and times. It's like a bad acid trip: you don't forget it, but you don't celebrate it either. As compelling as his paintings are, invoking deformity for the sheer hell of it is a tough pill for me to swallow.

When I draw, it's without watching what I'm doing and I usually end up throwing out four of five sketches because they are malformed. I look for one that has some redeeming sense of civility, or at least humor, in its chaos. I use the word "civility" out of convenience when comparing my own style with Bacon's, but I'm really just talking about marks on the surface. Formally speaking, I like to "vent" the main figure into the background. This reversal of figure and ground is a favorite device of mine that becomes more pronounced if I fill in a line drawing with color or shadings. I look for evidence of this same aspect in Bacon. Most of the sketches in my oeuvre were drawn years before I became familiar with his work. I've never cared for Francis Bacon's style but I recognize that his approach is most like my own—the only other artist's works in which I see that somewhat queasy quality. But whereas his paintings reflect years of anguish in his personal life and social milieu, my drawings are just pictures of my kids or home appliances or whatever subject I might find in front of me at a given moment. I sidestep such ponderous baggage as that which lurks behind Bacon's work, and instead entertain my own comfortable diversions. That's not to say I don't have any depth or turmoil in my life, it's just that I've expressed it elsewhere in my art, specifically a literary novel where some of my own demons are portrayed. Otherwise, it's nothing I care to exorcise in my visual art.

Bacon seemed to select his most hideous sketches and then reveled in making them even more formally repugnant. Admittedly, there is a fascinating aspect to them, like Warhol's car crashes, but Picasso covered that anguished ground more optimistically. It is a matter of taste, but I prefer humor to tragedy, contentment to angst, and when on occasion I confront the latter, then I prefer the edgy visions of other dark or disenfranchised artists—Dürer, Gericault, Anselm Kiefer, and Gerhardt

Richter come to mind. Conversely, I get a kick out of Larry Rivers and Jeff Koons, but that's leaning more towards deconstruction than abstraction.

I respect Bacon's artistic license and his place in history, especially in the British canon and I will continue to compare "notes" with Francis Bacon for their clear delineations before his works are fleshed out. I've tried to accept his style and give Francis Bacon's work a "seventy-five" for the rhythm, but I still have a hard time dancing to it. But on a final note, if you own a Bacon, then congratulations. His prices are skyrocketing.

<p style="text-align:center">* * *</p>

Art and Politics

Art transcends politics. In my view, any "art" with a political agenda or other ulterior motives isn't art at all but propaganda, and that stinks no matter from which political camp it wafts. The same distinction can be made between fine-art and commercial art although I've seen some really slick ads for products I'll never buy. It's also easy to confuse art with the "art scene." What you see depends on how you look at things and, to be objective, I've trained my brain to decode the formal elements of any artwork, while maintaining a healthy disinterest in its social milieu.

Political commentary will always infiltrate art and is ostensibly the subject of plenty works, e.g. *The Oath of the Horatii* or *Guernica*. Still I judge art by its formal qualities—contours, color and proportion—and only then consider its political slant. Folk art and music could be considered a special case and yet Bob Dylan's artistic statements—in song, paint, or print—seem to subordinate his political overtones whereas Woody Guthrie or Joe Hill seemed more like political activists than artists. Still other artists, for their own good, might best refrain altogether from editorializing outside of their main medium or field of expertise—not me, of course, but everyone else, from Ai Weiwei to the Dixie Chicks.

If an artist is proficient enough in his or her medium to qualify their ulterior motives and sway my personal convictions about some state of affairs or a consumer product, then more power to them. I might support a worthy cause or just buy some snazzy sneakers if the medium doesn't subvert the message. But don't expect an aesthetic judgment to emerge from the tainted objective properties of some propagandist pap just because the pose is dogmatic or the color palette evokes the political

spectrum: the symbolic "red states" versus "blue states." Also beware that you're not mistaking parody for propaganda, be it a presidential portrait rendered in an agitprop style recalling a Che Guevara poster or, conversely, a congress of suits and haircuts in some dandy tableau evoking a Great Gatsby convention.

It was an unheralded political blogger who nevertheless sparked this rant by insinuating that *I* was the one oblivious to blatant propaganda. Ha! But although he insults my intelligence, I will commend said poser for proffering the topical, if skewed, perspective: that all art is liberally biased. Also, my compliments for his adequate spelling, grammar and syntax that lends his contentions a semi-polished touch for the look and feel of genuine critical debate, despite the fact that his premise—that all art should be weighed on a political scale—is pandering to one of the constraints that real art must transcend. The whole debate parallels other near-sighted squabbles such as between abstract and realism, or Modern versus Post-modern. If an artist or gallery wants to narrow their focus on a given theme, then that's their prerogative, but to suggest that politics is elemental to the true essence—the pure and universal language—of art, is daft. When the dialogue becomes as narrow as to proscribe the strictures of expression, then it's time to rise above it. I implore real-world citizens—both big and little-endians—to abandon all divisive political agendas for the greater good.

So whether you boogie to the Obama beat, or party hearty with the tea-totalers, pure art is impervious to the distasteful artificial flavorings we tend to add. Art is an emergent property, like a spinning top that stands on its own whether it's turning clockwise or counterclockwise, leaning right or left.

* * *

Henri Cartier-Bresson

It is almost as if Henri Cartier-Bresson could make himself invisible, judging by the way the people in his photographs seem unaffected by, if even aware of, the great French photographer's presence. His images are completely candid; no posers allowed. His photos are value-added portraits of reality. He could extract drama out of the commonplace, and always found the balance point between narration and abstraction. Cartier-Bresson, whose

life touched every decade in the 20th century and beyond, was friends with another Henri, the artist Matisse. Maybe that's who influenced the strangely decorative aspect to Cartier-Bresson's photographs.

Henri Cartier-Bresson's images are gray-scale compositions with somewhat musical qualities. Harmony, rhythm, and proportion set the tone while the visual cues of highlight, shadow, and reflection fill in the details. His compositions are spontaneous; no darkroom trickery involved. Every photo has a quality that draws the viewer into a narrative of social realism beneath the surface. The interacting forms resonate with the life events they portray. He had a knack for compressing time: for making the exposure just before the very essence of the scenario imploded. Hence, "the defining moment" became his legacy.

The fleeting quality in a picture of a man leaping over his own reflection in a puddle of water is evidence of Cartier-Bresson's intuition and anticipation. He was always well-positioned and ever-ready to whip out his camera (a 35mm format Leica with a 50mm lens, standard issue) from under his coat, fire and hit the bulls-eye with uncanny accuracy.

Each of his photographs is a slice of life, a sideways glance that unhinges time from space. They are transient and subliminal peeks at naked truths, curious and captivating. The scowl of an old man is caught between what troubles him and what he is going to do about it. The gleeful smile of a child connects the promise of youth with the world at large. Static becomes dynamic—an amorous gaze in the blink of the eye.

If every picture tells a story, then each Henri Cartier-Bresson photograph is an epic novel in a single frame.

* * *

The Deposition of Christ

Looking at Raphael's painting *The Deposition of Christ* one can only imagine the preparation he put into that masterpiece, the finely orchestrated chaos of forms and figures depicting the somber entombment. His style was less dramatic than that of Michelangelo or Leonardo but more earthly and humanistic. This piece of work is strong and moving in its pathos. It transforms a sacred written chronicle into a believable illusion that engages the viewer with the narrative and not the artist's hand.

It was in 1508 when Raphael painted that picture, a recreated vision of an event that occurred in the year thirty something. It makes me wonder how the scene might look if someone had been able to snap a photo way back then and there at Gol'gotha. In their sorrow and passion, would this group really have looked as composed and harmonious, arranged in such perfect disarray as Raphael, the quintessential draftsman would have us believe? Who are these posers, anyway—actors, models? No matter. The important thing is the actual people and event that they are portraying. I admit I had to go to my bookshelf and blow the dust off of that number-one best seller of all time, *The Holy Bible*, to refresh my memory. Yes, of course: Joseph, John, Mary, the other Mary et al (including one mysteriously unnamed disciple mentioned in John 19:26). I'm a hard-boiled skeptic, but once again I am moved to tears by the account.

Figure 12. *The Deposition of Christ* (after Raphael)

Back to the picture, my eye moves in an arc from the hilltop in the right corner, pulled by gravity down to where the weight of a brutal world rests in Jesus' lifeless body before taking an upward trajectory into the dark uncertainty at the left margin. To get more familiar with Raphael's rendition, I redrew it (Fig. 12). Admittedly, some details were lost in my reinterpretation—the sparse foliage springing up in the foreground, the leaden sky and heavenly light of some unseen portal that shines on Christ and reflects on the disciples—but it still tells the story.

We call it Good Friday now, but it was a hell of a weekend. Crucified as a heretic, Jesus must have had his disciples wondering what gives with all the pain and humiliation. I mean, the Son of God is dying here—hello-o?! Still, he demonstrated the most amazing grace under pressure before giving up the ghost after which his disciples were given to lower his body from the cross, the ultimate symbol of sacrifice, like up on that hill, and carry him to the tomb as rendered here in my not-so-Renaissance style after Raphael who, ironically, also died on Good Friday some fifteen hundred and forty odd years later. But on the third day it was Jesus Christ who came through for us all, big time, in a spiritual rebirth celebrated to this day: The Resurrection. The scenario depicted here, whether well or crudely rendered, simply represents the saddest part of the happiest ending of the greatest story ever told. I thank the Lord for the ability to believe in miracles. Happy Easter, everybody.

* * *

The Old Blue Guitarist

Well, here's one more thing that I invented, discovered, or developed on my own only to find it's already been done. In this case it's the practice of putting visual art into words: making art from art, prose from paint. Sure, writing about art is like dancing about architecture; I've been doing that fox trot for years, but I guess the ancient Greeks were doing it too—Homer, Aristophanes, and all those guys verbing on their favorite temples and sculptures and stuff. Come to find, there's even a word for it: ekphrasis. John Keats was still doing it ages later with his *Ode to a Grecian Urn*.

There's a whole ekphrastic universe out there, creative writers waxing poetic about other people's artwork. Why give verbal expression to a painting when every picture tells its own story? Just to keep it honest, I

suppose. Maybe a painting doesn't really know what it's trying to say and I can help articulate its meaning. Maybe not.

I was going to ruminate about Picasso's *Old Man with a Guitar* but I figured I'd have to mention all those things we already know about Pablo's "blue" period after the death of his friend, his acquaintance with a seamy society, and how he honed his style on this tiny canvas that, by the way, has the image of a woman painted under the surface of the broken down old blue guitarist. Is it mere coincidence that there is some gal behind this dejected looking fellow? Probably. Pablo just didn't have the coin for art supplies. It was early in his career when he migrated to Paris to live on the fringe. Regardless of that, an ekphrastic number has already been done on this painting—Wallace Steven's poem, *The Man with the Blue Guitar*. Here's an excerpt:

> They said, "You have a blue guitar,
> You do not play things as they are."
>
> The man replied, "Things as they are
> Are changed upon the blue guitar."

That is more proof that art says what can't be said, but it is ironic that in the actual monochromatic painting the guitar is the only thing that isn't some shade of blue. So I sketched up my own pen and ink version of *The Old Guitarist* in Son of Pete style (Fig. 13) which is a second cousin to Cubism on the temporal side. It shows things at the moment of abstraction: when the whole starts losing track of its parts. Form escapes from the lines of contour like steam venting through fractures in the continuity. Of course, my process had a head start on this image considering that it was pre-visualized by Picasso, an artist not prone to realism in the first place. But here's how I see and say it when all is said and done. Ahem:

> 'Tis not here Tom Dooley, folks, hangin' down his head,
> But Pablo "Blind Onion" El Greco instead
>
> Like Howlin' Wolf, Muddy, or Mister Bo Diddle,
> He gots dem bad blues and plays the git-fiddle.

Coaxing out vibes in a funky blue sonic
From a hole that appears to be stereophonic.

Strumming fandangos with knuckles a rappin'
Don't mind that his forehead it has a big gap in.

While fleet fingers flailing an E-minor chord,
He hums *Malagueña* through that hole in his gourd.

Despite any strange visual cues that decoy,
The tune isn't *Flat-footed Floogie with a Floy-Floy.*

A song as unheard of as Hank's *Cheatin' Heart*
Way back then on any flamenco pop chart

Far fetched as it seems though, it's debatable whether
It's some wistful Dylanesque ballad like *Boots of Spanish Leather.*—GP

Figure 13. *Old Man with a Guitar* (after Picasso)

* * *

5. ART & MUSIC

Music Aesthetics in Art

In the realm of aesthetics, music spans the gap between matter and metaphysics. Music is an aesthetic model for all forms of art.

Music is all math and vibes. It doesn't inform us like words or pictures do. Its "language" is a balancing act of sound and silence based on syntax not semantics. Tones have no meaning but it's their relations to each other—the differences between them—of which music is made. Music and art aesthetics are extraneous to the physical world. Beethoven was stone cold deaf when he wrote his Ninth.

Absolute music doesn't tell stories but it evokes feelings. If I'm moved by a good guitar solo, it's not just due to modes and moods, sympathy or empathy, but by the genius of the artist—the sense that he or she has captured lightning in a bottle. Sure, I can relate to simple harmonic structure too; aesthetics are the natural resonant frequency from which one cops a buzz. My life is an A minor seventh chord. Books, poems, and films can move me too, but a painting hanging silently on the wall can bowl me over just as well. That's the kind of power that has made aesthetics a propaganda tool for commercial and political ends. Forget "branding" for now. Aesthetics are indifferent to context but not ulterior motives. Of course clichés exist in music and art, from the "shave and a haircut, two bits" musical cadence, to that icon of corporate culture—the ubiquitous "let's make a deal" handshake image. Put it there, partner. Here's to the boobs in beer ads and mud-bathed pick-up trucks.

Musical tones and colors aren't like words but they could be. The crude melody uttered in "nuh-uh" means "no" and in "woo-hoo" means "yes!" Stories are told with voice inflections and facial tics: physiognomy. Visually, red means stop and green means go (or port and starboard) and "code blue" means "step on it." O.K., that's a metaphor, but verbal language is more nuanced, and eidetic (visual) thinking is more direct in

its representations. In music there is no encoded message, just pattern recognition and its appreciation, assuming it's played by a musician, not a plumber.

A musical scale is not an alphabet per se. Letters are specific to words but tones are only relative to a melody. If every note of *Twinkle, Twinkle Little Star* is transposed up or down by one musical step, the tune still sounds the same, but if you bumped each letter in the alphabet up a notch, the phrase "see what I mean?" would read "tff xibu J nfbo?" Then again, the Fauvists painted wildly colorful, if unnatural, portraits to great effect by jazzing up their palettes.

Music represents nothing but itself. It exists in the time and space between its notes, which means it's made out of nothing; it is defined by what it is not. This makes it a paradigm for aesthetic value in the arts. Its logical structure—the scales, intervals, and dynamics—have parallels in visual composition. A symphony is like a novel or master painting and a simple tune is a poem or pencil sketch. Birdsongs are something else, but I like them too.

There is beauty in math. A chord built on the fifth tone of the musical scale (called the dominant) has the lowest ratio of 2:3 to the tonic key at 1:1 which makes it pleasant to the ear. The subdominant chord has the next lowest ratio of 4:3. Thus "three-chord" rock and blues is basic to orchestral music as well in Western civilization. In art and architecture, the Golden Mean proportion plays a similar role in visual harmony.

I liken musical chord progressions to the figure and ground in painting—the basic configuration. If it's easy to discern, the viewer will "get it." Harmony has a sense of gravity while lines and contours are like the melody in a drawing. The dynamic range (pianoforte) makes for dramatic lighting in a painting as well as perspective; hearing a soft sound is like seeing through the haze. Rhythm suggests pattern and gesture, the bump and grind in a picture whether representational or abstract, cha-cha-cha. Instrumentation and phrasing lend texture and style to the plastic arts. Dissonance in music or art can be comic, tragic, or just plain annoying.

When we hear the four-part counterpoint of a Bach fugue, it is actually a single chord at any given moment in time. In painting, we likewise splice visual cues into a cohesive whole. An artist adjusts each color segment of various flesh tones to convey the streaks of a shadow on face and forms, or combines the reflections of treetops above, and a catfish beneath the surface of the water on which autumn leaves float—a triple whammy

to achieve an illusion of singularity across the picture plane (à la M. C. Escher).

God is in the details—a grace note or a glint of light. Aesthetics boil particulars down to generalities—sentiment without referent. The artist makes it look easy, not just convincing, so that the observer might not see the forest for the trees. For "good" art, the artist becomes unconscious, guided by an intuition that informs the hand and mind when he or she is in the zone. It's a coordinated effort for a painter to achieve color, line, and volume like a drummer gets all four limbs to do their separate things to the same beat—kick, snare, ride, and crash. That reminds me of a funny quip by comedian Stephen Wright:

> I wrote a song, but I can't read music, so every time I hear a new song on the radio I think—gee, maybe I wrote that song.

The extrasensory aspect baked into a work of art will elicit empathy from the attuned viewer which affects a reaction in the brain (prefrontal cortex, meet hypothalamus) that feels like a supernatural event. It's like learning a foreign language and, for the first time, you hear or speak it without "doing the math" in your head—actually thinking and comprehending directly in that language without interpretation. Vous comprenez?

A human being, like a work of art, is a process and one's identity depends on the continuity of that process. Art is a reflection of history and culture of its time and one must account for the conventions of a given period, but just like the abstract properties of music combine to make a whole beyond any objective purpose, a visual image transcends the surface through "intellectual intuition," as Immanuel Kant would say. It's phenomenological; creative thinking at its best—really "outside the box." The art aesthetic brings our conscious reflection into harmony with the modern world much like mythology did for the ancients. It's the spirituality behind a simulacrum. Art says what can't be said.

*　*　*

Life Is Not a Dream

I wrote a song and then painted a picture based on the lyrics (Fig. 14). It all started when my fingers stumbled across an A-minor 2nd chord on the guitar. That feverish tone cluster has a half-step interval between B and C at its core, dissonant but in a good way.

I usually compose instrumental music, which in my mind equates to abstract art, but a song is narrative, hence the illustration. The watercolor-pencil drawing was done afterward but the image evolved in my mind's eye as I worked on the music. The words describe idle pleasantries and the psychological relationship between a man and woman. The picture is a still-life in multiple exposures. Life is not a dream but it's stranger than fiction. The music engages the mind to explore the space of this painting. The colors are less than natural but then so are the vocal harmonies in the song; they're dark sounding at first, like the Volga Boatman, but they lighten up.

I used a flat pick for this tune instead of my usual finger-style guitar playing. The wrist action articulates the bright, treble tones of the Am2nd arpeggio heard after the first two lines of each verse. It's atmospheric, sounding like water in a river, all swirling and eddy-like. That minor chord jangles the nerves real nice and then resolves perfectly into the C-major of the main chorus which soothes the ear and translates to the calm, ordered scenario of this dreamscape.

Inspired by a "row, row, row your boat . . ." motif, I was even going to put "merrily, merrily" in the background vocals but my empiricist philosophical leanings insisted that life is *not* a dream. Still the illustration looks like someone's dreaming—or hallucinating. What's with the couple in the tree, anyway? The line, ". . . up a tree without a paddle" is just me being funny. We've all been there. Musically, I underscore this semantic glitch with a B-flat major in the chord progression just prior to that line, sidestepping the established pattern. Ha!

Elsewhere, the line ". . . steady as a rock, now let it roll" points to two lovers who look kind of like Canova's version of Cupid and Psyche perched on a boulder on the far bank. The entire scene is viewed from an enclosed foreground as if inside the listener's head. The dreamer is both the object and subject. Geez-O-Pete what a mix-up; It's like hearing the music from the inside out. This reverie ends with the ethereal A-minor 2nd chord.

Lyrics:

It's not how things look that makes them real
But how you see them, what you think and feel
Funny how that works but here's the deal . . .

Life is like a dream

Lying fast asleep upon the bed
You were wide awake inside my head
Looking through my eyes you smiled and said . . .

Life is like a dream
You row your boat downstream
But it's not what it seems . . . to be
Life is not a dream

Sometimes we laugh until we cry
'Til streams of consciousness run dry
Out on a limb we straddle
Up a tree without a paddle . . . high, high and dry

Love is like a river let it flow
We can make the time to take it slow
Steady as a rock, now let it roll

Life is like a dream
You row your boat downstream
But it's not what it seems . . . to be
Life is not a dream

I love you more than life, no lie
I cross my heart and hope to die
But if I die I won't be dead
I'll be alive inside your head, surprise!
Close your eyes

(guitar)

Life is like a dream
A boat that floats downstream
A glossy magazine
A picture on a screen
It's never what it seems . . . to be
Life is not a dream.

Figure 14. *Life Is Not a Dream*

* * *

The Legacy of Folk Music

Folk music resonates with myths, legends, and heroes of ordinary people; songs about high-ballin' engineers and steel driving men like Casey Jones and John Henry—or the occasional ode to a train wreck or mine disaster. There are tragic love songs like *Pretty Polly* (if not show tunes like

Unsinkable Molly) or *Sweet Betsy from Pike*, a portrait of pioneer life in waltz time.

Folk music is democratic music: an engaging mode of personal expression for the masses, oppressed or otherwise. There are work songs, drinking songs; traveling songs; courting songs; "I shot my lover" songs; prison songs; preaching songs and dying songs. The dazzling instrumentals of "bluegrass" music are a tonic for ailments of the soul. The high lonesome harmonies help mend broken hearts and reconcile despair with its Gospel promise. And with old time country music, the whole clan can hoot, holler, yodel, & yell in the parlor or on the porch.

Musical storytellers offer the most memorable accounts of history and life. It is honest music played by people with as much gumption as talent. Folk music is played "by ear." It is informal music, rustic and naïve in its beauty. Whether they are songs about the American frontier, or the ballads and broadsides of the British Isles and Europe, every culture in the world has its unique folk music and dances. Flamenco—an Andalusian art form—is dance music played on guitar at a fever pitch. Its Italian counterpart is the tarantella in which mandolins and tambourines fill a "dance or die" prescription—a musical folk remedy for those bitten by the tarantula spider.

Homemade musical instruments were often substituted for traditional ones in the New World. The five-string banjo emulated the drone of bagpipes for the Scottish and Irish immigrants working in the Appalachian coal mines. Dulcimers sufficed for pianos; mandolins and fiddles became dance partners. Today I can hear jigs and reels in blues-guitarist Johnny Winter's musical riffs. The instrumental techniques are often unconventional. Bottlenecks slide along the strings for a whine that's sublime. Music is made with washtubs, jugs, and spoons. Bob Dylan, who helped elevate folk music to an art form, offended his acoustic-minded audiences when he first dared to use an electric guitar, but he stayed true to the sensibilities of his mentor Woody Guthrie who, during the Depression era, played a guitar that had the inscription: "This machine kills fascists" scrawled on the soundboard. Sometimes folk music has a political agenda, but at least it's not a hidden one.

As folk songs evolve, their origins become obscured over time. Whatever motives folk music may have, commercialism is not one of them. But the recording industry cashed in on "the great folk music scare" (to parody the so-called "Red Scare" of communism) of the early '60s

when the cold war and "the bomb" dominated our psyches and bolstered interest in folk music via the protest song.

Folk music, both rural and urban, is at the root of most every other musical genre: blues, rock and roll, ragtime, jazz and even classical music. Many classical composers have based their works on folk melodies. Folk music is simple in form, but it uses the same twelve tones from which high-brow composers craft their symphonies.

Meanwhile, we should thank ethnomusicologists like Alan Lomax and John Fahey, who went into the fields and door to door in rural America with note pads and tape recorders capturing much folk music for posterity, sort of like Plato who wrote down the things that Socrates only ever spoke. Folk music as an oral tradition is sometimes bawdy, humorous, and even philosophical. A favorite of mine, *The Big Rock Candy Mountain*, describes heaven in terms of a hobo camp where there is "a lake of stew, and whiskey too, where you can paddle all around in a big canoe."

That being the case, then "all my trials, Lord/soon be over."

Until then, may the minstrels and troubadours (town criers in the key of C) continue to strum and sing on mountain tops and street corners and tell it like it is, was, or should be.

<p style="text-align:center">∗ ∗ ∗</p>

Song Review

Tommy Beavitt's song *Half Filled Cup* from his *Holding Water* album has an early Donovan sensibility except that Tommy Beavitt has the high lonesome wail suited more for a drinking song than a sonnet. He occasionally fits more words into a stanza than syntax allows but makes it work well. His voice has a Gaelic twinge and his lyrical lines like, "It takes experience if we're to gain wisdom" are philosophic in the empirical tradition of Locke or Hume.

The backup voices are smooth and sound like The Roches without the sarcasm; or something from a Grandpa Jones cult—a naive wholesomeness that makes the ironic world melt away.

This half Celtic/Appalachian sounding hymn in the key of A has a couple of refreshing twists in the chord progression that flows down the tonic-dominant stream, namely an F# minor that provides a stepping stone between the D and E chords. Then the musical bridge, "This cup

of life is a half-filled cup . . . " leads to the unflinchingly sincere homily of ". . . it's always half way full" harmonized and sung a cappella with maximum smarm following the sub-tonic shot of B major. Sweet! This leads back into the sparse but now familiar twang of the guitar and bass accompaniment of the main chorus all steadied by the meter of a kick drum, snare, and a touch of tambourine jangle in standard time.

The heartfelt honesty in the strain of Beavitt's quavering voice chokes me up. My soul soars like the eagle of which he sings while my feet walk on solid ground. This tune spins melancholy into a positive emotion, but one that is transportable because you can never really go home again. "My innocence was lost when I met you" is the bittersweet skew of his earlier proclamation: "There is no comfort without feeling sad and blue," and with this song, feeling sad and blue never felt so good.

<p style="text-align:center">* * *</p>

Why to Learn a Musical Instrument

You don't have to be a musician to enjoy music, any more than you have to be a chef to enjoy food—you'll just enjoy it more! The benefits of learning to play a musical instrument are more than the reasons that many players get started in the first place: appreciation, participation, or just curiosity.

For the beginner, musical competency is secondary to the creative process. As a guitarist, I can coax a decent jazz rendition of *Misty* or a Bach Fugue out of my box. But I can get the same satisfaction out of strumming a three-chord folk song or other trifle like, well, *Satisfaction* by the Rolling Stones. You can master that three note hook line in a minute, or you can spend a lifetime fine-tuning your art; that's part of the beauty. One can play alone in thoughtful solitude, or in an ensemble to an audience for a sense of accomplishment that far outweighs any tedium of practicing.

There are instruments to fit any personality or ambition. Wind and string instruments for band and orchestra help a student develop an added aspect of teamwork—a quality that translates well in other endeavors of life and career—while providing a realm of personal achievement.

Keyboards like piano or organ, more so than any other instrument, provide a straightforward visual representation of music theory, the various musical modes and scales of half and whole steps, literally laid out in black and white on the keys. Those same notes are more obscure on a guitar fret

board, but again I'm biased and feel that a guitar, in tone and touch, may be the most expressive of all musical instruments save for, arguably, the human voice.

To play a full set of drums requires brain activity unlike any other to orchestrate all four limbs into a unified effort that can make the heart pound both literally and figuratively. It is downright therapeutic.

Music can be tailored to any occasion: you can dress it up or dumb it down. It's a pleasant diversion or an otherworldly experience. With some formal training, one can learn to read music like a road map to any tune ever published. The other, more intuitive, tact is to play "by ear." Either way, a good instrumentalist can accompany singers or compliment other soloists. Songs have lyrics, but instrumental music doesn't have any such encoded message, just pattern recognition and its appreciation. Melody is relative; *Mary Had a Little Lamb* sounds familiar in any key, but there's plenty of room for style and attitude. If you've got an "axe" and some "chops," you can be the life of any party. And of course the fringe benefits of playing in a rock band are well chronicled.

Don't tell the kids, but there is some math and physics involved. The student will intuitively learn about ratios and proportion. The musical octave of any tone is the value of its sound frequency doubled. Divide that range into twelve equal parts and you've got the building blocks used for every musical composition ever written—at least in the western hemisphere. A tone is to sound, as color is to light. But music uses the element of time, and even silence, to create a story of sorts. Any string, membrane, or air column that vibrates 440 times per second produces the musical tone (note) A. Add to that a couple of its soul mates from the scale and, voila—you invoke the mind-altering magic of major and minor chords: harmony. When you play an instrument, whether you're conscious of it or not, you're dabbling in psychology and aesthetics, not to mention more mundane considerations like motor skills. But most of all you are having fun.

So whether it's honking a harmonica, slapping a bull fiddle, or tapping a glockenspiel, develop an affinity with a musical instrument and learn to express your inner self through it. That is the only way you can you experience the single most profound aspect of performing: Hearing the music from the inside out.

* * *

West Side Story: A Review

West Side Story is like Romeo and Juliet with switchblades and fire escapes: a story about the hate between two New York City street gangs—the Puerto Rican "Sharks" and the Anglo-American "Jets." But it's also a story about the love between Tony and Maria, one from each gang.

The book became a Broadway musical and then a Hollywood movie. I've watched the film as many times as I have seen live performances, but the motion picture sound track is my standard of reference. That can be a problem.

First of all, Leonard Bernstein's fantastic musical score marries Latin rhythms to orchestral fanfare, all shaded with a 1950s quirky-cool beatnik attitude, edgy and percussive, and Stephen Sondheim's lyrics accentuate the finger-snapping tunes with lots of "go man, go-s" and "daddy-o-s." The songs can be reverent, such as in:

> 'Maria'—say it loud, and there's music playing/say it soft, and it's almost like praying

or raucous like:

> . . . life can be bright in America—if you can fight in America!

And *I Feel Pretty* is a girlie song than can even lighten the hearts of manly men. If you only have six minutes to spare, listen to a recording of *Quintet/The Rumble*. For orchestration, intertwining vocals, and sheer musical bravado, it is as urgent and powerful as any stanza ever written. That sonic segment contains the nucleus of the entire score. It is the musical prelude to the tragedy of gang violence.

Meanwhile, Jerome Robbins' choreography for this brawling, back-alley ballet is custom-made for thugs in high-top sneakers. I never knew street toughs could dance like that.

So what's my problem?

I never saw the Broadway production, but for all the renditions of *West Side Story* that I *have* seen—from high school and Community Theater, to Detroit's Fisher Theater and Ontario's Stratford Festival—I still enjoy a live performance of the music and the portrayals of the characters: Riff, Bernardo, Anita, et al. And I never fail to fall in love with Maria no matter

who is starring in that role. But being so familiar with the Academy Award winning film, I find that whenever a theater troupe tries to freshen up the dialog with some new expression, it jumps out at me and challenges my expectations. Then I stand up and yell, "Do it right!" and that annoys the other patrons and I get kicked out of the theater. Well, not every time.

I've learned to embrace the nuance of interpretation as a good thing. Shakespeare himself would be flabbergasted—in the best sense of the word—to witness the evolution of this timeless story and the tragic but poignant way that history repeats itself. And besides, the music is—note for note—right on, every time. Es muy grande!

<p style="text-align:center">* * *</p>

Picasso and Activision: No Strings Attached

I was at the library again, this time watching the geriatrics shuffle in from the rest home next door, when I noticed the new issue of *ARTnews* (Feb. '11) on the rack. A banner on the cover read, "Picasso: Guitar Hero."

Turns out, the Museum of Modern Art in New York is exhibiting seventy works by Pablo Picasso that showcase his visual obsession with the Spanish guitar. Included are two of his sculptures—one cardboard and the other, tin—circa 1912-14. I've seen the pieces before at the MoMA and those ersatz git-fiddles are indeed spectacular in an abstract, scrap-bin sort of way. Picasso's liberation of a guitar's form from Cartesian space may be the first ever example of "thinking outside the box"—a shopworn cliché today but a perceptual sea change a hundred years ago.

My interest in these Modern Art masterpieces is heightened, if conflicted, by the fact that I too have built seventy or more acoustic guitars—real working instruments. So let me condescend for a moment. First off, I understand that Pablo couldn't play the guitar for beans. I could have played circles around him with my eyes closed. But, of course, Picasso's Cubist "guitars" are purely visual constructs that resonate, figuratively speaking, with a sense of time and history. They ring true to Einstein's relativity. Talk about negative space: Pablo inverted the guitar's sound cavity by extruding the hole into a tube, providing depth by proxy and essentially making something out of nothing. That's pretty funny—not hilarious, but I'm as much amused as awed. The jumbled aspects of his ideal guitar fold into each

<p style="text-align:center">94</p>

other like standing waves in a small listening room, or microwaves in an oven. The freeze-dried extraction liberated from its own material confines has a baked-in aesthetic that confounds my brain in a delightful way as it reconfigures itself in the appropriate corners of my head.

The author of the *ARTnews* article, Ann Landi, cites Picasso's creations as epistemological, whereas I would say they are downright ontological in that he imbues a sense of being, a conscious introspection as if the guitar was seeing itself from the inside looking outward to its immediate surroundings including the space it occupies. To truly know something is to be that thing, so Pablo becomes one with the object of his affectation and manipulates its myriad modalities, not the least of which is the guitar's female form. The man was a genius all right. But could he coax an A-minor seventh chord from well-tempered strings intimately coupled to a taut body of mahogany and spruce? Doubtful. That's the hands-on dimension that Picasso's assemblages leave wanting. A guitar should be played: seduced like a woman. Then again, Pablo had muses and mistresses whereas my guitars are the only girlfriends that my wife will let me keep.

Anyway, having waxed long enough on matters of art, I moved over to the business section of the reading room and learned, by eerie coincidence, that the multimedia/graphics company Activision Blizzard, Inc. had just given the axe to their popular, but unprofitable video game called *Guitar Hero*. I extend my sympathies to investors and enthusiasts alike, but—good, I say. To go out and buy a real guitar and learn to play it, beats faking it on some glorified joystick. It's not as finger friendly to the novice, but you can dumb it down to three chords and still find satisfaction; ask Keith Richards. Sure, the motor cortex in a game-player's head may glow a bit when he pushes big colorful buttons, but the fine motor skills atrophy and the higher brain centers—like the anterior cingulated cortex—are hard-pressed to muster an aesthetic buzz the likes of a Segovia, or even a Picasso-induced epiphany. You don't have to be a virtuoso. You could make a cigar-box banjo and pluck *Oh Susannah* on it, which is more than Picasso could say about his guitars.

On a dark note, the popularity of games like *Call of Duty* and *World of Warcraft* is booming. That's just as well; we don't need to be arming the bored masses with real weapons just for fun. Farmville wouldn't stand a chance. Still, the fact is, I've never played any video games in my life (OK, Pac Man, once) but my son—an accomplished guitarist, like his brother who also builds them—tells me he has played *Guitar Hero*. He says it was

fun—and he's a lawyer. So there you have it: I'm the one missing out on the experience and, frankly, I'd probably be hooked in an instant, but then again I've never golfed either. I do enjoy computer solitaire. That's my speed. I understand the value of games, min-max theories, dexterity and whatnot. I'm just too busy for video games, even now in retirement with nothing better to do than sit on the couch, strum my guitar, and harp about the evils of push-button distractions.

I really should embrace virtual reality as an art form and yet I've never strapped on the goggles and gloves or whatever interface is de rigueur these days—a chip in the head, I suppose. Nor have I ever floated in a sensory deprivation tank, although I've dabbled with enough psychedelics to know how the brain is tricked into perceiving altered realities. Like video games, it can be a waste of time. So, call me a relic, like Picasso's old *Blue Guitarist*, but give me real reality and real music—like Super Mario Brother's theme song. Seriously, I dig that tune.

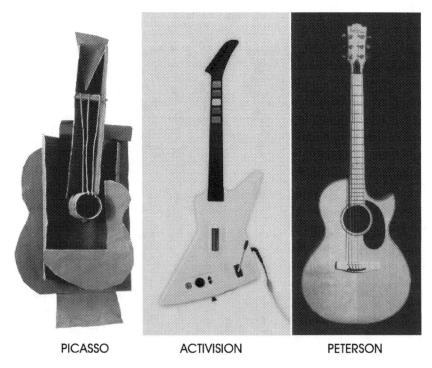

PICASSO ACTIVISION PETERSON

Figure 15. *Three guitars: A sculpture, a controller, and the real deal*

* * *

The Greatest Rock Guitarist of All Times

The greatest rock guitarist? First these honorable mentions:

The Holy Trinity of rock guitarists: Eric Clapton, Jeff Beck, and Jimmy Page, all played at separate times for a group called the Yardbirds. Eric (a.k.a. "Slowhand") later played with John Mayall's Bluesbreakers; He then went on to form Cream, the seminal power trio. Jeff Beck has an expressive, lyrical guitar style; a true instrumentalist who isn't afraid to cover tunes like Mingus' *Goodbye Porkpie Hat*. Jimmy Page, a former session player, is the best acoustic soloist of them all, but it was his hypnotic, heavy metal guitar genius that would later propel Led Zeppelin into the stratosphere of super groups.

Other figureheads include many of the original American bluesmen. I'm partial to Lightnin' Hopkins as a precursor to rock, and Big Bill Broonzy could roll with the best. In the 1950s, Scotty Moore, Elvis's guitar man, gave us rockabilly. Today, John Mayer is rocking in the old-school tradition. He honors Stevie Ray Vaughn—rest his soul—a guitarist who was never at a loss for the next note. And when you're talking Texas blues legends, Johnny Winter comes to mind: a slide-guitarist whose licks ring out like jigs and reels on Texas twin fiddles. ZZ Top's Billy Gibbons is a guitar slinger with impeccable harmonic overtones. Elsewhere, The Rolling Stone's Keith Richards proves that you don't have to be good to be great, but Aerosmith's Joe Perry shows that it doesn't hurt. And, just for the record, Jack White has carved a niche for his own worthy legacy.

But enough about the nominees—the envelope, please . . . Brothers and sisters, we have a tie.

I saw Jimi Hendrix play in Detroit. Sitting front-row stage-right, I could have tied his purple shoes together, but they didn't have laces. He chatted-up the girl I was with and sipped from her Coke between numbers. I remember thinking "he's just a kid," even though I was still in high school myself. He electrified the music scene. His style was unorthodox. He played left-handed with fingers that seemed long enough to wrap twice around the neck. His musical sensibilities were otherworldly, finding sounds never before heard, and at a time when other rock guitarists were just strumming bar chords.

Jimi was a showman who worked his magic on stage as well as in the recording studio. With a wang bar and the electronic feedback of his Marshall stacks, his trademark "Fat Strat" sound was just the undertone

of the sonic ecstasy that he induced by choking the strings or just strafing them on the microphone stand. It is a sound that echoes in the music of most every rock guitarist that has followed since.

Jimi was a poet, and his guitar was an extension of his body and soul. He elevated the power trio concept to psychedelic heights. It was remarkable that, after he blew everybody's minds that night at Cobo Arena, Jimi received an ovation (in the days before cell-phones or even disposable lighters) that, by today's standards, would be considered polite applause at best. Nobody was sure what had just happened to them or how to react to the Jimi Hendrix "experience."

A decade later, the world was primed for the bad-boy antics of the world's next rock guitar legend—Eddie Van Halen. Eddie is smooth and fast, owing to his trademark style of hammering the fretboard with both hands, a tapping technique pioneered by Stanley Jordan and others, but perfected by Ed. His classical training is evident in his mastery of phrasing and harmony, complimented by his sense of tone and timbre. If Hendrix was a poet, Eddie was a prodigy. Eddie is a survivor who has spawned a generation of imitators.

I didn't see Van Halen until the "Van Hagar" era. I hadn't been to any rock concert in years until I took my son to see this one, his first. (I had second thoughts as we were patted down for weapons at the door.) Eddie thrives on the bombastic and always plays to the-bigger-the-better crowd. He was matured and freshly rehabilitated but gave a stellar performance: a theatrical spectacle that made my memories of the Hendrix concert seem quaint. Van Halen's style is pure testosterone: an in-your-face style of pop-oriented mayhem. Eddie performed his precision pyrotechnics on the strings of a honey-toned PRS guitar (or possibly an Ernie Ball). The music was cohesive and rock solid. His melodic structures are both stark and elegant. They seduce you and then pummel you into submission.

It's a tough decision. I need a tie-breaker. Based on the consistency, catalog, and legacy of Eddie Van Halen, I'd tap him as the greatest rock guitarist. He has the knack of turning an art form into a competitive sport. But if this article was entitled "My all-time favorite . . ." then it would have ended on word one: Jimi.

* * *

By the shores of . . .

Here's a message I left my clients and colleagues as I skipped town for a weekend:

I'm up, up, and away from my desk at The Peterson Institute. I'm driving up north to the Copper Country in Michigan's Upper Peninsula (Keweenaw) for my Uncle Wilbert's 80th birthday party and hootenanny—maybe take a sauna and a splash in Lake Superior. I'll be back on Wednesday barring hypothermia.

So in case you've finally decided to send me your artwork to review, go ahead but I won't get around to it until next week. For new callers, here's some background.

The U.P. is a land of round heads—Suomilainens, or Finlanders—of which I am one. But you're saying "Peterson," that's a Swedish name. Yes it is, but it was originally Pääkkö. Remind me to explain how that happened some time. Meanwhile, behave yourselves; I'll be keeping an eye on yous guys if they've got the Internet switched on up there and the aurora borealis doesn't interfere. Now let's all sing the *Song of Hiawatha* by rapmaster Hank W. Longfellow. Come on everybody, one time in iambic tetrameter:

> BY the SHORES of GITCH-e GUM-me,
> BY the SHIN-ing BIG sea WA-ter,
> STOOD the WIG-wam of No-KO-mis,
> DAUGH-ter OF the MOON . . .

Pikaisiin näkemiin
Son of Pete

* * *

Uncle Wilbert

On the boat to Isle Royale, heading out of the canal towards Lake Superior, I spotted a bulldozer moving earth up on the highest bluff. I said to my boys, "That guy is sitting on top of the world." Turns out it was my Uncle Wilbert up there.

Back when I was a kid, Wilbert worked for the railroad. Sometimes he'd take me and my cousins down the tracks on a handcar, let us swing pickaxes and help replace ties, and then we'd go over the high trestles that spanned the Firesteel River, to pick the blueberries before the black bears got there.

Wilbert Leppanen was a hard working man in the hot summers and harsh winters of northernmost Michigan, homesteading and raising a family in the storied copper mining town of Winona. He was also a polished jazz guitarist—a working musician who performed in the clubs and taverns throughout the Keweenaw Peninsula. He could play a polka or cover a rock tune too, but he rendered the old standards with the best of them. He even traveled to Finland and played for dignitaries.

I'm obsessed with the guitar and its music and have often said my life is an A-minor seventh chord. It was Uncle Wilbert who taught me about major, minor, augmented and diminished chords: how to play them, where and when. I loved to hear him pick a tune on his old Gibson through an amp with a steer painted on the speaker grill, sometimes accompanied by friends and family. He wrapped a piece of twine around the knuckles of one finger to hold it in place due to an old injury. I have a record album of a live session that I attended when I was 8 or 10. He was an inspiration: a man with a big heart and hands to match, a real pair of mitts, with which he played sophisticated music with a masterful touch.

I spent many happy summers up north with Uncle Wilbert and Aunt Joyce and all of my cousins. But fifty-odd years later, just days ago, I was in Arizona—driving down Scottsdale Boulevard, back towards the hotel from a restaurant called Cantina something or other—when I got the sad news, a phone message, that Wilbert had passed away. Among the thoughts that flooded my brain, was one of him once telling me that he liked Mexican food. Such a trivial recollection, but that's what happens when I'm ambushed by time and circumstance. Suddenly, I felt a long way from home. He had called me just before the trip; seemed fine.

I last saw Wilbert at his 80th birthday party in the park at the lake—the same place I remember him driving me to in his '53 Mercury when I was five. But now, in my mind, I hear the final cadence of a jazzy guitar vamp that was his signature style at the end of many a tune and it makes me smile.

Levätä rauhassa, Wilbert.

* * *

6. ART & WRITING

Lunar Legends Abound.

I file this report from the edge of Lake Superior where amidst the firs I consort with wood nymphs smoking my red stone pipe on a log where woodpeckers peck as the sun sets. And when the moon launches over the water, I will lure the fairest fairy maiden into my cabin to seduce her with *The Song of Hiawatha* by Henry Wadsworth Longfellow. Meanwhile, I'll summarize it for you here, but only those parts that make mention of the moon.

A moon maiden was swinging with her gal pals when a rival cut the grapevines causing Nokomis to fall to earth. She landed in a flowering meadow and there, in the moonlight, her daughter was born.

Wenonah grew to be a lovely girl and her mother constantly warned her not to lie in the meadow when Mudjekeewis, the West Wind, came along. But she didn't heed her mother and the West Wind wooed her one evening in the serious moonlight. Soon she bore a lovechild named Hiawatha, but the West Wind abandoned them, and Wenonah died of sorrow, so it was Nokomis who raised Hiawatha from birth:

> By the shores of Gitche Gumee,
> By the shining Big-Sea-Water,
> Stood the wigwam of Nokomis,
> Daughter of the Moon . . .

One night when the moon rose above the waters, its face was shadowed and puzzling to Hiawatha. He asked his grandmother what's up with that, and she told him the tale of how an angry warrior had once thrown his grandmother so far into the midnight sky that she landed on the moon and it was her imprint that he now saw.

Nokomis had an attitude about men, understandably. She told Hiawatha about his false-hearted father Mudjekeewis—the West Wind—and how he had killed the boy's mother. Hiawatha was incensed and set off for the portals of the sunset to find his father and snuff out that blowhard. As a warrior, Hiawatha was bad to the bone, yet after a long, tumultuous battle he learned that the West Wind is immortal. Hiawatha finally backed off, content to inherit the wind.

Back at the wigwam, the pallid moon—the Night-sun—rose again above the tranquil water. Hiawatha was sleeping while Nokomis toiled patiently in the moonlight preparing fish oil while hatching a plot. When the moon swapped with the sun, Nokomis sent Hiawatha on another mission of revenge: A pre-emptive strike to kill Pearl-Feather, the evil magician from whose deadly tricks no one was safe. You see, Pearl-Feather had also come down from the moon, the dark side, perhaps, and killed Nokomis' father with pestilence and fever.

Hiawatha was soon on the warpath again, paddling his well oiled canoe westward through the water's black shadows while the air was white with moonlight that made a thousand frog's eyes glow as they croaked their hero's welcome. Meanwhile (in iambic tetrameter) . . .

> The level moon stared at him; in his face, stared pale and
> haggard, til the sun was hot behind him.

Long story short: Hiawatha slays Pearl-Feather (a.k.a. Manito of Wampum), with the help of a woodpecker who is forevermore honored with a red head.

On his way back home, Hiawatha meets the loveliest maiden in the land of the Dacotahs. Minnehaha is her name, which means Laughing Water. Later, Nokomis warns him to stick to his own kind, Chippewa, I believe, saying:

> A neighbor's homely daughter, like the moonlight, is the
> handsomest of strangers!

But Hiawatha tells her that he likes the firelight and starlight, but best of all the moonlight. He goes to win Minnehaha's hand from her father, an arrow smith. The young couple is rejoined, and:

From the sky the moon looked at them, filled the lodge with
mystic splendors . . .

Now, it's been said that a man will tend to marry his "mother," and
Hiawatha's mother was the grand-daughter of the moon. Thus the happy
new couple journeyed homeward to the lodge of old Nokomis where the
two women hit it off pretty well. The blue moon became a harvest moon.
Life was beautiful and bountiful under the influence of the moon. And
that's only the half of it.

* * *

Metaphors and How to Use Them

This is the dawning of the New Age of Metaphors. Everyday conversation
has become a game in which we use figures of speech instead of literal
descriptions. We speak of things as if they were something else. For
example, to "touch all the bases" is a baseball metaphor that otherwise
means "to be comprehensive" about such and such. Conversely, when
a baseball player "steals" second base, he's not being criminal, he's just
running from point A to point B faster than someone else can throw the
ball there (if he's got good "wheels," that is.)

A synecdoche is a variant of the metaphor. It's when a part of something
represents the whole thing, as in "they can't steal second if there's a strong
'arm' behind the plate." A metonym is also an associative term, like when
an athlete is called a "jock"—derived from "jock strap." (And do you really
think they called Randy Johnson the "Big Unit" just because he's like
some tall, lanky pitching machine?) Meanwhile, the "family jewels" are
more of a double entendre than a metaphor.

Here's an old standard from the meta-files: "He gave me a 'hard time,'
so I 'cleaned his clock.'" That is to say that someone offended me so I
thrashed him. But not really; I don't roll that way. It's better to "chill."
Then you can either "work around," "smooth over," or "iron out" your
differences if somebody is bugging you.

And speaking of bugs, we all use computers nowadays clicking and
scrolling our way through a world of digital metaphors. If we had to use
technical terms, the following statement could give even the most grizzled
computer geek the vapors:

> I peruse nonlinear data while navigating cyberspace with
> a hand operated raster coordinate interface device, but the
> algorithm is corrupt.

Translation: "I 'surf' the 'web' with a 'mouse' but my 'software' just 'crashed' my hard drive on the 'information highway.'" That's a string of mixed metaphors we can all wrap our heads around. Meanwhile, the now-burgeoning age of tablets, smart phones and cloud computing is antiquating even that quaint dialect as I clatter away on my clunky old keyboard.

Analogies, which spawn metaphors, are linguistic tools of science. They tell us that, for instance, electricity is like a sub-atomic version of its cosmic big brother—gravity. But metaphors are more subtle. They never use their real names. A metaphor is like the second half of an "if/then" statement: a conditional. For example, *if* the meta-object "face" combines with the referent "moon," *then* the result is, "Her face lights up a room"—a glowing testimony to radiant beauty. So then you say, "Hey there, Moon Pie—how about a little snack?" and, even though you're not the sharpest knife in the drawer, she invites you into her kitchen and hopes you can cut it. But someone left the cake out in the rain, and you'll never have that recipe again (more proof that metaphors don't have to make sense to be a hit record). Or as Ophelia said of Hamlet after he stung her with a pointed soliloquy:

> And I, of ladies most deject and wretched, that sucked the
> honey of his music vows.

Shakespeare must have been playing it by ear when he mixed up those metaphors. But then, I'm no rocket surgeon either.

* * *

Rod Serling

Imagine, if you will, the portrait of an offbeat TV host and purveyor of the quintessentially weird, as rendered by an itinerant artist marking the boundaries of shadow and light on an erratic journey across the cerebral landscape that lies between a roving eye and fitful hand creating what

appears as a face or facsimile thereof from a distance at which your perceptions may be found straddling the borderline between comic illustration and serious art as it is known in—the PeterZone.

Figure 16. *Rod Serling*

* * *

Rhapsody In Overdrive: An Author Interview

I wrote a novel entitled *Rhapsody In Overdrive* (iUniverse, 2003) back in the '80s about events in the '60s. Not many have read it, and even fewer have commented on it, but Brianna—a high-school student and daughter of a friend who actually bought a copy of my book—asked me for an interview. I guess it was an assignment on which her graduation hinged, but I felt like a celebrity and was happy to answer the following questions:

What was your inspiration behind the character of Floyd Wolf?

I must admit that *Rhapsody In Overdrive* is largely autobiographical. Floyd Wolf was my adolescent alter ego—a thinly disguised character that I hid behind in the name of fiction. The other characters were also based on actual individuals. Naturally, I changed their names too.

Did you have to do a lot of research in order to write certain parts of the novel? For example, the different places and the drug references?

All of the episodes, the people, incidents and even the hallucinations described in the book are essentially true to life: mine. The bad-acid trip, the cross-country trek and all that took place in the story, actually occurred within the span of a year or so but I condensed the timeframe down to one summer and occasionally switched the order of events for continuity.

When in your life did you set the goal of writing a novel? Was it hard to get started?

This novel started out as a short story and it just took on a life of its own. It was about 1980 and I had only hoped to maybe get it published in a magazine so that I might be asked to do the artwork, a graphic illustration. As it turns out, I did create the cover art. Now if I could just get someone to make a movie out of it so I could score the soundtrack . . .

How long did it take after you completed the 'rough draft' of the novel before it actually got published for us readers?

It took twenty years from the first hand-scribbled notes, to publication in 2003, and that included four rewrites. But that's because I let the manuscript sit in my desk drawer for most of that time after some early rejections by traditional publishers. It wasn't until the advent of the "print on demand" era that I found it viable to self-publish my work. I'd be hard-pressed to calculate the actual writing time it took.

> *Your writing style includes tough words and strong imagery. What made you choose this writing style? And as a side note, did you already know all these words, or did the thesaurus become your best friend?* :)

I've always been interested in the sciences as well as art, religion, philosophy etc., and my language simply reflects my thoughts. I use the thesaurus as necessary, but lately I swerve around the technical stuff when I can. In *Rhapsody* I tried to convey what it was like to think too much: to be trapped in the mental turmoil of an overactive, chemically altered state of mind.

Your observation about the visual imagery is a keen one. That is probably the most deliberate aspect of my style in this book. The story was a vehicle for me to expound on my surroundings and the sensory experiences that were my life. Most of the research I did was just to insure accuracy of related facts and backgrounds. For instance, I sat in the cave in Nevada and experienced what Floyd describes in Chapter 6, I just didn't know at the time that the rock formations are called tufa until I looked it up years later while writing the story.

> *Are you currently thinking about or in the process of writing another book? Are you working on anything else exciting? Basically, what have you been up to?*

I published a second book in 2004 called *Humor Scene Investigation*. It's a non-fiction treatise about humor, the creative process, and the literary devices that I developed while writing *Rhapsody*. I've also written many humorous essays and articles, some of which have been published in various science journals. I've also been recording my music and doing art stuff—drawing and painting.

One part of my project is to mimic your writing style. Do you have any tips?

My writing style has matured but there is, admittedly, always a tinge of cynicism. I try to keep it subtle, informative, and as noted—visually descriptive such as in the first sentence of Chapter 8 for example:

Sodium vapor escapes from the rash of pinholes in the celluloid night sky that envelops the accommodating cattle crossing called Winnemucca.

Also, I may take a hyperactively descriptive run-on sentence, convoluted but rhythmic like this one, and save the last word for maximum impact, and then follow it with a short sentence to let the reader regain his or her balance. Like this.

Rhapsody In Overdrive was originally written in the past tense (was, did, went, etc.) but I changed it all to the present tense (is, does, goes, etc.) to heighten the sense of immediacy that is essential to the final chapter. You don't find that in most narratives.

I read the back of the book cover, and I think it's awesome that you are an artist, musician, and an author. Did you have to make any sacrifices in pursuing this creative lifestyle?

My long-time job at a design firm allowed me to leave that work at the office at the end of the day so I could entertain my muses after hours. Now that I'm retired, it's a full time job trying to stay busy.

Are there any people in your life that helped encourage you in writing this novel? Were there any people that you based your characters off of?

My wife has always been supportive, even encouraging about my writing over the years and my brother was always a good writer. My sister largely cured me of horrendous spelling.

After the book was published, I got a phone call one midnight and someone said, "Hi. This is Bailey." I don't know any Bailey except for the character I named in the book. The caller turned out to be my old

buddy, now in Hawaii, who bought the book and recognized himself in that character. He enjoyed that. My Aunt Flora also called with much praise and thought she saw herself in one of the fringe characters although, frankly, that one seemed a misconception to me. I always worried that a lot of other people would recognize themselves and be offended, but so far so good.

What would you say has been your favorite part of the journey to become published?

Writing is a solitary endeavor which suits me well. I always enjoyed the couple of hours in the evening I devoted to writing that book, sometimes laughing or crying, and occasionally nailing a perfect line. It was exciting to finally have a copy of the finished book arrive at my door (and a few bucks in the mail now and then) and be able to show it off. But the most gratifying experience is having you ask me to discuss the behind-the-scenes aspects of the book. Thank you very much. Best wishes—Gary Peterson

* * *

Humor Scene Investigation

I published a second book a few years ago. It is a philosophy of humor. Here's an excerpt:

> Stereograms: This visual trick superimposes two perceptions directly to the brain—humor via incongruent sense data versus a purely mental synthesis.

What is even more stunning is when this effect happens unexpectedly. For instants, guys, when you're standing in the bathroom taking a whiz and staring blankly at some patterned wallpaper on the wall behind the can, your eyes may inadvertently cross and lock on points one pattern-width apart, causing the background to recede into space and the flowers, ducks, or polka-dots to jump off the wallpaper at you, causing a sensation (especially if you're stoned) that is somewhere between an amusing distraction and a quasi-religious experience. But, unlike a divine

vision, there is an *a posteriori* explanation (parallax) for this seemingly metaphysical event.

Such wonderment residing in the incoherent visual static on a piece of paper, is an incentive to re-examine all other mundane aspects of our world for strange things that, statistically speaking, must be dancing just beyond our senses, waiting to be aligned into reality by the simple cognitive shift of a glance askew. But then, that's not likely to happen until you least expect it because, to paraphrase Andy Warhol: 'It is absolutely axiomatic that a person won't get what they want until they stop wanting it.' So just cross your eyes and relax.

Humor Scene Investigation: An Owners Manual for the Laf-Graf Model 1300 Humor Analyzer—Gary R. Peterson, (iUniverse, 2004)

* * *

Letter to the Editor

Here's a letter I wrote to one of my favorite literary publications about art.

To the Editors:

I look forward to reading each new issue of *Art In America* more than ever, and Dave Hickey's column has become a destination for me. His recent comparison of the art market to the stock market ("Revision 5—Quality," Feb. '09) was engaging and only a tad snarky in its old-school renitence towards the flaccid foibles of "fairness" regarding art criticism and valuation. Anyone who can parlay a Fabulous Furry Freakism into a market barometer has my attention. Then again, I am one of those who might mistake a Titian for a Tintoretto.

I found his checklist for evaluating art to be quite utilitarian but there does seem to be one curious omission in his liturgy, namely, *who* is the artist of any given piece under scrutiny? I would like to think that it doesn't matter, but it must. I suppose a "name brand" work of art is assumed.

Though it's now clear that self-regulating markets don't cull the clinkers, I think the Wall Street parallel is encouraging. The market

abhors uncertainty and it's on the incalculability of art, like voodoo economics, that its market has tanked. The upside is that if and when the fair values are finally determined, there's a good chance that they won't be as bad as feared and—with a field narrowed by judicious selection—investors and collectors alike could be in for the mother of all rebounds. Meanwhile, I'll just hunker down and enjoy Hickey's ruminations and await further word from this streetwise arbiter of quality.

Gary Peterson
Troy, MI

I was pleased to read Mr. Hicks response to my letter in a subsequent issue. However, he has since vacated his editorial post at this venerated publication; ditto the editor-in-chief at the time. I hope it wasn't something I said.

Meanwhile, I must honk my own horn and cite the prophecy of my remark about "the mother of all (economic) rebounds" as evidenced by Sotheby's public stock price which, at the time was worth less than seven dollars per share but closed yesterday (two years later) above fifty bucks. Of course, if I was a real genius, I would have actually bought a few shares. As for investing in real art, you should only buy what you can live with; art that speaks to you. But it's not like I could afford the four million plus that Jeff Koon's polychrome barnyard menagerie *Stacked* sold for at the 2009 auction, recession or not.

Now, however, one can invest in affordable shares of individual works of art from renowned artists thanks to gallery/brokers like A&F Markets/ Art Exchange. I see they're offering to the public shares of, for example, a gouache painting by Sol LeWitt called *Irregular Form*. Ten thousand shares are being floated at $13 per share.

Now, I'm not being sarcastic—I'm quite intrigued by the marketing concept—but what if they actually cut the painting into ten thousand pieces and mailed the tiny squares, in various quantities, to the respective shareholders? This could enhance the value of the formerly intact painting even beyond the sum of its parts because of the possibility of the entire lot eventually being accumulated by a single investor/collector and reconstructed into the whole painting, which would lend an added conceptual aspect to the original piece. This approach probably wouldn't

work as well with, say, Old Masters paintings (Impressionists, no problem), but Sol LeWitt has been, after all, called the father of Conceptual art. Besides that, the minimalist piece in question isn't all that much to look at as it is.

<p align="center">* * *</p>

This Be Art

This is a test of my new style with words. I have a plan and I think that it shows. To start, I ask: What is art?

Art means to make, and do, and see things as new, not out of need but for want. All the works of art that have come first will give the next wave more worth, hence one adds to the past all the things that come next. Da Vinci shrunk his views right down to a point while Pablo P. showed us all sides at once. Yours should do what, and how, you see fit for the times.

Art shows us the truths that words can't say on their own, so let what is out there come in to your brain and then make a sight for sore eyes if that is what gives you a buzz. Go with what you know but take it out of the box. If you shine a strange light on the right stuff, your friends with think you are "rad," though your foes are sure to say bad. Just do it with soul and your mates won't mind that you did it at all.

If you're as smart as your art you will make it your own and yet others can think that it's theirs. The thing about art is, of course, that there are more ways to look at it than one. And one more note: All these words that I wrote—save for names and the one at the end—just for fun, all have but one syllable.

<p align="center">* * *</p>

Tripartite statements suffice

Any scenario can be summed up in three words, and it is an instructive exercise to do so. To compose a concise three-word sentence—one noun, a verb and an adjective—a writer must distill all aspects of the situation down to an elemental statement that conveys a pure essence. Like a fractal which comprises the big picture, this tripartite reduction is the core of any detailed description: a general proposition from which further deductions

can spring. Headline writers play this game with their tip-of-the-iceberg implications and stay-tuned ticklers—blurbs pregnant with meaning, or at least innuendo.

Three-word sentences would have complimented the monosyllabic format used in the previous essay (*This Be Art*) that informed us in dumb-down mode that *aesthetics exist objectively*, as if good and bad were ingredients baked right into the object: qualities independent of the viewers mind. *Pleasurably disinterested judgments* fortify that ruse. In actuality, the aesthetic agent is in the relationship between the work of art and the eye of the beholder. Still, a connoisseur at the Louvre, engaged in aesthetic judgment with, say, *Venus de Milo*, exalts at the figurative realism, the grace of line, form, and timeless beauty of Classical ideals and thinks, perhaps, in terms of *metaphysically embodied attributes* while the lowbrow standing next to him thinks "nice rack." Hey, can he help it if aesthetic judgments correlate to the *symbolically manipulated emotions* induced by *pleasingly proper arrangements* detected in a cingulated cortex of his brain? Just asking.

The words used in tripartite statements can be lengthy: big, fancy words with pretensions aplenty. Hyphenated words are useful as are prefixes and suffixes: the -ish, -ness, -ity, and -ables, that can morph nouns into verbs. Plus, the word "not" is a wild card that can be freely added into any existing three word statement without being tallied in the word count so as to negate the absolute value of a statement, e.g. "*factuality comprises truthiness—not.*" Neologisms are also encouraged; make up your own words if that's what it takes to convey a desired aesthetic—or cynicism. It's a method of crystallizing one's thoughts; something between formal logic—which are propositions that are either true or false—and fuzzy logic (set theory) which is a "more or less" proposition. Don't waste word count on singular articles such as "a" or "the" when plural nouns provide adequate generalizations but otherwise heed Grice's maxims, i.e. be concise, relevant, verifiable, and unambiguous. On a related note, a well-formed question is the first giant step towards its own answer.

This type of predicate calculus is fundamental to humor analysis as described in my book, *Humor Scene Investigation*, but it is also instrumental in detecting and filtering out the hokum that abounds on the Internet. That's important for vetting the blogosphere, not to mention social media, where peer review is a DIY proposition. I don't have much time for the nonsense found in most blogs (personal web logs) but my

tripartite reduction method can make quick work out of the conspiracy theories and other *preposterously convoluted obfuscations* rampant in today's contentious political milieu. Such is the following analysis of literary sump water sampled from the blog of a regular contributor at one of the many online art salons and clearinghouses. The name of said writer isn't important, but he rarely resorts to verifiable facts, or even falsifiable ones in the Karl Popper sense, when spinning innuendo for his readers. One particular fourteen hundred-word alarmist bulletin entitled *The Rise of Politically Conservative Art—Just Under the Surface* decries a perceived prejudice against what, I must admit, seems to me an inherently stodgy art faction.

From his online rant I extracted vague metaphors like, "The political heart of Conservative images are locked away by reviewers," and baffling conundrums like "Conservative viewpoints are rarely presented as visual dialogue pertaining to conservatism." I reduced the entire text down to the following string of tri-part sentences:

> Leftist art dominates. Critics ignore Conservatism. They're all Democrats. Let's git 'em!

In the final analysis, *propaganda supplants art.* Such fundamental misconceptions could be amusing if not for the growing movement to profligate such poppycock. And when I say movement, I mean a liturgical bowel movement with all the editorial splendor of a flaming bag full of Yahoo readers' comments. *Dimwits bloviate self-amusedly.*

I feel better. A *strategically abridged overview* is a verbal template by which one measures contextual meaning, a sort of tuning fork, the resonance of which gauges the fidelity of parts to the whole in any organization. A three-word proposition can portray character and convey a general argument. In the business world: *Objectives induce strategies.* The verb "induce" in this case provides both a semantic and conceptual link: it suggests inductive reasoning as a course of action. If an objective is known, a person then works backwards from that target to his or her current position, leaving bread crumbs on a single retraced path of action going forward. (Deductive reasoning puts one foot in front of the other not knowing where you'll end up.) *Specificity entails generality.*

I worked for a corporate think tank that was also a springboard to higher aspirations for gung-ho college grads and PhDs who would work

just long enough to get experience, acquire skills, upgrade their resumes, and then jump ship. *Aspirationally advanced attrition.* But I never shared with the board of directors that tripartite insight revealing the flawed corporate culture, the mélange of middle management at every level of that pyramid scheme, because, frankly, whenever some yupster defected, my stock would go up, being the highly motivated, multi-tasking, deadline driven, team player that I am—*not!* Worked like a charm for years until I assumed my lofty position at the Peterson Institute amidst the usual protests of nepotism. *Acquire transcendence, subordinates!*

Yes, a three-word statement is the scale of measure of my preferred analytical device. But why not just a single word—isn't that the epitome of efficiency? Indeed analytic philosophies like Wittgenstein's *Tractatus Logico-Philosopicus* attempted to give individual words the atomic powers of logic. But to answer the question in a word: structure. And in three words: Reductio ad absurdum. Three words can provide reference to an object, action, and property (and for the record, an object can be physical or a mental concept). As in our three dimensional world, we also find semantic stability on a geometric plane rather than a single point. *Verbosity emulates extensionality.* Meanwhile, the fourth dimension of time, or entropy, dictates the direction of a statement. It doesn't always work in reverse. For instance, the direction of the statement *"art reflects life"* is the natural progression and so countermands any notion that today's glut of "reality shows" are indeed real life. Observing changes the observed even if that entity is back-assward. Competitions that manufacture idols of song and dance, or doting celebrity interns to brash presidential wannabees, are more sport than art. Beware the feedback of a closed loop when art and life become trapped in that hall of mirrors. It can resonate like an emergent property and be mistaken for a valid new reality, at least until it collapses like a house of cards or a rickety economic carnival ride built on match sticks and convoluted derivatives after which the middle class rag-picks in the shambles of a downwardly-mobile scheme called the "new normal." It seems that the only artistic visions realized were those of scam artists.

Not to worry. *Quantitative easing stimulates.* Your dream home is now dirt cheap. Depression precedes prosperity. Conflict spawns innovation. Cool heads prevail. Art meets science. Boy meets girl. God is good. Life goes on. Peace and love. To paraphrase Einstein: *maintain elemental sensibilities.* In other words, keep it simple. We'll do fine.

* * *

Dale

I guess I was ten or twelve, flying through the air in the cramped cockpit of a Cessna 140—an old tail-dragger about as wide as a couple of shopping carts—shoulder to shoulder with the pilot: my oldest brother, Dale.

The engine roared while the hours passed like the ground below—slowly. We bucked a headwind for five hundred miles, from the Keweenau Peninsula to Detroit, occasionally threading knotholes in the cloud banks, landing to refuel once. During the flight, I watched my brother as he continuously surveyed the instruments, periodically pushing in a knob labeled "carburetor de-ice" that kept working its way out with the vibration, and glancing at the watch that he wore on the inside of his wrist so he didn't have to take his hand off of the control.

Nine years older than me, Dale was about as cool of a big brother a kid could have. He'd been flying since he was sixteen. Before then, he had a motor scooter and took me riding as soon as I was big enough to hold on. And there were always the pilgrimages north to visit the kinfolk. Over the years, he often took me along for the ride, and if not flying, then in whatever fast car he had at the time—a Thunderbird, a Corvette. Sometimes I'd get to skip school for a week. Back at home, if I was moping, he'd take me to the airport just to watch the planes take off and land.

Later on, he was a helicopter pilot in Viet Nam. He used to send home picture slides of beautiful landscapes and people and architecture. You'd never have guessed there was a war going on. He never said much about that but, although he made it back alive, he never really came home again, as the saying goes.

I'd grown up too—got married and started a family. Dale became an air traffic controller but his visits and brotherhood dwindled over the years. We always tried to get him to come over for dinner, holidays, anytime, but he was a loner at heart and left us all behind. Slowly but surely he disappeared from radar. No visits, no calls, no letters, and he made it clear he didn't want any in return.

I saw him only once in the last thirty years; he didn't even make it to dad's funeral. I practically had to get a court order just to get him to take his share of a small inheritance—something he said he didn't want or need

but finally gave us his signature to resolve the family matter. Never saw him again.

I got word just the other day that Dale had passed away of natural causes, alone in his apartment, early last fall.

Evidently, he'd put my name on a document many years ago and eventually I got a phone call from the manager of a self-storage unit asking me what I wanted to do with my brother's vintage Porsche. That's how I found out he had died.

Dale was a moral, ethical, and responsible person. He liked cats, homemade bread, bluegrass music, his BMW road bike and the open highway. He was a guy who gives the proverbial edgy loner a good name. But he died an unknown and was buried by the kindness of strangers using funds he'd left behind.

I'll remember the happy-go-lucky days, maybe dig out some old photographs, call my sister and try to track down my other brother. Meanwhile, I offer this meager eulogy just to let people know how I'll remember him. Rest in peace, big brother.

Dale R. Peterson
1943-2009

* * *

7. ART & HUMOR

Art and Aesthetics versus Humor and Laughter.

Art is aesthetic like humor is funny. It's the precarious balance of details that we appreciate. Both art and humor are illusions that often require a suspension of one's beliefs, but sometimes our expectations don't jive with reality. Art happens when things go right and humor happens when things go wrong. Either one involves a cognitive shift on the surface and/or in the content. Each must also provide an element of self-satisfaction.

There two types of humor: poetic and practical. Practical humor is when there's a glitch in the medium, as in the semantics of a joke like "the skunk that went to church and sat in his own 'pew.'" (Think "pee-yew!")

Linguist Noam Chomsky dreamt up the following sentence:

Colorless green ideas sleep furiously.

It shows that good grammar and syntax do not necessarily make good sense. In abstract art, such empty symbols are called *significant forms*. The human brain has feature detector cells that get fired-up only when stimulated by the sight of certain shapes and angles in a specific context or orientation. Hans Hoffman's painting *Rising Moon* for example is lyrical in composition but has no tacit meaning beyond the shapes (and the title which serves as a punch line). Abstract art is to representational art, as nitrous oxide is to a good joke. In all cases, reality is a chemical reaction.

Poetic humor (justice), on the other hand, has its glitch in its content rather than its form. It's often something ironic that could happen in the real world like an art critic slipping on a banana peel or let's say a clown dies and all of his friends go to the funeral in one car. The art of Richard Prince, such as his appropriated photos of the Marlboro man, is ironic.

Consider this Steven Wright anecdote:

> I put a blank CD in the player and turned it up full blast.
> The mime next door went nuts.

The pleasure here is in figuring out the breach of logic. In this case, a whole lot of nothing still amounts to nothing. There are parallels in the visual arts with Dada or Surrealism. Plug in your favorite Magritte, Dali, or Duchamp piece here. But what is it that makes the discombobulated works of Picasso and the Cubists aesthetically pleasing instead of flat-out funny? Perhaps there is more that is right about their pictures than is wrong.

Then there is the metaphor, a workhorse of humor. It is like the second half of an "if/then" statement. For example, *if* the meta-object "face" combines with the referent "moon," *then* the result is, "Her face lights up a room." A visual version of that glowing metaphor might include Amedeo Modigliani's *Portrait of Madame Hayden*. She is radiant.

An aesthetic judgment is based on the experience of pleasure without ascribing objective properties to the thing judged—art. The aesthetic value doesn't reside in the subject or the medium but in the agent that binds them together: your mind. It is a quiescent, self-transcending emotion that is farthest from passion. What the intelligence discovers, the emotions enjoy. Art strikes a chord that resonates on a wavelength to which your mind is attuned; call it resonance. It speaks to you in a good moral tone. One exalts, even rapturously. We view the artwork with empathy towards the artist, in a kind of "I know how you feel" moment (not a "been there, done that" moment).

Ancient Egyptian art seems cartoon-like to our modern Western eyes. Unlike the Greeks who sculpted the physical perfection of human forms, Egyptian art was all about depicting social rank. Likewise, the schematic flatness of pre-renaissance Byzantines art seems rustic, almost laughable to the less-than-astute. It is no wonder why some cultures don't like their deities depicted in any manner, because even the worthiest of artistic renditions has comic potential. But humor is a disposition: a mood. In the Dark Ages, the days before linear perspective, the human disposition was thought to be determined by the balance of four bodily fluids called humors, namely: blood, phlegm, black and yellow bile. This was an age where "doctors" (glorified barbers) would drain a quart of blood from a

man just to make him feel better. There was also a lull in art production during that period.

Laughter is caused by the sudden and favorable resolution of an anxiety. The endorphin-rush of laughter is a physiological reaction to humor. We yawn, we sneeze, and we laugh. Laughter is always triggered by an incongruity, whether it is real or just in one's mind. Granted, some laughter is social, mere posturing. Ditto with art snobs. Others laugh just to convince themselves that they are having fun. Fake laughter leaves a bad taste in my ears; genuine laughter has a musical quality.

If laughter is the symptom of humor, what do we call the basic vocal displacement activity for the aesthetic buzz, the "oohs" and "aahs?" What affectation, what physical paroxysm during a period of empathy or ecstasy signifies the dismantling of the emotive underpinnings of cognitions associated with the artwork? I'll suggest a new intransitive verb: "rapt!" That's short for enrapture. It's a reaction to the sublime: a prelude to tears of joy as opposed to tragedy which is comedy without the happy ending. Rapting! (Not to be confused with "the" Rapture of evangelical art.)

Intelligence and emotion are combined in both art and humor—but the sequence is crucial! Just like acid and water, adding one to the other can be inert or explosive. In humor, one is taken by surprise and must temper the emotions with intellect. It's called psychic inertia and the volatile reaction is laughter. But when appreciating art, the viewer is first intellectually stimulated—he or she elects to engage the piece—and then pours in one's own depth of emotions before rapting.

Hook me up to an EEG and show me a dramatic landscape, lovely portrait, or Bill Viola's *Isolde's Ascension*. If my alpha waves spike, then I'm probably rapting. The pleasurable feeling induced by art isn't exactly the euphoria directly achievable with drugs, but close enough. Art is pleasurable, but not pure pleasure. There are too many psychological biases involved in the perception of art. The anterior cingulate cortex is one area of the brain where opiates typically reduce stress and induce euphoria. Recent theories suggest that this same nucleus of gray matter factors into the appreciation of art by means of this pain relief mechanism. I'm reminded of a Gordon Lightfoot song that says:

> Sometimes I think it's a shame when I get feeling better
> when I'm feeling no pain.

I suspect that the neural substrates of laughing and crying—the insula, a cortex located deep in the sulcus fissure of the brain—conjoins the thalamus to the highly emotional amygdala in the limbic region (near the hypothalamus) that I call the *humorsphere*. Before our cognitive faculties kick in, the amygdala interprets any novel scenario to determine an appropriate emotional response. In case of humor, it calls to the septal area of the nucleus accumbens for some of the hormone called dopamine to plug the gaps where fear of the unknown (novelty) has filtered in. But when confronted with art, the dorsolateral cortex in the prefrontal lobes inhibits the amygdala in favor of the hypothalamus. The promise of self-transcendence thereby stimulates the anterior cingulated cortex for the aforementioned serenity in the afterglow of an aesthetic judgment: rapture. It's that junction of the brain through which memory circuits converge with the traces of one's life experiences that are pertinent to the pretty picture.

Well, that's it in a nutshell without all the axonal dendrites and ponderous arithmetic. For those who are still unclear on the concept, here are a couple of reliable indications that you are looking at great art: You are transported to a different time and place simply by gazing at it, and/or you hear yourself smiling.

In the meantime: Picasso, Einstein, and Elvis walk into a bar. The bartender says, "What is this, some kind of a joke?"

* * *

The Paroxysm of Laughter

It feels good to laugh but laughter is contagious and addictive. Humor should be treated like a controlled substance. After all, it is the leading cause of laughter—real laughter. I'm talking about spontaneous, involuntary spasms of genuine mirth. Artificially induced chortling needn't apply.

Laughter is caused by the sudden and favorable resolution of an anxiety. Humor is the ugly sister of art, the one we exhort instead of exalt. But some art—like Yue Minjun's toothy self-portraits, or even ancient hieroglyphics of people with cat or bird heads—can make me laugh. Music is more apt to make me cry.

Laughter is an effect, not a cause. It is a reaction to, and a symptom of humor. Again, we yawn, we sneeze, and we laugh. Laughing is a physical

paroxysm that is good for the heart due to stress relief. So this chucklish endorphin-rush is indeed a tonic to many mental and physical maladies but the quality of humor that uncorks it varies as widely as Bordeaux to Boone's Farm, or in artspeak—da Vinci to Dilbert.

Some people laugh only to signal their superiority in a social pecking order. I just let these connivers twist in their own wind. Others laugh to convince themselves that they are having fun. This too is fake laughter and, like canned laughter, grates my ears. Genuine laughter has a trenchant musical quality like Aristophane's Frogs versus, say, Kermit.

Humor is where it finds you. Be happy when it does, but don't try to summons it at will. It cheapens the effect. Maybe we should all just learn to relax: Meditate, do math, or paint a mustache on Mona. Can you touch your nose with your tongue? Pleasure has more manifestations than just laughter. One can chill without the venting action of laughter. If your disposition is good, humor will find you, like those cute little munchkins in Francois Boucher's painting, *Putti with Venus*. If you're really funny you may even get lucky like Toulouse-Lautrec; laughter has a charitable effect on people.

Humor can be an art form, so don't compromise it by cackling at every irony, pun, and bodily function. A sense of satisfaction will soon supersede the honk-fest of social laughter. Never laugh at your own jokes and there's no need for bloggers to write "lol," so knock it off. (Ha!) Your wit is an indication of creativity and intelligence whereas unbridled laughter at anything and everything can dim one's wit. As Don Quixote said:

> Nothing is as foolish as the excessive laughter over a slight occasion.

Then again, he jousted with windmills.

Beware: Humor is usually based on someone's misfortune or shortcoming so your laughter is sure to offend someone. Of course, that may very well be your intent. Humor is a quick fix of poetic justice like David slaying Goliath. (By the way, have you seen the hands on Michelangelo's sculpture of David? Those mitts are huge!) At other times, it is just the ego gratification of solving a pun or riddle, i.e. "getting it." But if your ego, urges, or vanity feeds a laughter addiction, then the underlying anxieties may grow to be more serious than can be laughed off. Or not.

Laughter is a good thing but it is best when it sneaks up on you. It's that highly coveted kind of spontaneous hilarity that makes your face hurt and beer shoot out of your nose. So go ahead, let a smile be your umbrella—but plan on getting wet every now and then. Meanwhile, laugh responsibly.

<p style="text-align:center">*　*　*</p>

Going to the Doctor

Buck and Edith were empty-nesters living on the outskirts. He was a semi-retired tunesmith who, aside from the ringing in his ears, enjoyed good health so far in his life and thanked God for it every day.

One night Buck's ears started ringing again. He answered the phone on the bed stand, but all he heard was a dial tone. He didn't know what to believe. In the morning as he and Edith watched the squirrels over coffee, he said, "The ringing in my ears is driving me nuts." The herbal remedies weren't working.

"Go see a doctor" said Edith—a wonderful wife, mother, and travel agent, "It could be a symptom of something serious—very, very serious." She was also a hypochondriac. Buck was "old school" in the "not broken, don't fix it" vein, and rarely went to the doctor. But he made an appointment with a general practitioner and—thanks to a cancellation—he was in the parking lot of the clinic the next morning, walking towards the newly designed-by-committee glass and pre-cast, faux marble building, with a host of other early birds amidst the clatter of crutches and oxygen tanks. He took the stairs (whenever he can) to the third level where, glimpsing patients and staff through the window-lights along the corridor, he finds the suite of Wang, Larco, and Dharntutian, MDs.

The vinyl, Dacron, and Formica clad waiting room—all decked out with colorful prints of flowering meadows interspersed with musculo-skeletal diagrams, sinus cavity sections, and know-your-polyps posters on the walls, and golf magazines on the end tables—is nearly full. Buck isn't enthused until the attractive young receptionist asks him to sign in. He flirts with late-middle-aged bravado with the girl who humors him as she repeats insurance questions into his ringing ears. He finally sits down in the corner under the TV, feeling pretty cavalier. She calls his name an hour later.

<p style="text-align:center">123</p>

Buck thinks maybe his blood pressure is high and the doctor will simply prescribe some medicine, and he can get back to feeding the squirrels and listening to the birds, ring free. But of course there are procedures. He is weighed, interrogated, stripped and placed in solitary confinement to wait for the doctor in another synthetically sterile room, except smaller with bio-hazard containers, tongue depressors, and harsher lighting.

Within a half-hour, the doctor—a man looking no older to Buck than his youngest son—walks in with a clipboard, makes some small talk and looks into his ears, nose and throat.

"Do you drink?" the doctor eventually asks.

"Red wine with dinner," Buck replies.

"Chianti?"

"Sometimes."

"That can make your ears ring. Try Cabernet. Smoke?"

"No thanks."

"I mean, do you?"

"Once a day whether I need it or not," Buck informs him.

"Quit. How's your sex life? Everything working all right?"

"Fine, but I'll be telling my wife you prescribed more sex."

"Ha! I'll put that in writing for you."

The doctor reads his blood pressure and tells him that it's normal. Buck is heartened. But then the young medico starts poking him with needles; booster shots and whatnot. The next thing Buck knows he's giving blood. Then the kicker.

"I'm going to do a DRE," the doctor says.

"Huh?" says Buck, and not because his ears are ringing.

"A prostate exam" he clarifies, snapping on a glove. "Just lean over the table and relax."

Buck complies, thinking—I've always wondered how that wo . . . OH! "Was that necessary? I'm here for ringing in my ears you know."

"Oh yeah, tinnitus. People your age get that a lot. Get used to it. I can recommend a specialist if you'd like."

"No, that was special enough. I'm just glad my blood pressure is good."

"Buy yourself a blood pressure monitor and keep track of it at home. Meanwhile, fill this cup with urine and give it to the nurse on your way out. The receptionist will have a few items for you before you leave."

Buckminster uses a tissue where the doctor had dared tread, and then pulls up his pants. He gives the nurse her due and proceeds to the reception area. The girl at the counter looked different now. The whole world did. He knew that she knew that he had just been violated. To add insult to injury she hands him a handi-pack for three days worth of stool samples. Then she schedules him for a colonoscopy.

"You know, my ears are so much better now. I'll get back to you on that," he promises and, walking gingerly, beats a hasty exit.

The next evening, Buck and Edith are playing pinochle with another couple, Jerome and Betty. They are drinking Cabernet and, between hands, taking turns cuffing each other with Buck's new blood pressure monitor. "I couldn't believe it" says Buck, "I go to the doctor for ringing in my ears and the next thing I know he's sticking his finger where suppositories don't even go. Then his assistant starts passing out poop sticks and party favors."

"Big deal," says Jerome—a man who has heart surgery as often as Buck visits the dentist. "I've had doctors put both hands wrist deep in my chest, and you're whining about a single digit up the wahzoo?"

"That's just what they do," chimes Edith, "and you should go for that colonoscopy too. I did."

"Of course you did. But Dr. D. called this morning to tell me my prostate was good and my cholesterol was excellent. That's all I needed to hear."

"Are your ears are still ringing?" Betty wonders.

"Yes—and it doesn't bother me a bit."

"See? Aren't you glad you went to the doctor," says Edith.

"Right" says Buck, "Now pass me the pressure cuff. Who's got low score?"

* * *

No Laughter in Heaven

There is no laughter in heaven. Here's why. Humor can be summed up in three words: *Somebody else's problem.* Humor needs a victim, the butt of any joke. This malfeasance of humor sparks a sense of superiority in others, which in turn fuels their laughter. Even puns and riddles have a victim, and sometimes the victim is you. We admire those who can laugh

at themselves, but if you've ever felt the pain of humiliation, then you won't miss the spiteful howl of laughter.

Laughter is a quick fix of justice, and justice is but a quick fix for the eternal bliss of heaven. Justice is revenge, but the Lord sayeth, "Vengeance is mine" which means in heaven there's no one to laugh at. And besides that, the Golden Rule—"Do unto others as you would have them do unto you"—pretty much nips humor in the bud.

It's been suggested that Jesus had a sense of humor. For instance when, in his Sermon on the Mount, he sarcastically (and metaphorically) said, "Cast not ye pearls before swine." Not a big laugh-getter even back in the year thirty-something. Thank God he wasn't sent here to be a comedian but rather our Lord and Savior. Cheating death can be a real knee-slapper for mortal man, but if you're in heaven, then you've transcended that earthly predicament. And by the way, folks—you know those Ten Commandments? Sorry—no joke.

Heaven isn't just a big rock candy mountain; it is total peace of mind. No laughter is necessary because there is no pain or sorrow to make it relevant. Puns, parody, and poetic justice all culminate in the most sophisticated "humor" of all—the rapture! This means joy to an extent that we cannot imagine here on earth: heavenly bliss that the human mind can't even comprehend. Consider that "happy" is as good as "funny," then multiply it tenfold.

Now, even I have some reservations about an afterlife without laughter, assuming I make it past the pearly gates. It's conceivable that once a month, maybe on a Saturday night, one angel is selected to, oh say, make a prank phone call to the devil:

> Hello, devil? Is your toilet running? Better go catch it!"
> (click).

But I doubt it. And what about squirrels? They're funny. I love to laugh at squirrels. I hope there are squirrels in heaven. But will I still have dominion over them? I suppose if the lion will lay with the lamb, then we can all live with squirrels. Of course there will be no need for alcohol, pot, or laughing gas (sex is another discussion), but once again—the rapture of heavenly bliss will eliminate the need or the desire to laugh, or to partake in any meager activities that promote such foolishness.

Meanwhile, as long as we're still doing time in this world—did you hear the one about the skunk who went to church? He sat in his own *pew!*

<p style="text-align:center">* * *</p>

The Skunk That Went to Church: Humor Analysis.

I was at a potluck supper at the church when the reverend leaned over my folding chair and told me the skunk joke mentioned in the paragraph above. I laughed politely, but I prefer humor from certified comedians. Clergyman should offer homilies, not homonyms. Don't get me wrong, Reverend Blauffaert is a cool guy—stops by now and then to borrow my belt-sander and talk theology, the Nicene Creed and whatnot. But that skunk joke echoed in my brain like a pop-song. It was like trying not to think about a blue nun or a holy mackerel. So I ran it through my Laf-Graf Model 1300 humor analyzer. Sure enough, it turned out to be a matter of semantics. That verbal quip hinged on the double meaning of the word "pew." Did the skunk sit in his own "pew" meaning bench seat, or his own "PU" as in bad odor? The answer is, of course, both. It was a play on word—a pun!

I trust you've read the preceding essays on art, humor, and aesthetics so I won't cover too much of the same ground, but the parallel between humor and art is form and essence. There are two types of humor: "practical" versus "poetic." Practical humor means a glitch in the medium that makes the message ambiguous. Poetic humor, on the other hand, is real-life irony: poetic justice. In art, the surface provides the optical illusion that conveys a message or tells a story, be it comic, tragic, or just anecdotal. The narrative beneath the surface is, in this case, about a church congregation dutifully accepting their new member—insufferably, by the looks on their faces. Figure 17 isn't a visual pun or optical illusion per se, but merely an illustration of the literal content suggested in the ambivalent semantics of the joke.

In a book review of Richard Wollheim's *Art as Representation and Expression*, David Hills of Stanford University cites the duality of visual form and content thusly:

<p style="text-align:center">127</p>

Gary R. Peterson

> . . . there is a sense in which a detailed point-for-point
> comparison between them is out of the question: seeing-in
> and the simpler experiences to which it is in various ways
> analogous are 'phenomenologically incommensurate.'
> (Painting as an Art—Princeton University Press, 1988,
> 47) Such, Wollheim thinks, is the 'twofoldness' involved
> in seeing-in. A painting 'represents' a given subject matter
> when we are retrievably intended to see that subject matter
> in its surface and can indeed do so.

Man oh man; remind me to read *that* book sometime.

I pondered the social implications of the skunk scenario and reconciled the use of humor in church. Along with all of the singing and dancing, guitars and hand bells, spotlights and theatrical hoopla, it helps keep the faithful from nodding off. After all, it was Jesus who quipped about stuffing a camel through the eye of a needle. He was being just a little sarcastic, no? More proof that the Good Lord has a sense of humor. But as for The Golden Rule? Still no joke.

Figure 17. *The Skunk that Went to Church*

* * *

Incongruity Theory

When two trains of thought collide, it can cause a brain wreck known as humor. Incongruity theory describes what happens when two lines of reasoning intersect on a single word, such as: "I just *flew* in from Detroit. Boy, are my arms tired."

When our expectations go astray, we are surprised. If the surprise is pleasant, then we laugh. For example, a man is sitting at a bar when a woman with a Border Collie under her arm walks in and sits down next to him.

"That's a fine fox you got there," he says.

"It's not a fox, it's a dog," she replies.

"I know. I was talking to the dog."

Ha! I thought the man was talking to the woman too, but then, bang—a sudden perceptual shift. Not a problem, I laughed it off. Philosophers through the ages have commented on this aspect of humor. Plato called it "impotence masquerading as fate." Immanuel Kant called it "a strained expectation reduced to nothing," and Henri Bergson cites "the mechanical encrusted upon the living" as the formula for laughter. Incongruities, all.

Incongruities can be detected by any of the five senses. There are *visual* puns like cartoons and optical illusions: things that look like they're not; and *audio* bloopers like Victor Borge playing the *Hungarian Rhapsody*—or even just a whoopee cushion. There are incongruities of *touch* like tickling or hand buzzers, and even of *taste* and *smell* like, say, Raclette cheese: smells bad, tastes good.

Humor also has a superiority aspect, the sense of satisfaction derived by elevating one's own status over others. I recently overheard a verbal exchange where one insult curtailed another. A man in a bar started telling a "dumb Slobovian" joke. The bartender interrupts and tells him, "Hey, those two guys next to you, the other two at the end of the bar, and I myself am a Slobovian. Do you still want to tell that joke?" The man carefully rethought his position and decided, "Never mind. I don't want to have to explain it five times."

Even just the self-satisfaction of solving a pun or riddle can provide some degree of both the incongruity and superiority necessary for humor; rarely is either sufficient on its own. Anything that triggers laughter will involve an incongruity, whether in a real event or a misconception in the mind. Sometimes it's a premise or pattern that is broken, like when the priest, rabbi, and mullah walked into a bar and the bartender said, "What is this—some kind of joke?" Yep, that's a joke about a joke.

Incongruity is also the basis of creative processes such as invention, discovery and aesthetics, but more often than not, it's just a false alarm that we can laugh off. It's all very subjective: Beauty is in the eye of the beer holder.

Figure 18. *Laughter is caused by the sudden and favorable resolution of an anxiety*

* * *

A Book Review: Humor Theory—Formula of Laughter by Igor Krichtafovitch (2006, Outskirts Press, Inc.)

Psychoanalysts aside, there are two main camps of humor theorists: Incongruity and Superiority. Igor Krichtafovitch, the author of *Humor Theory—Formula of Laughter*, is a proponent of the latter—with a bullet! He views humor as a "weapon" used exclusively to gain social status.

131

In this book, he randomly quotes or references more than 125 diverse scholars, scientists, humorists and politicians (many of them Russian), but his claim to "unite and make peace" and "tie their assertions into a unified whole" is unrealistic. There are just too many contradictions to reconcile. For instance, on page 80 "humor exists as an objective phenomenon." On page 81 it "doesn't exist outside of the human factor." Even the term "humor" is alternately defined as "the comic," "the funny," and only occasionally as the more definitive, "the laughable." The most tenable statement after the first 44 pages is, ". . . laughter exists independently of our wishes." That is the bedrock of any rational humor theory. The spontaneous physical paroxysm of mirth, i.e. laughter, provides the starting point for further deductions; it is palpable evidence of genuine humor as opposed to the egoistic horn honking of social (false) laughter and the submissive posturing that superiority based "humor" breeds.

Krichtafovitch's claim that the 1/7th funniest segment of the population is destined for leadership is a compelling, if amusing statistic. He also concludes that "humor" is a necessary function for the survival of the human race—no less important as food and sex, and that "a sense of humor is built into us like the homing instinct is built into sperm." Then quoting A. Dimitriev, ". . . 90% of anecdotes heard and recorded in preschool and kindergarten have to do with politics and the world," (no examples given) that portends their advance in society (in the former Soviet Union, I suspect). Growing up in a historically feudal based culture (landowners vs. serfs) may tilt the "purpose" of humor to procuring class, status, and power. Stalin would have been a shoo-in on the TV talent show, Last Comic Standing. Krichtafovitch conveys a good anecdote about a patient in an army hospital who is the constant butt of jokes until said patient reveals that he is a colonel. Suddenly he's the funniest guy in the ward; more proof that it's the singer, not the song.

If humor is indeed a "weapon," Krichtafovitch seems most content to analyze the proverbial "warrior"—the joke teller—more so than the "wounds" inflicted. But even superiority-based humor, at some point, boils down to reflex, a chemical reaction in the human brain. Therein lays the secret for any politician, dictator, or circus clown bent on world domination. Fortunately, Dr. K does address the cerebral aspects of humor and provides some of the most salient paragraphs in the book with the formal descriptions and mathematical calculations from the likes of Miroslav Voinarovsky and G.A. Golitzin regarding the mechanism of

suddenness of recognition and resolution of a logical incongruity by the brain. Unfortunately, Krichtafovitch's own logic is sometimes fuzzy and his calculations obscure. Too often the deductions that he repeatedly calls "clear" "obvious," and "evident," are none of the above. He mentions, for instance, that "the expression 'Management jokes' is well known to us" (who is us? not me!) and refers to its "short formula" but never reveals what that is. His methodology includes Russian folk wisdom, instinct, and more leaps of faith than *The Da Vinci Code*.

That brings us to Krichtafovitch's formula of laughter, which does seem to include all the necessary ingredients for the detection of "humor." His equation is

$$EH = PE\ (C/Tp) + BM, \text{ where:}$$

EH is the effect of humor, which he regards as the degree of advancement in social status of the narrator, relative to the audience and to the butt of the joke. The maximum value of one unit of laughter is arbitrarily assigned to this result. It doesn't get any funnier than that.

PE represents the empathy factor of the audience. It amounts to the emotional investment projected onto a humorous (disparaging) circumstance due to ones affiliation with the victim: A measure of poetic justice, if you will, also arbitrarily set in the range between -1 to +1.

The variable **C** represents the complexity of the "riddle" (incongruity) that is found in every instance of humor, and that triggers (disjunctor) the resolution sequence over a relatively short time, Tp, the brevity of which amplifies the level of satisfaction and personal pleasure attained by the individual problem solver. This "magnitude of impulse," a concept with many parallels in physics, is one of the better-conceived aspects of Krichtofovitch's formula, no doubt due to his background as an electrical engineer.

BM is the background mood, the general predisposition of the listener such as willing, contentious, receptive or drunk, which will enhance or detract from the humorous effect. The last two variables are kept in the range of +/-.5 so as not to exceed the absolute value of EH.

The downside to the formula is that the value of EH, social status, is slanted in favor of the joke teller in this popularity contest. The book repeatedly asserts, "An orator laughs at a joke he knows well with greater pleasure than the audience" (pgs. 37, 81, 87). This makes the formula self-referential because one cannot surprise oneself (or tickle oneself). Furthermore, the orator is given the power to "change the sign" from negative to a positive PE factor, a defensive mode whereby laughing at oneself serves to elevate his own status. The orator always "wins" such a hierarchal preponderance.

Krichtafovitch points out that the above values are arbitrary and subjective. This allows social advancement EH to be attributed to laughter. The measure of C does prescribe an "informativeness" factor: the efficiency of framing the problem for maximum humorous effect. One must also account for the IQ of the audience. And timing, Tp, must not be confused with the element of surprise, the "suddenness" which triggers the "fight or flight" instinct. Krichtafovitch undermines this important aspect proclaiming that it is always funnier if the audience is "warned" that a joke is ensuing. As for BM, mood rings from the jewelry department of any novelty store could be numerically calibrated by color, although today's technology, including MRIs, EEGs and other lie detecting hardware, promises an even more accurate measurement of disposition.

Krichtafovich's equation can, of course, be reformed to solve for PE instead of EF, for instance. But I could not understand what the quotient EH/(PE • C) is supposed to signify, and why it suddenly appeared as the de facto template for each of 16 examples given towards the back of the book. As a given, the timing was set to a constant of one second, and the mood factor was dismissed as negligible for the "lone" reader. Which brings me to dispute the supposition that "a lone man never laughs," attributed to Henri Bergson, and that "the purpose of humor as a phenomena consists precisely of one's advancement up the social ladder and none other." What of those who drink alone and laugh at squirrels or the occasional potato chip shaped like an ear? Their mirth is at least as genuine as that of any social climbers tickling each other's fancy. When, Krichtafovitch quizzed individuals as to whether they ever laugh in their sleep, the answer was unanimously no. His conclusion: That's because there is no one to laugh *for*. I contend that humor is anywhere it finds you and serves no purpose. Granted, as he quotes Dmitriev, "The recognition by the crowd . . . brings the raconteur incomparable satisfaction." I suspect that any public speaker

would agree. As Krichtafovitch emphasizes, there is no humor completely independent of the social aspect. To his credit, the book gives sufficient consideration to the syntax, economy, and critical placement of key words when scripting the optimal joke or narrative. This process demands a precarious balance and perfect timing.

The final chapters address nonsense humor and relegate it to incongruity recognition and the sense superiority it instills, and later acknowledges the link between humor and the arts: the ridiculous and the sublime. Also the book cover is worth noting. The image of the Mona Lisa with her smile stretched tautly with string and tacks is disturbing, but at least visual humor (attempted) is represented in a forum where verbal and scripted humor predominates. I found the writing style in this book to be a bit stilted, perhaps a consequence of its translation from the original Russian, but in the end I learned something about humor and about myself. I must become more aggressive in my daily dealings with my fellow man, and will henceforth strive—thanks to Igor Krichtafovitch's effort—to always get the last laugh.

<p style="text-align:center">* * *</p>

8. ART & TRAVEL

Travel destination reviews: Venice, Italy

A waterbus ride from the airport initiates the adventure in this romantic and historic intersection of Roman, Byzantine, and Moorish cultures. Take a water taxi directly to your lodgings if possible. For one thing, an excursion on this beautiful mahogany watercraft is as spectacular, if not as intimate, as the fabled gondola rides (which remind me of a theme park ride where you are on display for the throngs that line the sidewalks along the canals). Besides, the cobblestone streets and constant bridge crossings are not conducive to dragging baggage even if you've got little wheels on them. I don't know much Italian, but by the time my wife and I found our hotel, I overheard a woman—who saw me drenched in sweat—say, "Che dolore!" What a pain is right, signora. But a sweet misery indeed: we were in Venice!

We stayed in a bed and breakfast that served as the Russian embassy a hundred years or so ago. Of course, there is much marble everywhere and décor as lavish as the scenery. But an unexpected highlight—and that is my favorite kind—was the coffee in the morning. So *that's* how it's supposed to taste. Sensazionale!

The sun lends a unique and splendid color to the awe-inspiring architecture and geography of this floating city. It was particularly hot during our summer visit, but a forgiving breeze off of the Adriatic seems ever-present to caress your face no matter which corner you turn as you walk (eat, shop, explore) along the canals.

Art and fashion abound in this expensive town, but the panhandlers and vendors are as assertive as any I've encountered—annoying, but never a problem. The merchants are friendly in the shops and venues. Most speak enough English and, unlike the French, they don't demand that you speak their native tongue to make a transaction. I enjoyed just buying a pair of socks. The neighborhood grocery store may prove a bit less cordial, while

you practice your Italian, to tourists who wander away from the crowds. But then again, I recommend doing just that. I suspect that snippy young cashier at the drogheria was just having an off day.

A great pleasure for me as an artist, was taking my sketchpad to a picturesque spot, which means anywhere you look, and drawing with my box of watercolor pencils, a Q-tip, and a bottle of water. I stood on the Ponte dell'Accademia and rendered the scene looking over the Grande Canal towards the Basilica di Santa Maria. I'm happy with the way that picture turned out, but as gratifying was the process itself. Over the course of an hour or so, my eyes necessarily absorbed the details that the casual observer glosses over; the flags, flowerboxes, verandas and architectural adornments that can otherwise go unnoticed. I also drew the attention of curious passer-bys, not to mention the other itinerant artists who seemed well aware of the new kid in town. The sketches from our vacation in Italy are my most prized souvenirs. But just the inspirations, the memories and indelible images in my mind's eye are treasured.

I must mention the pigeons, the piazzas, Santa Maria Gloriosa dei Frari (if you could only visit one church . . .) and Doges Palace & Bridge of Sighs—the penthouse of all medieval political prisons. These and all of the other "must see" landmarks that you will read about elsewhere really are as fantastic as everyone says. In my humble travels, Venice is as memorable as any destination I've been fortunate enough to visit.

* * *

Florence Between the Lines

I had just finished reading that medieval epic *Dante's Inferno* when these words took hold of my mind:

"Ché la diritta via era smarrita"—I had lost the path that does not stray.

Like an acid flashback those words turned into an obsession. It wasn't the deeper meaning but some hidden meaning that vexed me. So I left for Italy with my brilliant colleague and travel guide Elizé—a Scottish lass whose legwork can compliment a plaid miniskirt like nobody's business—to locate the source of my mental melodrama. We ended up in Florence.

"Why do we call it Florence when the natives call it Firenza?" I wondered aloud as we made our way down the narrowing streets towards the ancient part of town.

"It's like da Vinci's *La Gioconda*, or as it is known in English, the *Mona Lisa*. It must be some sort of code!" she said sarcastically alluding to another best-selling novel of contrivances.

It was Dante Alighieri who made the Italian language viable with his fourteenth century blockbuster, *The Divine Comedy*. But that book wasn't funny either—well, except maybe in Canto XXI where Barbariccia signals his demons to march, by tooting his butt trumpet ("ed elli avea del cul fatto trombetta"). I chuckled as I plodded along looking for clues, a street sign perhaps along la via stretta.

As we walked, I saw women on scooters clutching purses between their knees and men clad in black leather arguing about politics as if the heat wave that enveloped us was all in my mind. My nervous excitement turned to paranoia as I looked over my shoulder and saw a man with a hash pipe the size of a battleaxe. I said to Elizé, "Don't look now, but I think we're being followed by the Hashanista. She looked anyway and said it was just a Dan Brown look-alike dressed in some kind of festival garb.

"O.K., but what is the etymology of the word 'assassin?'" I challenged her.

"I don't know. Asinine? Hallucination?" Wrong.

Throngs of tourists spilled through every street and archway. We saw Michangelo's *David* in the Gallerie d'Academia and again in the piazza, but he couldn't answer my questions. Nor were their any clues at the Uffizi or Ponte Vecchio, but I sensed I was getting closer. I checked the souvenir stands not even knowing what I was looking for—but I did buy a Caravaggio print. Man, could that guy draw or what? A real Mannerist. Suddenly we turned the corner and saw a spectacular doumo.

Elizé covered her shoulders and knees and we entered the Basilica di Santa Maria del Fiore. The magnificence, the history, the devotion of the ages expanded my mind to the volume of that domed ceiling cavity filled with a spiritual resonance. I spied a painting of Dante, but I still couldn't formulate my question regarding the splendid edifice, something about a pathway leading me out of the Dark Ages. Perhaps a ghost? Who ya gonna call? Virgil? Beatrice? The Holy Ghost? Surely, He's the "true path," but I'd made peace with God long ago. That wasn't my mission. Was the answer in the Codex Rustici? Giotto? Donatello? Arnolfo di Cambio? So close,

but the walls were closing in, so I retreated past the architect Brunelleschi's tomb near the entrance and back into the blazing sun outside of the massive doors.

The tourists were amassed, bumping and shooting each other with camera-phones. I bobbed and weaved my way out of the line of fire. I got so disoriented looking up at the angels in the architecture that you could have called me Al. Then it hit me.

A great divide of sorts presented itself to my eyes. There was a visual labyrinth, a maze in the façade: a mystery that revealed itself like a road map as my eye slowly gravitated from the high parapet and meandered towards its conclusion in the swarming humanity on the portico. I whipped out my sketch pad and rendered the line drawing you see here (Fig. 19). I had found the pathway I was looking for. It divided the façade into a two-piece jigsaw puzzle

I pointed it out to Elizé and she stared silently for a moment. "You're the only one who can see it" she said. That was probably so, but not any more.

How I detect labyrinths in the ornaments—or why—is beyond me but I feel better now. The way my eyes cascaded down that Gothic facade has changed the way I look at things. And, incidentally, you can likely still buy a print or even my original pen and ink drawing of that basilica at: www.garypetersonart.com. Prego!

Figure 19. *Basilica di Santa Maria del Fiore* (a maze)

*　　*　　*

A Secret Louvre Affair

I went to the Louvre some time ago, that fancy art museum in Paris. The details are sketchy now but I remember my wife Elizabeth (a.k.a. Elizé) and I walked along Les Tuileries past a giant Ferris wheel and a gold statue of Joan of Arc. Not to be all touristy, we went past I. M. Pei's glass pyramid at the Louvre and in the side street entrance.

I was on a mission to see just one painting: Jacque Louis David's *Oath of the Horatii*. I'd seen it in a picture book and even did a sketch, but aside from that painting I didn't care about anything else except avoiding crowds. I didn't need to see *Venus* or *Victory* or *Liberty*—and certainly not the *Mona Lisa*. No maps, no guides, no headphones. And no Mona! That would be typical. I'd hate to be typical. I don't run with the pack. I'm a contrarian.

Elizabeth had her own agenda that started with the gift shop so I took off to find David's *Oath*. Sure, I saw some famous artworks on the way: Gericault's *Raft of the Medusa*, that desperate shipwreck of a painting, and Ingres' *Odalisque*—she with the serpentine spine. I saw pictures of revolutionaries and aristocrats aplenty as I searched the galleries until, bam! There it was, the *Oath of the Horatii*—that big old Neo-classic masterpiece: a picture painted in 1784 after a story told in 0 AD about an event in 660 BC. It was big and manly, potent and heroic, a fraternity of brothers ready to fight the enemy. That was a favorite theme in Revolutionary France, and with their penchant for antiquated morals, this Roman scenario fit the bill. The painting shows Horatius handing out swords to his three sons who were all jacked up on a "let's go get 'em" trip against a clan from Alba while their women whined about the coming rumble. Me, I'm just thinking, like, "Careful, boys—or somebody's gonna lose a finger." So, yeah it's a pretty awesome painting. Mission accomplished.

I was backpedaling away from that heavy scene when I stumbled blindly into another gallery where I was caught off guard—taken by surprise. I suddenly sensed a force field, a magnetic presence in the room. I turned and there she was, holding court over her subjects, presiding from her elevated position over a flock of adoring fans, onlookers all agog, buzzing like bees, snapping pictures and clicking devices as if she was giving a press conference. Calm and confident, she knew how to make a statement, how to win a popularity contest. All eyes were on her. Mona Lisa.

In spite of myself I was drawn by her countenance to the outer fringe and flux of her followers. She was radiant, well-modeled in form with hot and hazy contours—sfumato I guess they call it. Smoke got in my eyes. Then our eyes locked and she followed me as I inched through the crowd. She smiled at me. I wasn't sure at first, but yeah—it was definitely aimed at me. Her beauty was way more than skin deep. It reached down to the very soul—mine. My heart raced. She tried acting all coy and demure and stuff, but we were having a moment. I nodded and she winked. She was beguiling and I was smitten. I drew closer and closer and finally confronted her and right then and there, with her back against the wall, we consummated our impulsive affair. We sublimated. That's right—we had an aesthetic interlude, Mona and me, in front of a crowd of onlookers and security guards. What was I thinking? We parted just as suddenly as we had met.

I caught up with my wife. She'd been browsing, people watching, checking out her own cast of bronze and marble stud muffins. The next thing I know, we're in a café dining on chateaubriand. I was feeling guilty and pondered the wisdom of telling her about my secret rendezvous with a woman not nearly as beautiful as she is. But how to tell her? "Hey honey, guess who I bumped into" or "You'll never guess what happened in the Louvre." What a putz I'd been—a typical tourist seduced by paint on a poplar panel! Now I'll have to admit it to Elizabeth, 'fess up to the whole psychic affair. But then, it's not like Mona was going to be blabbing anything to her husband Francesco. What to do.

"Garcon" I said, "Bring us a bottle of La Gioconda—I mean *Gigondas!*"

* * *

Reflections on a French wine: Vacqueyras

While we were in France, we took a train south. One evening we sat on the patio of a chateau in a vineyard near the town of Vacqueyras, enjoying a meal and a bottle of red wine. The gazpacho was a stone cold knockout as we watched a field mouse scurry about. These are some of the memories in a glass of Vacqueyras—the sights, the fragrances, kids playing, bells chiming. But even back at home in the burbs, a glass of Vacqueyras can

make my neighbor's lawn mower hum like a hurdy-gurdy and the crows on the power line look like cockatoos.

Vacqueyras is near Gigondas and not far from Chateauneuf du Pape in the Cote du Rhone region of Provence. The earth is hard, chalky, and sun-baked on the slopes of the Dentelles Mountains, and yet everything grows abundantly: grapes, olives, lavender. The red wine of Vacqueyras is made from Grenache, Syrah, and Mourvedre grapes. Wines from there may have higher alcohol content due to the way the Mediterranean sun radiates on this unique landscape. It's the same sunlight that inspired Vincent Van Gogh to paint.

I'm hard-pressed to explain the chemistry, the molecular fingerprints in the soil that impart the various tastes in the grapes that it touches, but the French call it *terroir*. I get how the flavor of Vacqueyras wine can suggest blackberries or licorice and even chocolate to the palate, but why are coffee, tobacco, molasses, or asparagus revealed in fermented grapes? In a word: radioisotopes. Seriously. I detect unusual flavors in some wines, everything from carnauba wax, to latex, to gunpowder—but in a *good* way! It's just how my brain interprets what my taste buds propose. Vacqueyras has limestone and flowers in the equation, like Gigondas but at half the price—say twenty five bucks, U.S.

Let's open a bottle. I'll put on some music first; maybe some south-of-France troubadour or, better yet, Eric Satie. Yeah, that's quirky enough. Open the shutters and let in some light. We'll just taste for now. It's too early for pork chops or steak au poivre, but maybe some olive pate or Gruyere cheese for you. I'm fresh out of black truffles but frankly a pretzel with peanut butter works for me.

This bottle of Vacqueyras is a Perrin & Fils—Les Christins, 2005 vintage. Bless its pointy little head. I caress the tapered neck of the sloped-shoulder bouteille, sans the customary embossed glass. Strip the foil, pop the cork. Butterflies and bumblebees issue forth. Kidding. Let it breathe. Now pour.

The color is deep garnet with a trace of copper at the edge. Swirl the glass and watch the long liquid legs extend slowly down the inside. I park my nose on the rim. The bouquet suggests black cherries and molasses, then tulips in a weathered flowerbox on a Provencal window sill, sprinkled with artesian well water from an old tin watering can.

The first sip is flinty, almost abrasive on the palate—but in a good way. It's like diamond dust or limestone in liquid lavender, slightly astringent

with tannins. These grapes must be thick-skinned to take the heat. It's slightly musty. I like musty. With another sip, hints of licorice emerge. The flavors are a dialog: a conversation between the taproot and its fruit as told to my tongue. There is a peppery essence and something woody but not too waxy, like tulipwood sawdust and steamed mahogany (I used to build acoustic guitars). Lovely liquid utterances tickle my tonsils as they slide down the old pipe. I'm not one for spitting. Vacqueyras has a firm body that finishes with a full-figured flourish and a high-pitched whine. By the time it hits bottom, it has warmed my soul. The heat expands like the lofty view from atop Mt. Ventoux that rises up between the Alps and the Mediterranean. It makes me want to ride a bike in the Tour de France. Or just kick back and look for faces in the clouds. Yeah, it's good stuff alright.

Here a home, Elizabeth makes a gourmet pizza—chicken, broccoli, bleu cheese, etc. That works fine with Vacqueyras wine, but a real bell-ringer is the chocolate truffle for dessert. Talk about a marriage made in heaven.

* * *

Driving Ettiquette

Driving etiquette is alive and well—in California!

We were vacationing in Sonoma and Napa Valley. That entailed renting a car in San Francisco and driving the hour or so north. I was pleasantly surprised by the courtesy of the native drivers in both the city and country side.

I've come to accept as normal, the traffic-battling mindset of Detroit area drivers: aggressive & competitive. In that regard, the Motor City compares with most every other city, state, or country in which I've ever driven. And last summer I spent three weeks in driving hell: Italy. Don't get me wrong. I'd go back to that splendid country in a heartbeat—I'll just never drive a car there again. Italian drivers all seem to have been born with a Mario Andretti gene or something; it's everyone for themselves on their roads (just ask the pope).

Everywhere else, tailgating is my pet peeve with the usual suspects including young drivers, late drivers, delivery truck drivers, and multi-tasking drivers who insist on grooming, dining, and/or fiddling with

whatever personal digital device is trending this month, while operating massive vehicles (CEOs or soccer moms in Hummers) inches from my back bumper. Back home, the so-called "Michigan left turn" often consists of multiple U-turn lanes across the median. In this regard there are only two types of people: Those in the outside lane who courteously hold back to leave a clear view of oncoming traffic for any other car and driver watching and waiting for a safe entry point—and those who don't!

In California, all drivers in all situations seemed to be working together for the common good and safety of all. And, above all, there was no tailgating. Maybe it had something to do with the fact that I was driving a marked car: A silver Toyota means tourist (i.e. rental) which, in Napa Valley translates to "wine taster." Granted, this vacation was brief and not that wide ranging. For all I know, L.A. to San Diego is eight lanes of anarchy with all commuters packing heat. They've had their share of road-rage incidents. But I hope that there is the same overriding sense of peace, love, and understanding between motorists on those freeways as there is up north. Sure, San Franciscans got a tad honkish on their horns on occasions, but those were decidedly civil occurrences. And of course in California traffic matters, pedestrians rule all. It took a near miss or two for me to remember that important protocol.

No, I've complained too often about inconsiderate drivers for me not to say something positive when I have the chance. So, perhaps it's legislation, or enforcement, or just a mystical aura, but in my 40 years on the road, I've never experienced the sense of teamwork among motorists as I did in California. Arizona was a surprising close second, but I understand they've since repealed their highway camera enforcement, so all bets are off on that frontier. Meanwhile, I commend Californians for their monumental achievement in common courtesy. The Golden State practices the Golden Rule.

* * *

Sedona in The Zona

We are touring the mountains and deserts of Arizona, Liz and I. We stayed at a bed and breakfast near Sedona last night. In the morning, we ate waffles and took a hike up Bell Rock. The mountains are named after saddles and coffee pots and stuff. By twelve o'clock high, the sun was

blazing and half way up the mountain, the path becomes a trail and then a cliffhanger, so the wife decides she's climbed far enough, takes the water bottle, and heads back down one level to sit in the meager shade of a small evergreen under a rock ledge while I climb up one more level just for good measure.

When I slide back down, I find her sitting, not in the shade, but out in the scorching heat on top of a massive red rock. I asked why she was sitting out there. She said it just felt right. So I sat down on that stone dome and took in the panorama of buttes, mesas and mountains surrounding the canyon. Wow! She was right. There was an aura of calm in the standing waves of some energy field radiating out into blue space, good vibes like on some drug trip, and I hadn't even taken anything, maybe a couple Excedrin. The horses down below looked like ants—or really tiny horses. The wind, which had been a blast furnace, was now a cool breeze. I even proclaimed the buzz to be my new standard of feel-good. Call it transcendence. It was only later that we found out that we had stumbled into a vortex! No kidding. It was one of a half dozen sites marked on a tourist map from the Visitor Center.

The rock formations around here are wild: spiraling spirals and funny funnels on a Grand Canyon scale. It's easy to see the forces of nature—the effects of wind and water over a million years or so, but, believe me, I'm a skeptic; I'm not much into supernatural stuff like magic crystals, pyramid power and astral planes or, in this case, "vortexes" (as opposed to vortices, which is a scientific term) of psychic energy lifting the spirits heavenward. I'm just not that metaphysical. Hell, it's all I can do to stay on friendly terms with the Good Lord, what with my empirical mindset and all. But, swear to God, I think there might be something to this vortex business.

*　　*　　*

Les Mal Traductions

Parfois j'ecoute a radio francophone de Windsor, Canada mais je faire les mal traductions en Anglais.

We think our thoughts in our native tongue, in my case English. But learning a different language, say, French, means thinking differently. It isn't a mere substitution of words (or as Steve Martin quips: "Oh, those French—they have a word for everything") but an alternate system of

grammar and syntax with which to paint verbal pictures of the world. Reading it is easy, but speaking it is another story. The hardest part is parsing the words. It would be easy if native speakers talked slowly, and clearly articulated the beginning of each word in every sentence. Not going to happen. Still, after diligent study and practice, it is profoundly satisfying, almost surreal, when, for the first time, your brain directly comprehends something spoken to you in that foreign language without having to translate it in your head; you are thinking in French.

Sometimes I wish translators would be more literal such as with the line: "Va voir dehors si j'y suis" which, word for word, says: "Go to see outside if I there am." Many translators would just say, idiomatically: "get lost" or "take a hike."

I often practice comprehending French late at night while listening to a French-Canadian radio station across the border from Detroit. That's when I realize that I might not fully comprehend the words of the francophone disk-jockeys, announcers or news reporters when I translate into English what I think they are saying in French. Here are a dozen examples:

1. My heart sizzles like liver in a fry pan.
2. Teach the cow to make good cheese.
3. Exploding stars are not good companions.
4. A new species is made of stardust.
5. Tourists should hurt themselves to see what a palace our new hospital really is.
6. He was sent to a hospital in Vancouver to eat his vegetables
7. A white Christmas is good for your health.
8. Mr. Windyhands sojourns to the horse latitudes.
9. Bathe in the sick light of Mexico.
10. This is my llama, I feed him fish.
11. Sunday, I eat the orange.
12 and now the news from a fly who sings.

* * *

The Most Stylish City

I'll name a most stylish city, but first a few words about some other obvious candidates.

Rome: I'm walking along a street when a woman in fine apparel comes whizzing around the corner on a motor scooter. Wearing a silk blouse, short skirt, and Ferragamo heels, she holds her purse between her knees and a cigarette in her lips. Her sunglasses are a smoky shade of lollapalooza and her designer helmet sports a microphone into which she speaks while jockeying for position alongside a bus. The cobblestone street imparts a good vibe to her wind swept figure. Even the local men (all wearing long pants, despite the heat, except for one gente in clam diggers with shoes that I might wear to church) turn their heads as the stylish motorista scoots past.

Paris: Standing in front of the Comedie-Francaise, I spy a debutante in an A-line dress, babushka, and sunglasses. She folds her arms, pouts, and stamps her Christian Dior-sandaled foot on the sidewalk at her beau. The boyfriend is an existentialist type wearing an Yves St. Laurent smoking jacket, ascot, beret, and a pencil moustache—the whole nine metres. He thumbs his cell phone in one hand and pinches a Galois between the two middle fingers of the other, all the while enduring the temperamental geste of his little cabbage. I have to laugh.

New York: A career women in a business suit and sensible shoes hangs on to a handle as she stands in the subway train. With ear buds in place, she is lost behind a paperback novel. Her Anne Kleins are fashionably strapped to her backpack as she makes her way to work. The commuter next to her is a man, I think, wearing pinstripes, wingtips, a paisley tie and a dew rag. It's a noisy, rollicking, nervous ride to the Big Apple for a first-time visitor like me. I get off the train and surface on Fifth Avenue, deep in the palpitating heart of mid Manhattan. The collective style of the pedestrian mass hits me square in the face as I try not to make any eye contact.

London, no doubt, has its dedicated followers of fashion, and L.A. its twenty-first century foxes, but enough about the fashion hubs of the world. For a pure and unique style, without the attitude, I recommend The City Different—Santa Fe, New Mexico!

Santa Fe's southwestern style is steeped in ochre landscapes with sagebrush polka dots and a black-blue sky of the high desert that provides

a backdrop for its colorful inhabitants. Sacred ground for generations of Native Americans, it has also become an international art center and its denizens are knowingly blessed. Not only can you crawl the galleries, but also shop, opera, or rodeo. Hobnob in hippie chic, casual elegance, or your most resplendent couture. Artisans in the old town Plaza near the Governor's Palace offer jewelry of turquoise and silver that is more than an accessory—it's an art form. Wear western boots adorned with hand-tooled roses and barbwire by Lucchese, or go with Louis Vuitton pumps. Whether it's kokopelli or women's shoes, you can find your fetish here. For designer fashions, Santa Feans know their ABCs (Armani, Boss, Calvin etc.) But a pervading sense of Spanish, Mexican, and Native American style weaves a spiritual thread throughout the fabric of the metaphysical tapestry that is this land of the Anasazi, Coronado, and Georgia O'Keefe. From a manic mechanic's point of view, the streets are a showcase for low riders and three wheelers. This art commune and spa retreat is a stomping ground for Hollywood stars. The mustachioed man in a duster, chaps, and a sombrero sized Stetson, leaning on a lamppost, may be from an historic festival, indie film, or a musical group playing Tex-Mex at one of the venues—or maybe not. You can hear western swing, mariachi, Tejano, jazz and rock. Every group seems to cover at least one Motown song. (Did I mention the Santa Fe Opera?) The architecture is pueblo. The food is legendary and the wine, up and coming. And talk about spirits; did someone say tequila? Of course all the standard commercial fare is around too, but stray cattle still roam on the hardscrabble outskirts.

Santa Fe is two parts flying and one part driving from Detroit (unless you're a card-carrying fashionista in which case you'll probably fly direct to SAF in your private jet). It's not a big city, but a destination to which the average tourist may not detour; a place where you can watch a fifty-foot puppet named Zozobra rock and roll and burst into fireworks during Fiesta. If you like coyotes, crucifixes, calla lilies, and chili peppers—go there.

* * *

Radda In Chianti

Drawings are like currency in the memory bank. Flipping through my sketchbook, I was transported back to Italy, to a Tuscan hillside village called Radda in Chianti (Fig. 20).

I'd already drawn a picture of the valley that smelled so good from our balcony, so I grabbed my pad and pencils one sunny afternoon and walked with my wife down the cobblestone via looking for something to sketch. Drawing helps me see like writing helps me think. Elizabeth veered off to scope out a leather shop, so I found a shady bench in front of a house across from a fountain and church steps, and started doodling. Before long, two kids, a boy of four or five and his little sister, came out of nowhere and hopped up on the bench with me. They leaned, one each, on my shoulders to watch me draw. I paused . . . turned my head to the boy on my right . . . and then to the girl on my left . . . "Whassup?" I asked. Not much, apparently. "Buongiorno" I tried again.

The boy starts chattering at me in Italian so I say "Whoa—hang on there, Pinocchio." They laugh. "Oh, you like that—Thumbelina?" I add, kind of smart-alecky. Nothing. So the boy points at my sketch and says something like "belvedere" or "bananarama." I'm not sure what.

"Well, you obviously don't know much about three-point perspective, do you?" I scoff. He gives me this quizzical puppy-dog look, you know, like "Huh?" He points at the building and then at my drawing and starts in with the "bandiera, la bandiera" stuff again. Just then the children's mother steps out of an archway with a watering can, sprinkles some flowers and says, "flag." She disappears.

"Oh, right—the flag. I knew that" says I to the boy. There's an Italian flag hanging off of the building next to the church and so I line it into the drawing, filling it with red and green. I could have done better but the kid kind of rattled me. I'm not used to people looking over my shoulder, yet someone did it each time I pulled out a pencil in Venice, Florence, and Spoleto. The flag was the last thing I drew before another woman, the grandma this time, came out of the big wooden door next to the bench. I think she told the kids not to bother me (but she might have been telling me to scram, I don't know). I indicated that they were no problem. Frankly, I was entertained. The woman spoke slightly better English than I did Italian and sparked up a conversation. Turns out she was an artist too and invited me into her home to see her paintings. I jumped at the

chance to see behind one of the magnificent doors that lined the street, and followed her into the medieval apartment.

Despite the blinding light of a courtyard, it was dark inside. Dark and cluttered—and meravigliosa! The place was filled with statues and artifacts and cool junk. Her studio was hung with drawings and paintings—portraits, landscapes, and even a picture of the very scene that I'd been sketching outside. After all, it was her bench and her view. Her style was rustic but expressive. We communicated just fine in the language of art, thank you.

The younger mom came in from the courtyard and listened briefly before saying something that got the kids all geeked up again—"gelato" I think. They started dancing towards the door all "arrivederci" and stuff, so I followed them out but not before saying plenty of grazies to "Nonna." I told her that of all the museums and galleries I'd seen in Italy, hers was my favorite. Still is. I think she got it.

We all hit the street just as my wife was walking by with her new handbag. She was surprised to see me bounding out of the door like the man of the house with my secret Italian family, but 'splainin' that one was a piece of cake. Bidding the *madre e bambini* a happy *divertimento*, Elizabeth and I headed back to the inn.

Now, I know most pictures have deeper meanings or stories behind them but my half-baked sketch reminds me of that colorful, cultural episode. So excuse me if I consider it a masterpiece.

Gary R. Peterson

Figure 20. *Radda in Chianti*

* * *

9. ETCETERA

Intellectual Property with Duck Pond

Back in the '80s, artist Richard Prince took a picture of a picture of the Marlboro Man and sold it as art. The original photo by Jim Krantz was part of an ad campaign to sell cigarettes. Talk about "branding!" What Prince did was liberate a cultural icon, the cowboy, from the sales force. His re-image is sort of a parody—humor so sophisticated that it's not even funny. The dialog between those two seemingly identical images is not about craft, but meaning.

Did Prince's copy lessen the value of the original photo? No, I'd say Krantz's stock went up on the notoriety of his cowboy and its doppelganger. Similarly, Shepard Fairey's portrait of Barack Obama, appropriated from an API photo, now hangs in the National Gallery with compliments from photographer Mannie Garcia.

Richard Prince compares the contextual effect of his work to the funny way that:

> certain records sound better when someone on the radio
> station plays them, than when we're home alone and play
> the same records ourselves.

I get that. It also reminds me of how the musical group The Doors, in the final four notes of their hit song *Touch Me*, took the tag line "stronger than dirt" from Ajax, the white knight of scouring powders, and liberated the underlying musical cadence in the name of art.

I too have scrawled portraits aplenty, like my *Rod Serling* which was based on a publicity photo, but I don't sweat copyright issues thanks to the "parody" and "fair use" rules. My renditions look like cartoons. I also interpreted the dozen famous images from the Detroit Institute of Arts collection without once thinking that the DIA, or the artist's estates,

might object. The fact that they agreed to sell my art card versions of the same in the gift shop is an encouraging sign.

I don't claim anyone else's idea or creation as my own and always give credit where due. Yet, in a world where everyone seems to be packing a picture phone or camcorder, there are bound to be duels in the gray areas. Frankly, I'm more wary of lifting musical motifs than visual imagery. There's something about a melodic fingerprint that keeps me from replicating too closely any existing tune—but I still scoff at the judge's decision that George Harrison's *My Sweet Lord* plagiarized The Chiffon's *He's So Fine*. I suspect the tipping point was where George turned "do-lang, do-lang" into "ha-re krish-na."

Then there's the vintage Indian-head TV test pattern that I recreated as a screen print. With a retro-style mahogany frame and a custom-cut '50s era gold metallic picture-tube mat, I transformed, nay, elevated that antiquated broadcast paraphernalia into art. Since then, I've been looking over my shoulder thinking that RCA might have a bone to pick with me, especially when they learn I've been earning tens of dollars off of that familiar chart. I've stopped losing sleep though and I'm pretty sure they've let it slide—although with the stock market in another swoon, even corporate behemoths are scrounging revenues.

Television has come a long way. The picture quality is awesome. Of course, the Stanley Cup Playoffs are my only excuse for watching TV but, regarding art, it's hard to compare marks on paper with, say, a National Geographic special. Even the commercials are mind blowing. I was watching a hi-def fiber-optic hummingbird flit across an enchanted psychedelic landscape that stimulated my retinas like no Rembrandt, Picasso or cave painting ever could. It was an ad for some big-ass flat-screen HDTV and, ironically, when the camera panned out, I saw that the product was the exact brand and model I was watching—a device with every bell and whistle short of an ice maker right there in the comfort of my living room. It was disquieting.

I needed to get outside, back to nature, so I took refuge in the bird sanctuary adjacent to my property where, I swear, I saw twelve acid-yellow finches in one bush all whistling in full fidelity on this sunny spring day. I thought of snapping some pictures or recording the sounds, maybe do a color sketch and hone my craft like a real artist or jot down the cacophony in musical notation. But, no, I was just standing there having

my grand think-fest without actually lifting a creative finger when all of a sudden—bam!

A bunch of hooded henchmen leaped out of the brush and overpowered me. Oh, I got in a couple good licks, but it all happened so fast that my vertical hold went haywire and my mind went on the blink. I was taken to a Quonset hut (with a familiar corporate logo on the door) out beyond the duck pond where I was interrogated by a bevy of beautiful babes in skin-tight metallic jumpsuits, just like in a beer commercial. They tried to get me to fess up about stealing the Indian-head TV test pattern but I was hip to their tactics and after a lengthy but not-unpleasant interlude we were joined by some paramilitary thugs. Oh, I knocked a beret or two off of their heads before they threw me in the pond, much to the consternation of the ducks who hadn't seen me this irate since I fell through the ice a couple months earlier.

I schlepped back to the house pondering my total immersion in the arts: the creative process of melding disparate elements into something novel, a practice I defend for every artist, scientist, and philosopher in this swamp. Slogging across the patio, I can see my lovely wife in the window, a "what now?" expression on her face. Through the door wall I see my big-screen TV flashing more graphics and logos, all spinning and morphing in virtual reality, heralding the start of the hockey game. True story—except maybe for the part between the finches and the ducks*—I'm still sorting out the details on that episode.

*(Not to be confused with the Ducks whom the Wings beat in seven last year; this year—bring on the Sharks!)

<div align="center">* * *</div>

Why the AMC Pacer was a failed car design

The Pacer was the futuristic descendant of the Nash Rambler which was an automobile that had all the style of a meat freezer. But whereas the Rambler was inherited by the American Motors Company, the Pacer was *their* brainchild. As a trend setter, the Pacer honked with plebeian pride. But in 1975, America had already run into a brick wall in the form of an energy crisis and an outmoded auto industry.

While the Big Three continued to fulfill the American dream of a muscle car in every driveway, AMC had given us the Gremlin and its sporty "hockey stick" accent stripe. The unqualified success of that utensil-on-wheels gave rise to the visionary Pacer. It was two parts bumper car and one part punchbowl, but the interior of that glass dome had enough elbow room for the Mahavishnu Orchestra. The power plant was to be the Wankel engine—about as practical as the turbine engine that Chrysler test marketed a decade earlier. The Pacer's design evolved in the years following the Apollo space program. Hovering around town in their silver-toned Pacer my parents were as stylish as The Jetsons. I used to call that vehicle the "Spacer."

The Pacer was a high concept at the end of an era when the car-buying public was still secretly hoping for bigger-stronger-faster fare and maybe even the return of hood ornaments and tail fins. But with all of its utilitarian sensibilities the Pacer became an early victim to economic and quality concerns better addressed by the Japanese auto makers. Like the Edsel in the Sputnik years, the Pacer just didn't quite have the right stuff. AMC was eventually bought out by Chrylser cum Daimler which may have been an omen if you recall how that chapter ended. Let's see if Fiat can dodge a bullet.

In the history of automotive design, the Pacer was a giant leap sideways, the likes of which we wouldn't see again for twenty-five years and the advent of the Pontiac Aztek. But considering that I haven't seen a Pacer on the road in all that time, I wonder: Did they all self-destruct or fall off the planet, or are they being hoarded by some very savvy collectors?

* * *

The Corporate Office: A Cerebral Landscape

I get a kick out of "right-brain, left-brain" theories of personality types—the logical left-half versus the creative right side of the human brain. Now I read a business report suggesting that, at the corporate level, the balance between employees of the intellectual left and those of the emotional right is the key to success for any design/manufacturing firm. Why not extend that notion to the typical corporate office layout? It should emulate the spatial configuration of the human brain with two banks of office cubicles, populated by left and right-brained employees

respectively, separated by a wide aisle in which the Department of the Corpus Callosum can orchestrate the interactions of left-headed managers with the right-minded creative staff. Across this landscape, one can see brainstorms popping up over the right side while a bookkeeper hunkers down in the last cube on the left.

A corporation is a bunch of people acting like one person. Their collective habits define the corporate culture, so an architectural space planner must be a psychologist too. The floor plan and office landscaping expands on the metaphor of "nerve center" and world "headquarters." Anthropomorphically speaking, a square office building three stories high is like a big blockhead with entrance doors as the mouth and windows as eyes. Call it physiognomic fenestration. A person achieves success by visualizing it, so a corporation must have "vision" too. The brain's visual cortex is in the back of the head, so the CEO or president of the company has a top-floor wrap-around office with corner windows and closed-circuit TVs. A right-headed honcho should forego any hands-on style that promotes diversity at the expense of uniformity but can still don the ass hat every now and then just to say, "You're fired!"

The Corpus Callosum director is a rare breed having a well-balanced brain: a logical left hemisphere that can turn on a dime and an emotional counterpart that makes wide right turns like a bus. A person with an enlarged corpus callosum in the gap between brain hemispheres might be best suited for the job. That condition statistically favors women (hence a woman's intuition, I kid you not), musicians, and left-handed people, suggesting the revered folk music legend Elizabeth Cotten to be a perfect candidate, except that she's dead. But any prime candidate could use a "dashboard" of business software to help integrate metrics with production methods of any sort of marketable trinkets, with an inventive flair designed and to keep the proverbial bus from veering outside of the white lines where orange barrels fly. Just-in-time delivery—meet artistic license.

Likeminded people gravitate to each other. But opposites attract too, even if just for the purpose of mutual destruction. Occasionally, left and right-brainers must work side-by-side to cross-pollinate ideas between departments. Individual employees must remain positive, respecting one another yet knowing that the person in the next cube is irritated by your pencil drumming or fragrance or that egg salad sandwich. The workplace is also a minefield for inappropriate behavior, so be as politically correct as legally prudent. Make someone's day, especially if they're hot, by offering

them a Tic-Tac or friending them on Facebook, but remember: memos are forever. HR and legal on the second floor can read your mind and admirable conduct isn't your strong suit. Just act professional and it'll shine through on the security cameras.

Attention, left-brainers: Your stilted vernacular does not compute. Move your desk between agents Broca and Wernicke and try to cobble together a coherent memo about production deadlines that the design department can wrap their heads around. Placing staff on the opposite side of the aisle can strengthen the organizational structure providing they can do math and chew gum at the same time. The left side is neat and anal, with classical music wafting pretentiously above the file folders while the right side gesticulates with a lot of hand movement, heavy on the drum and bass. The rights might have a higher incidence of bipolar depression, but the lefties have a higher suicide rate. It's a wash. But they all have wheels on their chairs, so you must widen the aisle and expect head-on collisions. As for shop and warehouse personnel: they need only two brain cells connected together—one from each side.

Right-brained business models are too intuitive, allowing emotions to influence staffing decisions. Those hires then feel hurt when they don't make employee of the month and frequently hit the road to become entrepreneurs, hawking chocolate bacon or whatever new social media has the twitbots all agog that month. Left-brained business models, on the other hand, are vulnerable to numbers analysts, hard-nosed statisticians like Six Sigmas who promote profit at the expense of creativity. A right-thinking design department will run things up the flagpole and see who waves back before resorting to math and bottom-line projections, while left-headed doctrine fosters algorithmic machinations whose operators are hard-pressed to conjure the mystical aura needed to capture the imagination of the hoi polloi or glitterati in the marketplace. The logic of standard deviations smacks of Fibonnaci numbers often proffered as reliable methodology when in fact old-fashioned pride in craftsmanship can empower the right-headed artisans producing the goods. Either way, fist fights occasionally break out in the cafeteria.

Office carpeting should be a polyester twill or some other static-free weave and blend to avoid synaptic gapping due to static electricity in the event that managers come into physical contact with creative types in this volatile atmosphere. Employee profiling can be facilitated by a magnetic resonance imager (brain scanner) located between the photocopier and

water cooler. The bulletin board features jokes and cartoons—irony and poetic justice for right-siders while puns and riddles amuse those gauche left-heads. A mission statement adorns the wall along with some inspirational posters with images of rowers and golfers, and feature sappy prose based on buzzwords like "Succeed" and "Determination," or maybe "Redundancy" and "Cliché." Highly motivated employees have no limits of achievement regardless of their head bias. Meanwhile, put that complimentary copy of *Where's My Cheese?* in the toilet where it belongs.

A note about Democrats and Republicans: There is no hard evidence that the liberal left is any more logical than the conservative right is prone to rhetoric and conspiracy theories. It just further complicates the seating chart.

Right-headed spin-doctors convene at two round tables near the head of the class in both dorsolateral hemispheres of front office space. They conspire to make the public passionate about the product and elicit an emotional response from the "brand." They don't want you to be logical; they want to make you their bitch. Self-absorbed righties dominate the altruistic lefties in this department because consumers must buy the goods for themselves before they'll give them as gifts to others. Provide them with perks and free passes to the library of incentives where they'll find tickets to events that nobody cares about, a snack bar, and the pharmacology lab located in the ventral striatum next to the Department of Fads and Trends. When the left-brained staff of client managers aren't doing right-brain calisthenics in the weight room, they mostly occupy the conference room or product showroom for public meet-and-greets to hand out free samples to target groups in the annex across the orbital-frontal corridor in the west wing of the complex located behind the state-of-the-art Temple of the Tech gurus.

Being an intellectual handyman, I am myself ambi-cerebral. A subject-matter expert on cognitive dissonance and conflict resolution in the workplace, I roam freely throughout the complex while shunning meetings and avoiding deadlines, contented to let the hoard of micromanagers try to hit their benchmarks and move up the corporate escalator. I scheme and ruminate and dance to my own music in the humorsphere, an office with northern light and one-way mirrors on the brain-stem mezzanine of the atrium overlooking the lobby where I monitor the desires and inhibitions of bean-counters and paste-eaters alike while keeping an eye on the pert new receptionist, a free-spirited temp from the Frontal Lobe Agency.

Nowadays, theoretical models are giving way to statistical ones—thanks a lot, Google—and a new business model looks scarily like Facebook. We form business bonds with people we'll never meet. The money is tallied on your touch screen and you don't even have to leave your couch let alone the feng shui of your own domestic head room unless you actually have to manufacture something yourself, but then 3-D printing will soon take care of that nuisance. Dream it up, punch it out. No wonder all those big buildings in your neighborhood are vacant. Still, we desire the physical interaction with the wetware we once called the work-a-day world. So go ahead to the coffee shop with your digital device and a left-brain/right-brain app, if you don't already have one implanted in your brain, and contribute to the worst-case scenario of a Craig's List economy spawned by today's crowd-sourcing mentality. Reality will become totally virtual (and viral) unless we move to preserve the corporate office landscape. People deserve the chance to work in a real office building with fluorescent troffers, industrial grade air freshener and OSHA approved emergency exits.

Ninety percent of our behavior is habitual. Reclaim the corporate culture one bad habit at a time in just thirty days by integrating the left and right sides of the office using my proprietary blend of pop psychologies based on stimulus-response principles from the Behaviorist school and names the likes of B. F. Skinner, Thorndike, and Watson, as well as key holistic precepts from Gestalt Psychology, you know—the whole is more than the sum of the parts. I mean you could put John, Paul, George and Ringo all together and they wouldn't be as good as The Beatles. (Cue the music.) "Help! I need somebody . . ."

Profitable, creative teams are built to leverage both left and right-brain skills sets.

Corporate success is not a zero sum game: Not every individual can be a winner, but they can be part of a winning team. (Is this a script from *The Office*, or what?) Cerebral landscaping will help strengthen the "handedness" of your corporate environment so that you can nail any opportunity that stumbles into your headlights. Take action now! Who's with me? Show me your right hand. OK, the other right hand.

* * *

Quantitative Easing

The manipulation of money by the central bank—or, "The Fed"—even in a free market economy, is as much an art as science. And just like the art world, there are different styles and schools and techniques to achieve a desired result. In economics there seems to be a rift between the ideas of Maynard Keynes and Milton Friedman (not to forget Adam Smith, who was also a moralist with an invisible hand). They have signature styles of monetary and fiscal policies. This isn't unlike the contrasts between the art and artists of a given era like, say, da Vinci and Michelangelo, or Picasso and Matisse. One is more Cubist than Decorative but they both get the job done in creative ways which the average viewer only enjoys through the finished image.

Quantitative easing is a bold and, frankly, novel approach intended to grease the money pipeline and get the economy banging on all cylinders again. Interest rates are already at an all-time low so we can't make money any cheaper, but only make more of it. This flood of fresh money—made to order by the magic of a printing press and extensive credit—lowers the value of the dollar, thereby making our products more affordable on the world market. We can all worry about inflation later. Of course, we blame China for affecting the same advantage in their back-handed manner with their own currency, the yuan. I don't distrust the Fed any more than Wall Street but rather presume that those who know more about how the system works will naturally use it to their advantage. That's human nature. The average citizen has only to try and understand the mechanisms to be a productive member of the steering committee. But do we, the vanishing middle class, participate in the market, let alone manipulate it? Is our leverage just an illusion? It is if you've got no chips to ante up into the pot.

Frankly, nobody knows yet if quantitative easing, now in its second round, will work (although it should be clear by the time you read this). We need jobs more than anything, but I give The Fed credit where due and can work with their policies so long as I know what rules I'm playing by. They are, by and large, committed to making us key players in a global economy. That's the only way we can hope to continue calling the shots. The dollar isn't the world standard by accident. It takes a growing sophistication to call the tune for the American people. And by playing, I mean the stock market. We should be getting used to a bubble

economy by now. It's no more criminal or subversive as the difference between, say, Post-modernism and Abstract Expressionism in art. I can appreciate the evolution of thought and utility in either of those modes. Ditto the monetary policies of our great country which are always subject to tweaking, goosing, or even flat-out paradigm shifts like lowering our material expectations and raising our standards of aesthetics—green tech, not greenbacks—so long as "we the people" are willing to be flexible without being flummoxed by "experts" on either side of the equation: our government or the conspiracy theorists who habitually oppose it on principles, blind, biased, or otherwise.

Excuse me if I cut short this rant, but the opening bell is about to ring on Wall Street and I've got some decisions to make.

* * *

Stock Market Advice Twaddle

The best things in life are free, but not financial advice. Then again, the Internet is not the rigorous, peer-reviewed conduit and brain trust it was before the World Wide Web got a toehold.

The following text is a deconstruction—my logical written reduction—of a financial column in a highly regarded financial publication (in both print and online) that I came across on a very prominent website. I'm not out to embarrass anyone in particular, but the source file that I analyze here is typical of a hundred fresh offerings one can subscribe to on any given day. After all, journalists re-invent the wheel on a daily basis, and finance in particular is by nature "forward looking" which means "speculative" at best, and more like "useless" unless you're looking for humor value and you have the time to kill. This article was feigning to give valuable insight into the stock market metric known as the daily trading volume which is listed among myriad technical indicators on the stock exchange.

The original article has the ambiguous semblance of enlightening, coherent advice. That's what's so scary. I hope this sentence by sentence analysis clarifies the convolutions and double talk, and helps you pick a winner. (At least the original author was ethical enough not to recommend a particular stock based on this gibberish.) I swear it shakes out thusly:

Volume could be meaningful—or not. Some think it is, others not. Some people make silly decisions.

Words can sound dangerous, but concepts come and go. Things seemed different once, but then again, not so much. Therefore, the first sentence still holds true, which means it could be false. An expert says volume tells us how popular or unpopular something is, but it might also mean something else.

Today, one sign says favorable but another says not. A different expert says many investors are more cautious since the financial crisis. That might mean something, and it may have been true at one time. Some people don't think that good news will last. But is that a bad thing? Should it matter? (No answer offered.)

Volume shows the changing sentiments of various groups from time to time. Any group can go either way, but if one investment negates another, then it all averages out.

An early expert, long ago, likened two common economic indicators to a couple of scientific terms with no direct parallels, but never mind because that false inference, admittedly, has no bearing on the current conditions. Still, there are principles.

So, don't view a popularity contest as a judge of merit. It just means that if you make silly decisions, you have lots of company.

* * *

Honesty

Honesty is the best policy but, as with my homeowner's insurance, black mold and white lies aren't covered. In other words, there are exceptions to the rule. A policy only has to be fifty-one percent preferable to qualify as "best" in a two policy race. Still, "honesty is best" beats "lie through your teeth" every time.

It's been said that the average person tells fifty lies a day, but those would include "courteous" lies. For instance when someone asks, "How are you?" you generally say, "Fine, thank you" instead of "I'm a tad dyspeptic."

Other technical lies include the "customer is always right" type; again more policy than fact. Furthermore, your honesty policy may have a "don't rat on your friends" clause that can be exercised to a reasonable extent. These are gray areas but the line should be drawn at fabricated half-truths like, "I can't help you move this weekend—I'm going 'up north'" when, in fact, you're just going uptown to the Northland Mall.

There are few absolute truths in life, so honesty is often based on one's beliefs instead of facts. But if there is no malfeasance or deliberate deception, the path shouldn't lead anyone astray. Honesty hinges on purity of heart.

It takes strong character to put the interest of others in front of your own. Still, you don't have to volunteer information that doesn't serve you or some honorable purpose. It would be tedious if everyone willingly and honestly divulged their thoughts on demand. Pretty soon we'd all be thinking the same thing: Is there no privacy? Silence is a suspicious alternative to honesty, but it can circumvent needlessly hurtful truths. That's why we have the Fifth Amendment. "Don't ask, don't tell" is a laudable policy in its own right.

In any case, you should always assume that your honesty will inevitably be tested, so conduct your affairs accordingly. Honesty is a policy that provides the greatest good for the most people. Honestly.

* * *

Fancy Donuts

I went to a lighting conference once. It was an overnight affair at a hotel that served complimentary coffee and donuts in the morning. I happened to be first in line as the hostess put out a tray of donuts, an opulent assortment that would put Amy Joy to shame. I don't usually indulge, but I took one plain donut from the tray.

Well, let me tell you—the gal in line behind me was appalled! A real go-getter, she couldn't believe that I chose a *plain* donut over all of the glazed, frosted, nutty, sprinkled, cream-filled sugar bombs waiting to be plucked and devoured. What was my problem? "Who goes for the plain donut?" she wondered aloud. They're free! It was unnatural, un-American, or so thought that young mover-shaker, making clear her disgust with my plain-brown

sensibilities. She was pissed! Sheesh—I should have taken a bite from the fanciest one and left it on the counter, but I just blew her off.

I sat at a table with some other attendees and munched my paltry fried-cake. It was sweet 'n' greasy. I sipped my coffee, black, while the editor for some trade magazine rattled on about a new blue light bulb that could make a silverback gorilla look like a mink coat, while a suit from St. Louis divulged a flare for mannequins or something—I wasn't really listening. All I saw was that judgmental bitch sitting at another table, thumbing her report to Snark Central, I presume, on her personal device, then, still rolling her eyes at me, dipping her finger into the whipped cream and sequined glory hole of the obscene donut in front of her and licking it with contempt. But I could tell that I'd already ruined her fun. Ha! Nice try, Toots, but don't challenge my manhood. I have a trophy wife and she knows cheesecake the likes that you fancy-donut types couldn't handle. Besides, you could stand to lose a donut or two off the hips, I noticed as she was getting on the bus to the conference center.

I rode in the back of the bus and sat at the back of the lecture hall, wondering if perhaps I *was* a tad too conservative. Luckily, the lighting demonstrations gave me some dramatic philosophical insights into the epistemological nature of perception: the effects of any medium between an object and the observer, and how one's perception of reality is based on phenomena and that one can't truly know an object unless it becomes that object. It took my mind off donuts for a while. But lighting can only go so far to make a plain donut look like Pandora's plush puddin' pop. I was boiling in oil again. If fancy donuts are too rich for my blood, what else was I missing? Nothing!

I like salads but I'll eat steak. I can listen to a Fernando Sor guitar solo or full-blown Stravinsky. I play a mean fugue myself. I ain't afraid of no fancy donuts. I'm an artiste! I can doodle in ink or slather in oils and get an aesthetic buzz from a perfectly flexed line or even a hedonistic Fragonard. I'd just as soon sit in front of a Rembrandt etching than in the cinema with 3-D glasses, watching some pyrotechnic honk-fest of a movie with a budget bigger than some third-world economies. I'll take Woody Allen. I like existential Sartre or ponderous Shakespeare. Give me Grandpa Jones or Leonard Bernstein, preferably both together. I like the logic and elegance of Gödel's Theory of Incompleteness. I like calculated risks, not wild speculation. I can dig origami or Giacometti; beau gestes or macho

bravado; mind over matter. I ride a bicycle but my car is boss. Size matters, yes, but bigger isn't always better. I can take a punch, and land one. I know what it's like to hit the sweet spot. What I don't like are printed T-shirts and bumper stickers. I love tequila but not the super-premium stuff: that's too smooth for its own good.

I don't give a Fig Newton about cholesterol or body fat; it's just that fancy donuts are too rich for my blood. And that donut of yours, sweetheart, is a cliché not a metaphor, and frankly I can think of better things to do with whipped cream. I pick my spots and in the donut line at some glorified décor seminar isn't one of them.

Back at the hotel it's happy hour and the line is forming for complimentary wine. I'm not pushy but if I spy a bottle of Vacqueyras or Valpolicella, don't be surprised if I get my elbows up in your face. Later, as I boarded the shuttle bus to the airport, I saw the snooty one get in her car. Now, I'm not going to scoff at the plebian make and model that Ms. Fancypants was driving; that would be shallow. But, hey, it was no CTX V-Series, folks.

<p style="text-align:center">* * *</p>

Never Scratch Your Head at an Auction

We went to a fundraiser Saturday night, an auction slash gala event at Cranbrook Academy of Art, that toney boarding school designed by Saarinen & Son for newspaper mogul George Booth about a century ago. My wife teaches at the lower school. We schmoozed with high brows and jet setters—artists, athletes, heads of state, and titans of industry whose lucky kids go to school there. I could drop names but how tacky would that be?

It was pretty fabulous but not as ostentatious as in past years: fewer ice sculptures and chocolate fountains. This dang recession has even the über rich throttling back.

The hors d'oeuvres included little vials of tomato bisque and tiny grilled cheese sandwiches that were real tasty. The salmon was a little dry though. But I was disgruntled by the new two-cocktail limit at the bar, a travesty that turned the complimentary drink vouchers into valuable currency. The powers that be must rescind this rule if they want me to

show up at future shindigs (as if they actually give a rusty nail about my compulsions). I tried to rally the other patrons into a protest in the dining room but I guess I looked like hospitality in my black vest because people kept handing me their empty glasses.

The live entertainment included artist Martina Hahn who got up on stage and, to the beat of some techno-music, speed-painted a stylishly spooky picture of a swooping owl in black and white on a large spinning canvas before our very eyes in a matter of minutes. That was a hoot. It sold for a few thousand dollars and kicked off the live auction. I didn't intend to bid on stuff (although I have donated pen & ink drawings of mine in the past), I was just there to sip and kibitz, get off my couch and maybe match wits with a scholar or two.

The bidding was lively on the various art objects, sports memorabilia, travel packages, and other luxury goods. Yawn. At one point, I took off my eyeglasses and held them up to the light to wipe a smudge. Elizabeth elbowed me and said to be careful or they'd think I was bidding on whatever was on the block at the moment. Good advice. Yet, a little later—I swear this is true—I had an itch and so I reached up to scratch the top of my head with my hand and—bam! Suddenly I'm in the running for a vacation package at some place called Turks and Caicos. Yep, with that inadvertent flick of my wrist, I had bid five thousand dollars for a week's stay at an island resort. Realizing my faux pas, I was going to wave off the auctioneer but figured that might only make it worse and jack up the price. Given the snafu, I'd have preferred an earlier bid package: traveling with the Detroit Red Wings on their team jet and sitting behind the bench at an away game. But there's no NHL hockey on the tropical islands now in play. Fortunately, I was easily outbid by some dueling hedonists who were dead set on that West Indies pleasure cruise. I understand it is tax deductible.

Man, was I relieved, although my wife hadn't even noticed what happened. It's not like I was waving a paddle or the card that all the other bidders seemed to have in hand. I suspect the auctioneer was just trying to teach me a lesson. OK, I'd be a little peeved too if some yokel kept knocking me off my game while I was working a room, doing my thing and sounding all abiddy-abiddy like rap master Porky P. But then, even his assistants could see I simply had an itch. He made a tactful mention of it after dropping the hammer, cautioning the crowd in general about scratching.

Gary R. Peterson

All's well in the end. And now, standing near the main doors, watching the movers and shakers ease into their Bentleys and Beemers that the valets have lined up in the circle drive, we wait for a shuttle bus to take us to the auxiliary parking lot. But the good news is we won't be taking a trip to Turks and Caicos for spring break. The bad news is, well—ditto.

<div align="center">* * *</div>